D1003283

RICHARD GARVEY-WILLIAMS

MASTERING **COMPOSITION**

THE DEFINITIVE GUIDE FOR PHOTOGRAPHERS

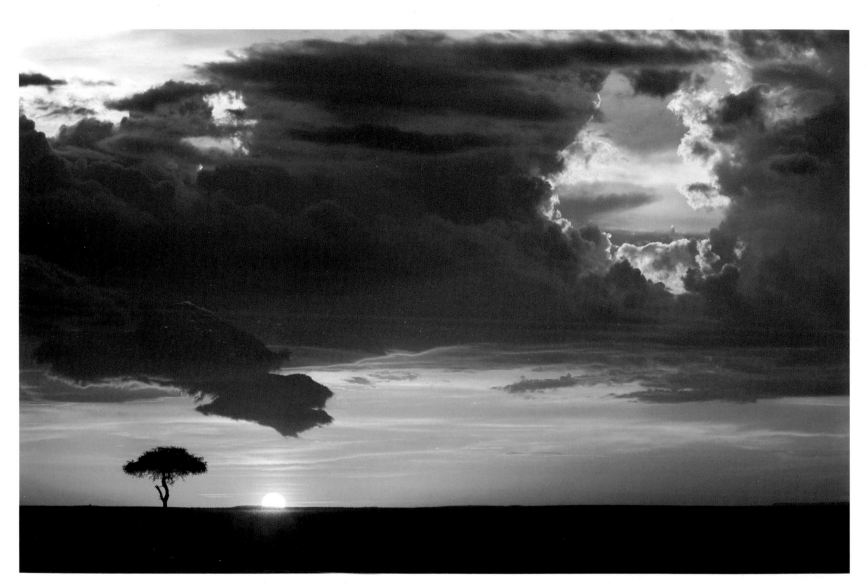

Above: In this image of a Kenyan sunset, the strong, isolated shapes of the tree and setting sun on the left are balanced by the aperture in the clouds and ample negative space toward the right.

RICHARD GARVEY-WILLIAMS

MASTERING **COMPOSITION**

THE DEFINITIVE GUIDE FOR PHOTOGRAPHERS

AMMONITE
PRESS

First published 2014 by
Ammonite Press
an imprint of AE Publications Ltd
166 High Street, Lewes, East Sussex, BN7 1XU, UK

Reprinted 2015

Text and photographs © Richard Garvey-Williams, 2014, except images
© Mark Shuttleworth, pages 71, 85 (top r), 95, 107, 111, 127, 131 (r), 132,
133, 136, 138, 143, 157 (l); © Edwin Westhoff page 86.
Copyright © in the Work AE Publications Ltd, 2014

ISBN 978-1-78145-063-5

All rights reserved.

The rights of Richard Garvey-Williams to be identified as the author of this
work have been asserted in accordance with the Copyright, Designs, and
Patents Act 1988, Sections 77 and 78.

No part of this publication may be reproduced, stored in a retrieval system,
or transmitted in any form or by any means without the prior permission of
the publishers and copyright owner.

While every effort has been made to obtain permission from the copyright
holders for all material used in this book, the publishers will be pleased to
hear from anyone who has not been appropriately acknowledged, and to
make the correction in future reprints.

The publishers and author can accept no legal responsibility for any
consequences arising from the application of information, advice, or
instructions given in this publication.

British Library Cataloging in Publication Data: A catalog record of this
book is available from the British Library.

Editor: Chris Gatcum
Series Editor: Richard Wiles
Designer: Robin Shields

Typeface: Helvetica Neue
Color reproduction by GMC Reprographics
Printed in China

Contents

Preface & Acknowledgments

I am fortunate to have a very active and progressive photography club in my local town. We frequently have critique sessions and guests come in to judge and comment on competition entries. Although there appears to be a general acknowledgment of the importance of "composing" the photograph, the evaluation and cognition that underpins this is often skirted over. I get the impression that people know it's critically important, but don't know quite where to turn to for guidance. Flicking through the pages of most popular photography magazines you might be left thinking that there's only one compositional rule of importance: "The Rule of Thirds." Indeed, it appears that some will judge the merit of a photograph based almost solely on this. Rarely do you hear discussion about "visual weight," "balance," "negative space," "depth," and so on.

This, together with various comments I have heard and feedback I have received regarding the compositional quality of my own images over recent years, has prompted me to write this book. I am fortunate (or perhaps not!) to have a mind that seeks out order, simplicity, and harmony and I believe this is reflected to some degree in my photographs. I frequently take care to consciously compose my photographs rather than relying purely on instinct. This is not always a good thing, but it helped instigate this inquiry into the principles of composition and design. Through this book, I hope to share the fruits of this investigation.

In addition to having a mind that seeks out order, simplicity, and harmony, I am also burdened by one that is meticulous in its quest for precision. So, I hope that this will also make for a clear and ordered discussion of what is potentially a rather "airy" subject.

The supporting photographs are almost entirely of my own making, and I hope you enjoy them. I also hope that you will find fault with many, as I would like to think that you are applying a ruthlessly critical eye to them as part of your development as a photographer. Understandably they are not all chosen purely on merit, but often simply for the fact that they support or illustrate a point. I have tried to include a range of genres and to this end have included some by my good friend Mark Shuttleworth, to whom I would like to say a big thank you. Also, I am very grateful to Edwin Westhoff, photographer and teacher of photography and former lecturer at the University of Utrecht, for his clarifications regarding his own "Diagonal Method" and for his informative correspondence and suggestions in general.

Finally, I would also like to express my thanks to my wife, Lisa, for her encouragement while I redefined myself as a photographer, and for her patience when I lose myself "in the zone" with my camera.

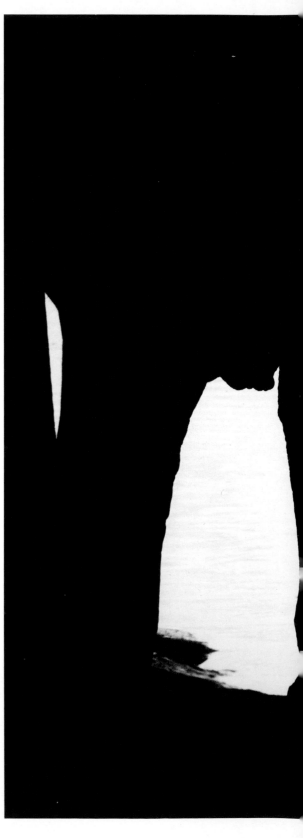

Right: Removing color from high-contrast images can help draw attention to the shapes and contours.

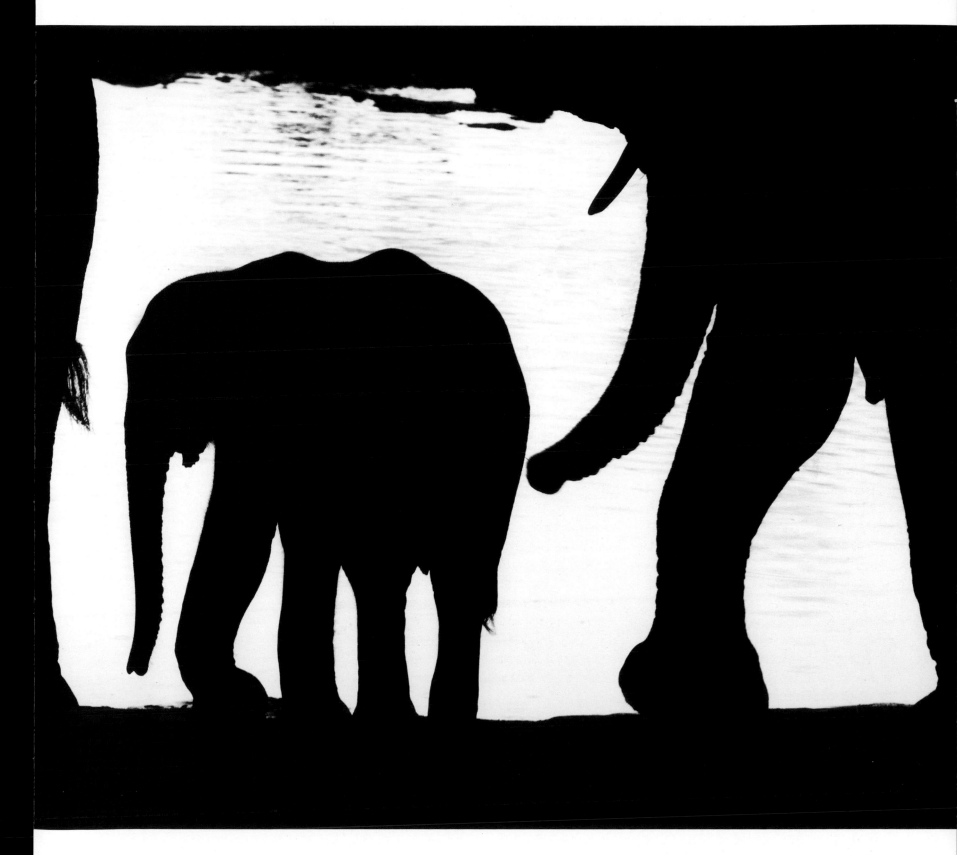

Introduction

Due to the scope of the subject in question, I feel compelled to start on a somewhat philosophical footing. We need to ask some questions firstly about what we, as photographers, are trying to do. The measure of the success of a photograph needs to incorporate consideration of the photographer's intent.

Photography is employed for a whole host of reasons. It may be simply representational or depictive, as in the case of a field botanist wanting to illustrate and study the detail of a new species of orchid. An extreme example is a passport photograph, where even a smile is not permitted.

A Form of Expression

At the other extreme it may be used simply as a form of expression, with the photographer giving the process over to the right side of his/her brain. Here the photographs may not even be shared with others, with the process of producing the image being a form of "expressive therapy" for the individual.

For most of us, however, we enjoy our photography as something that is a little more than representational. It is not only a way of conveying something about the subject matter, but also about ourselves to other people. The "ego" is perhaps calling out to be noticed as much through our photography as through our other pursuits in life. As David Ward, one of Britain's best-known landscape photographers, said, "Ultimately, isn't it better to be noticed for the way we see than for what we see?"

As we shall see, an important first step in taking control of our picture making is this acknowledgment that most of us are taking a photograph partly for ourselves, but also to impact or influence others.

Through our photographs we aim to say something about the subject. Often, but certainly not always, it is an attempt to express and capture the beauty of a scene or subject, or to convey our emotional reaction to an aspect of our surroundings. If we simply "point and shoot" with our cameras, the problem is that we are asking the camera to do the impossible—to convey the thought, reflection, or vision that made us lift the camera in the first place. Composition enables us to better express this with clarity.

Evaluating Images

In terms of our personal reaction to a photograph, psychological factors invariably come into the reckoning—we see with our eyes, but perceive with our brains. This is done selectively and largely automatically, with the visual information being filtered according to our makeup, experiences, and conditioning. Therefore, the experience of seeing a scene or of viewing a photograph is highly individual.

This is the subjective aspect of photography, which clearly defines it as an art form. From this standpoint, there is no best or correct way to photograph a particular subject, as no judgment can be put on what is largely self-expression. However, even in this subjective realm we can discern certain patterns that most of us share relating to how we perceive and interpret images. This leads to the claim that there is also some degree of objectivity in the process of evaluating a photograph.

Most of us can agree that certain photos are good, but why are they good? Through asking this we can learn a lot about the common ground we

WHAT MAKES A GREAT PHOTO?
I would suggest four elements that are significant components:

1 A subject with impact: something that captures the viewer's mind for one reason or another. It might be through its beauty, its ugliness, its uniqueness, or its interest.
2 A dynamic composition that supports the emphasis on the quality being expressed or the stories that surround the subject matter. If the intention is to produce a "pleasing" image, its composition will also need to exhibit good visual design and balance.
3 Effective use of lighting. This is to support the messages being conveyed and again to evoke pleasure in the viewer through the quality of the light and balance of it throughout the image.
4 Although it can be argued that this is encompassed in the above, the fourth element is perhaps the most crucial: the image's ability to invoke an emotional response in the viewer. Through this it might convey emotion, mood, or perhaps a sense of place, location, or space.

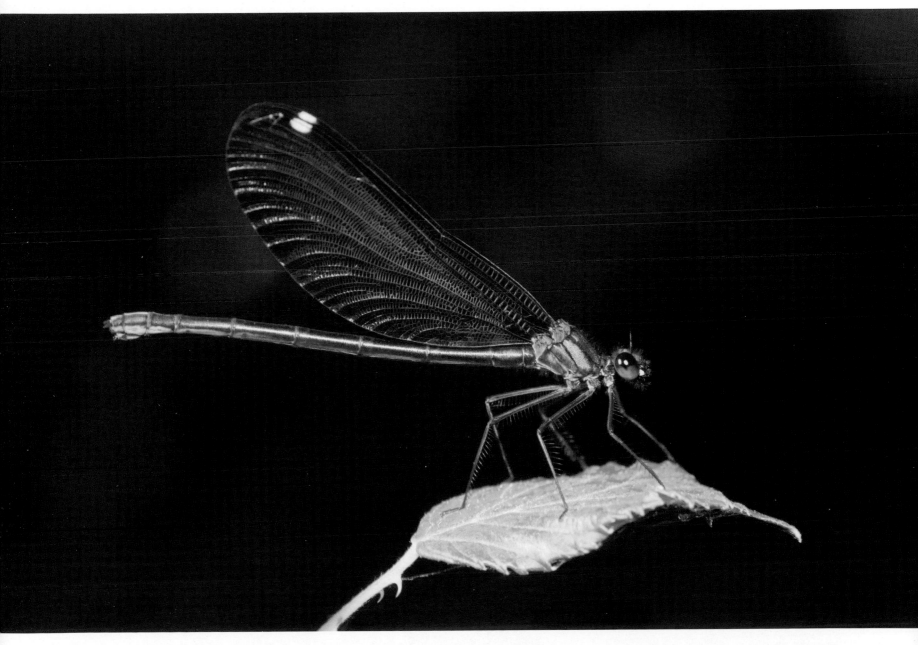

Above: A typical illustrative nature image that aims to reveal clearly the morphology of an animal· the entire damsel fly is depicted sharply in profile against a neutral background.

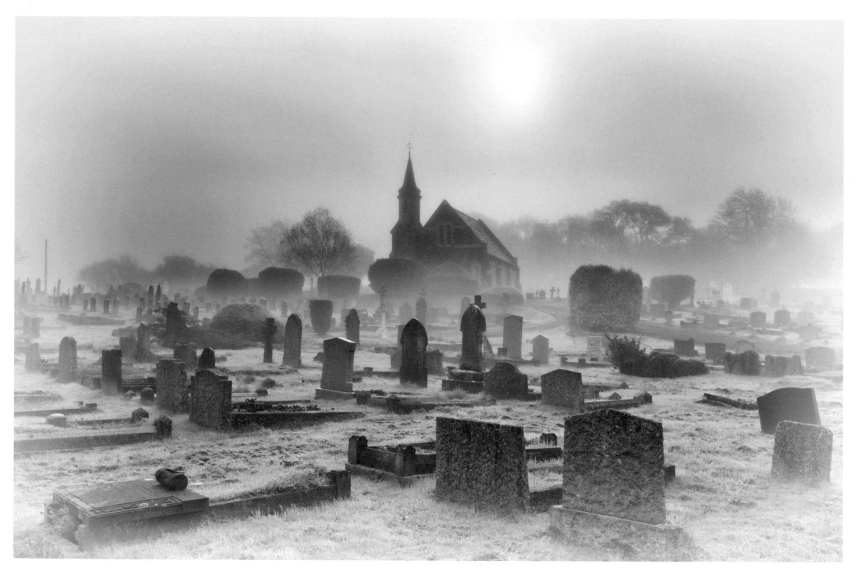

share in terms of our analysis of (and our reaction to) two-dimensional images.

Photographer's Vocabulary

The subject matter and lighting can be viewed as the vocabulary at the photographer's disposal and the composition as the grammar that is used to knit them together to help create the story or poem of the emotional response. Of course, the intention may not be to create something beautiful that will provide a sense of peace and tranquility to someone's living space. Instead, it may be to shock an audience, as is often the case in journalistic and some fine-art

imagery. It is still, however, equally important that the lighting is appropriate and that the subject matter is arranged and positioned in the image frame to make the intended message as concise and clear as possible.

Even if your intention is that the message is ambiguous, so the image engages the viewer more in "reading" it, the composition can be fine-tuned to support this ambiguity. Indeed, when used effectively composition can often help you to create something special from even the ordinary.

Above: The subject matter of this cemetery scene is reasonably captivating. The light quality certainly supports this, with the backlighting emphasizing the shapes of the graphic structures within it. The lines formed by the foreground headstones tend to draw the eye up through the image toward the chapel, and the bright orb of the sun beyond also tends to draw the eye through the scene. Finally, the fog gives the image a sense of depth and plenty of atmosphere—it scores well regarding all four elements.

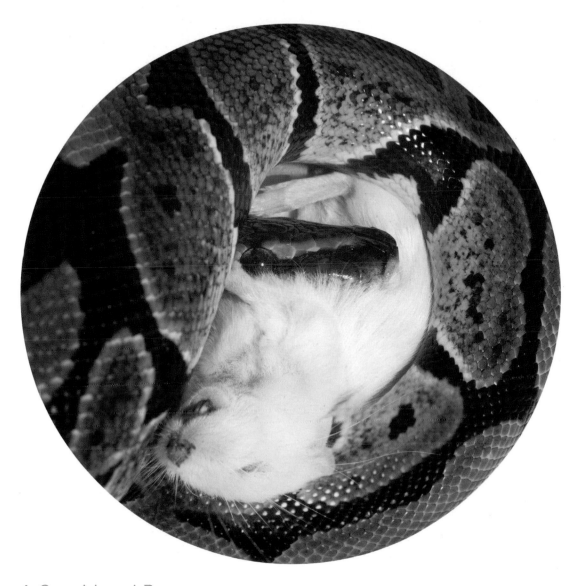

DEFINING COMPOSITION

In essence, composition is simply "the arrangement of pictorial elements." My dictionary defines it as:

1 The act of putting together or making up by combining parts or ingredients.
2 Something formed in this manner or the resulting state or quality: a mixture.
3 The harmonious arrangement of the parts of a work of art in relation to each other and to the whole.

"Design" is a closely related word, and here my dictionary suggests it is:

1 To plan and make something artistically and skillfully.
2 The arrangement or pattern of elements or features of an artistic or decorative work.
3 An end that is aimed at or planned for; intention; purpose.
4 To work out the structure or form of something, as by making a sketch, outline, pattern, or plans.

Collectively these definitions suggest that an important part of the composing or designing of a picture is the purpose or intention that underpins it. Usually the purpose for us is to increase the effect of the photo. We aim to balance the amounts and relationships of the ingredients, so as to create a mouthwatering delicacy. Design is about leading the audience to a clear, predetermined conclusion.

A Considered Process

In his book *Practical Composition in Photography* Axel Brück suggests that composition is "a well thought-out arrangement." I believe that the "well thought-out" element is important here. It emphasizes that composing an image is a considered process that depends on your intentions and some acknowledgment of the perceptive processes involved when individuals view an image.

We also, however, need to acknowledge the unconscious component. The working definition of "composition" that I will use in this book is "the process of selecting, arranging, and emphasizing the component parts of a photograph to support the intended message or effect." This can be performed consciously or unconsciously.

The component parts of the picture might include distinct physical entities or objects; areas of different or contrasting tone or color; perceived elements of design such as lines, shapes, and patterns; or even relatively empty, "inactive" spaces. I will use the term "element" to encompass all of these potential components.

Through the choices we make as photographers, such as those in relation to

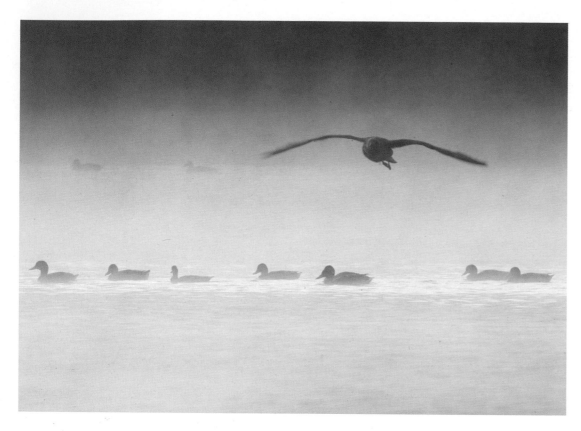

Left & Above: Key elements positioned on divisions of the picture plane made according to the "divine proportion" help bring a pleasing balance to this image of ducks and a gull on a misty lake.

viewpoint, focal length, and indeed when we release the shutter, we compose our pictures. We make use of what the subject matter offers us, and combine this with our technical photography skills to (hopefully) come up with an image that is in accord with our vision.

Ancient Rules & Ratios

Throughout history, artists and scientists have tried to analyze what makes good and effective design or composition. The Greek mathematicians came up with "The Golden Rule," for example, which identifies what appears to be a "magic" proportion by which to divide space or lines in an image to give a pleasing result. They even went as far as describing precise mathematical dimensions for this ideal.

The definition of this proportion is also attributed to Leonardo Fibonacci, who, around 1200 A.D., apparently proposed that there was a ratio often seen in nature that is pleasing to the eye—that ratio is 1:1.618. He also associated this with a mathematical

sequence given his name. In this sequence, each subsequent number is the sum of the previous two: 0, 1, 1, 2, 3, 5, 8, 13, and so on. By the 40th number the ratio between the consecutive numbers stabilizes at 1:1.618.

This ratio is also termed the Divine Proportion, Golden Mean, or Phi, and it came to have a significant influence over classical drawing and sculpture. Various individuals, including Leonardo da Vinci, provided their input and continued the examination of how positioning elements at certain locations within a two-dimensional field could convey a sense of harmony. We will look at some of these ideas in due course.

In the early 20th century, German and Austrian psychologists pursued a similar quest through the school of thought known as Gestalt, a German word meaning form, figure, or shape. It was noted that when viewing a picture we tend to organize visual elements into groups or unified wholes and their intention was to understand more about this

process and how the mind perceives and processes visual inputs. The resulting "Gestalt Theory" consists of principles that artists and designers have subsequently been able to use to present visual information of various forms.

Conveying Concepts

Consider how the arrangement of simple shapes can be used to convey concepts such as space, size/scale, congestion, tension, order, sequence, conformity, unity, direction, and distance, and how this is applied in the design of road signs and the like: this is, to a lesser or greater extent, Gestalt Theory put into practice.

Most of us will have certainly been exposed to some of these concepts through "mind game" and "puzzle" pictures involving simple black-and-white shapes that challenge our perceptions. Furthermore we now live in an age where we are routinely influenced and manipulated by the press, publishing, and advertising industries making good use of the

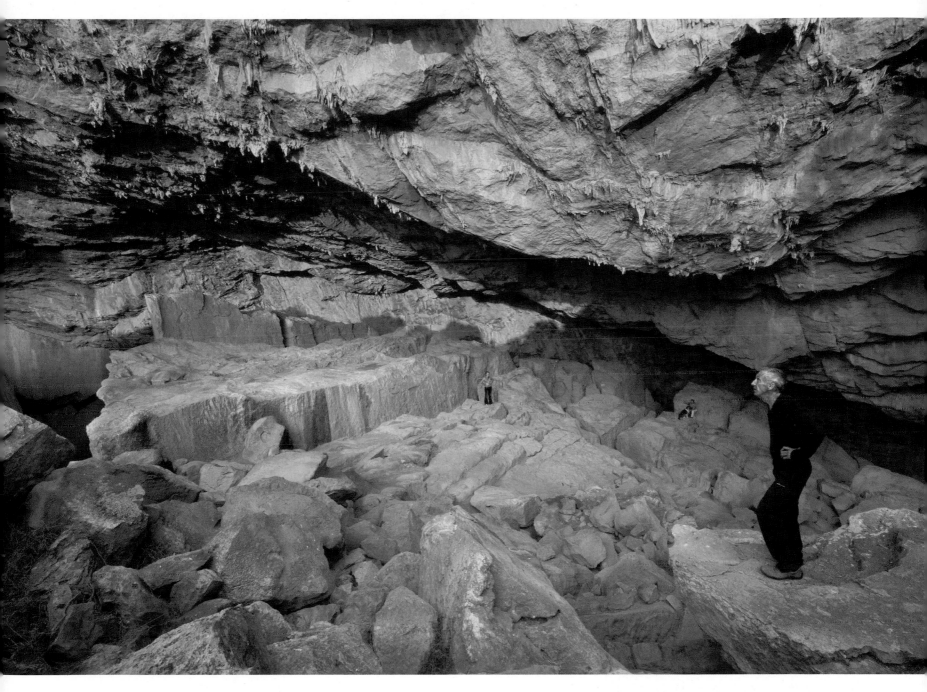

findings of these psychologists. In the following chapters we will examine some of these findings in more detail. You will appreciate how you might use them to improve your photographs, and how they can help you to take control of the perceptions of the viewer (to some degree) and more effectively convey your message.

Above: The relative size of the figures at the front and back of this cave in the Peloponnese of Greece immediately tells us a lot about the sheer size of the cave.

Chapter 1
Visual
Perception

A fundamental understanding of the various processes that take place when we look around us—or indeed look at a photograph—is an important foundation for our appreciation of some of the basic principles of composition in photography that we shall encounter.

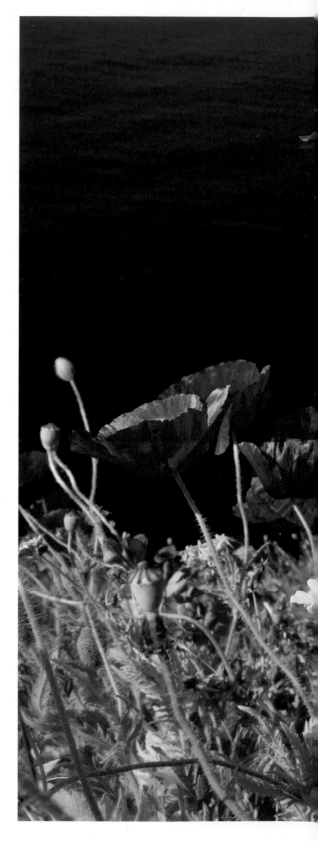

Right: Anyone passing poppies on the roadside will appreciate how the color red tends to grab our attention.

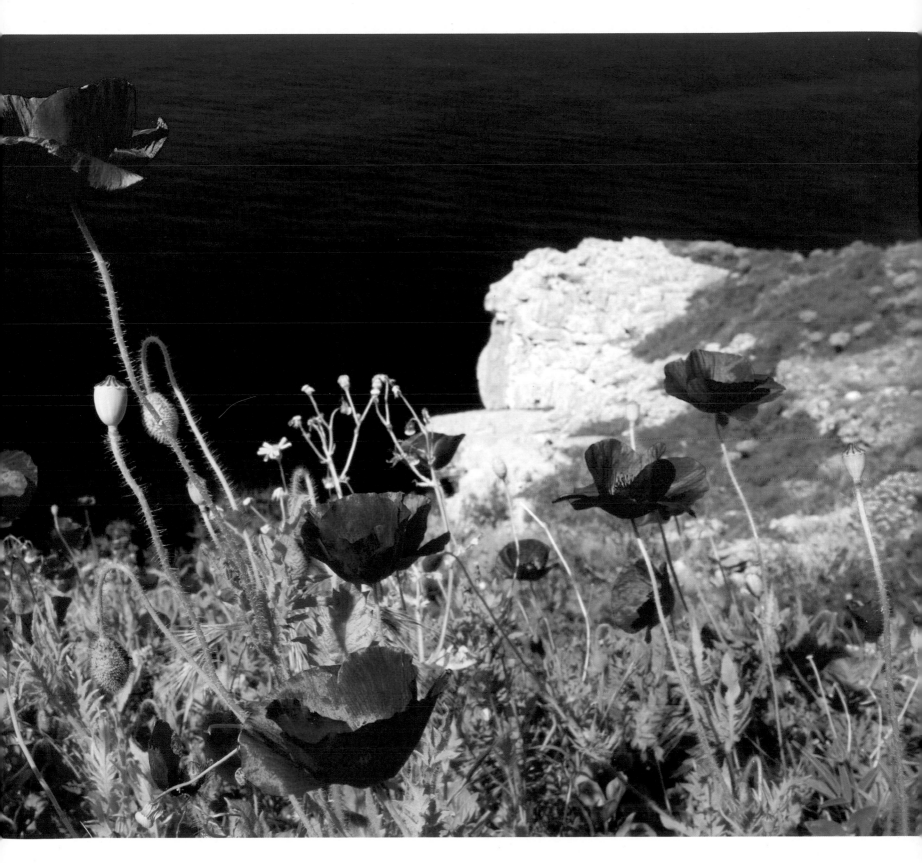

When light from the scene before us enters our eye it is focused by the lens to form an inverted replica of the scene on the retina. At this stage it is rather like a camera, with the light focused on the sensor or film and the gathered data being "true" to what is out there. However, in the retina the majority of light-sensitive cells are concentrated in the central area, meaning that resolution and sharpness fall off rapidly toward the peripheries of the field of view. Indeed, at 10 degrees from the axis of fixation it is already down to 1/5 of that at the center. Because of this our eyes must actively scan scenes to explore them and take in all the information we need.

This process is selective and the driving force appears to come from the "higher" and "lower" centers in our brains. Those in the higher centers (typically the cerebral cortex) tend to instigate a more conscious, directed, and calculated examination of the world, such as actively looking for something. Those in the "lower" centers (typically in the brain stem, cerebellum, or even parts of the spinal cord) tend to be more automatic and incredibly quick responses, such as responding to movement somewhere in our visual field.

We actively scan the scene, building up a version of the outside world in our awareness. This process of visual perception is complex. Gathering and interpreting this information involves feedback based on "primitive" reflexes that have been acquired over millions of years because they have bestowed on us some degree of advantage. There is also feedback from learned and conditioned reflexes that are based on our experiences as individuals in the culture and society in which we were raised.

There is no simple answer to the question of where our eyes first focus when presented with a scene or a picture to view. The way the image is presented may be one factor. For example, when viewing a slideshow, we will often start off looking at the same position in a new slide that we took interest in when viewing the previous image. Generally

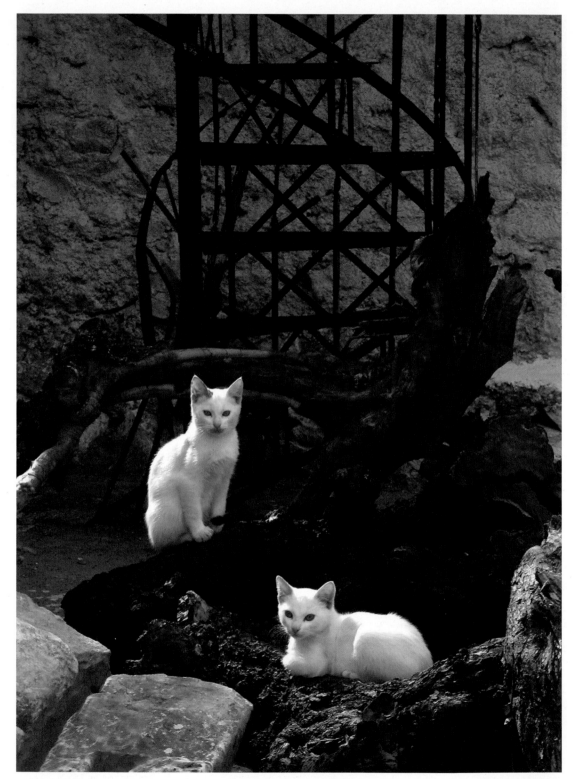

Above: Our attention is more likely to be caught by a scene such as this than the same scene with two darker kittens. I have capitalized on this by clarifying the tonal difference by converting the image to monochrome apart from the faces of the kittens.

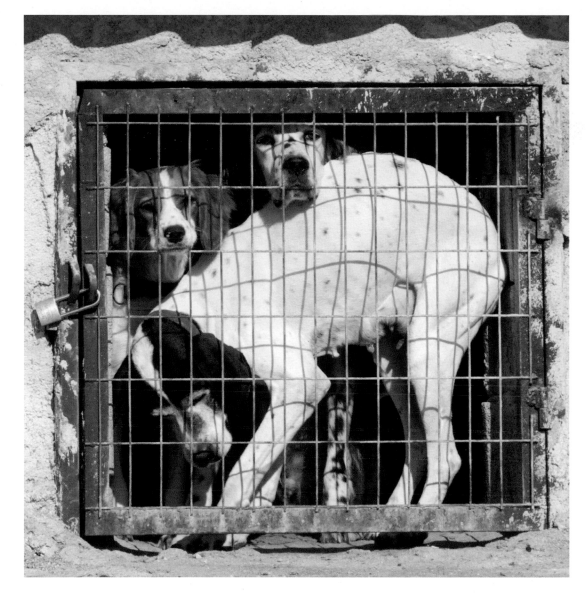

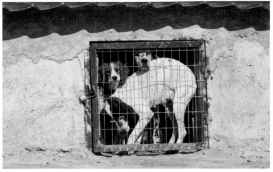

Left & Above: Due to our tendency to perceive two-dimensional images as representing physical space, the amount of room we leave around our subject matter will affect the feeling conveyed. Cropping this image tightly emphasizes the cramped "prison" of these hunting dogs in Greece. It makes the dogs and the viewer seem even more confined.

speaking, our eyes tend to be drawn to the area of a scene with high contrast (a high difference in tones among objects in that part of the scene) or highly contrasting colors. Our attention is also attracted more by lighter tones and certain colors. We are also drawn to parts of an image that our memories, knowledge, or experience tell us are likely to contain useful information—e.g., faces, street signs, or text.

Looking for Clues

Cognitive psychology endeavors to study the processes of our perception. Of interest to us here are the theories of visual information processing based on the idea that an image consists of hierarchical levels of form. In the case of a portrait, for example, the subject matter can be broken down into head and face as higher levels of form, and the constituent parts of eyes, nostrils, ears, and so on as lower levels. We routinely perceive and recognize faces that are known to us from a few simple visual cues. Even some of the constituent features when isolated can elicit the same response as the sight of the complete subject, as in the case of a caricature. Our brains actively fit perceptual characteristics to the shapes and patterns that our eyes see.

There are various ways in which these snippets of information could be processed to establish some meaning from them. It could be done in a "top down" way, where the identification of a higher order (head or face) facilitates its subsequent analysis into lower-order components (eyes, ears, or even skin pores). Here, knowledge or expectations are used to guide the processing, so it is considered a more "active" process that may involve goals and targets.

Alternatively, this processing could be done in a "bottom up" way, whereby identification of the

lower-order components facilitates their subsequent synthesis into the higher-order form. This could involve processes such as matching the forms to templates stored in our memories.

Visual Processing

Other factors such as the familiarity, complexity, and expected probability of appearance of a form influence the speed at which a form is recognized, but there is some debate as to which of these modes of processing prevails. Electophysiological analysis of "receptive fields" seemed to suggest a bottom-up mode, but more recently it has been suggested that the order of visual processing is best described as a top-down process. There are even some studies to support the implication that our processing does not occur consistently in either a top-down or bottom-up mode, but in a "middle-out" way.

The suggestion here is that forms at some intermediate level of structure—having an optimal size in the visual field, for example—are processed first, leading on to the facilitation of processing the higher and lower levels of form. The jury is still out on this, but it seems likely that our mode of processing is variable and probably depends on many factors. This would include, for example, our visual experience and the distance away from us that the form is: distance clearly influences the volume of lower level information we might receive.

Visual attention—the process whereby something catches our eye in the real world or in an image—is generally argued as being a largely bottom-up process. Our attention is drawn toward a red flower as we walk through a grassy meadow not by our prior knowledge that the flower was there, but by the visual stimulus of the redness of the flower itself and our automated responses to these stimuli. So, certainly some of the perceptive processes relevant to us in our consideration of composition will be relatively automatic and instant. However, there can also be elements of composing a picture and of "reading" a photograph that occur in a top-down fashion. These include the

more considered, calculated, interpretative, and judgmental aspects.

Understanding & Meaning

Behind all the visual perceptive processes involved in examining a scene or picture is a desire to establish understanding and meaning. So, it is perhaps not surprising that we derive pleasure from viewing a work of art when its composition aligns nicely with these processes and provides us with a rewarding insight.

With this in mind, let's now look in more detail at what we can learn from the early 20th-century Austrian and German psychologists who studied these processes. A foundation for their enquiries was the observation that we have a tendency to psychologically map out two-dimensional designs as if they were physical space, applying all the same connotations. This can mean, for example, that minimal negative space (empty or "non-subject" parts of the image; often background) in an image can leave us, as viewers, feeling claustrophobic or cramped. By contrast, ample negative space allows the subject matter and, by extension the viewer, to breathe. An excess, however, can give a sense of luxuriousness; of "space to spare." For a more neutral perception you might try to balance the amount of positive space (that occupied by the subject) and negative space in the image.

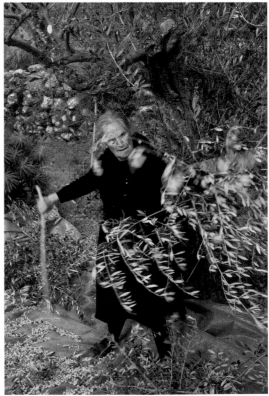

Right: This shot of an elderly lady beating olives off a branch (top right) benefits from the inclusion of more of her surroundings (right), which (literally) gives her room to swing the stick.

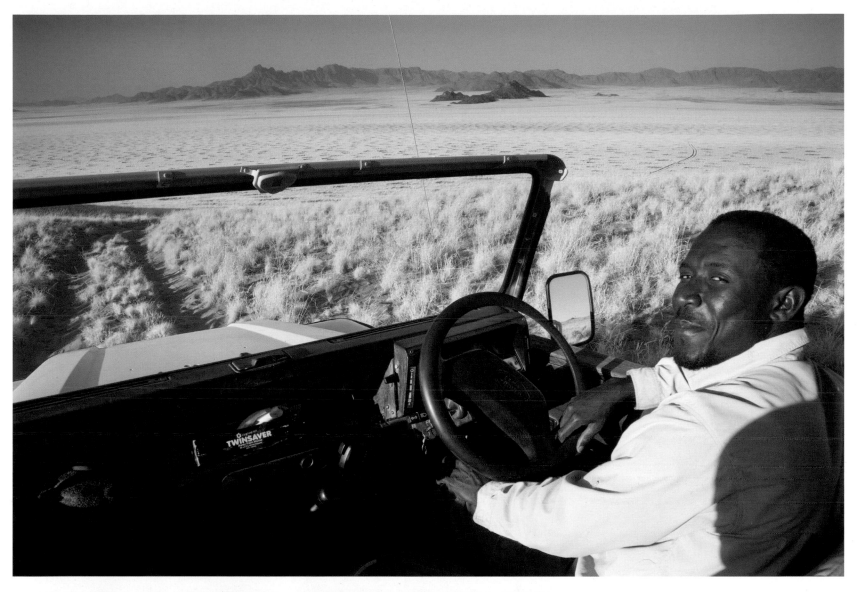

Left & Above: With this shot, the temptation might be to crop tightly for a more intimate portrait (far left) or to crop a little off the left side of the photograph (left). However, the wider image (above) gives a sense of space that conveys a lot more to the viewer about this location in Namibia.

Related Principles

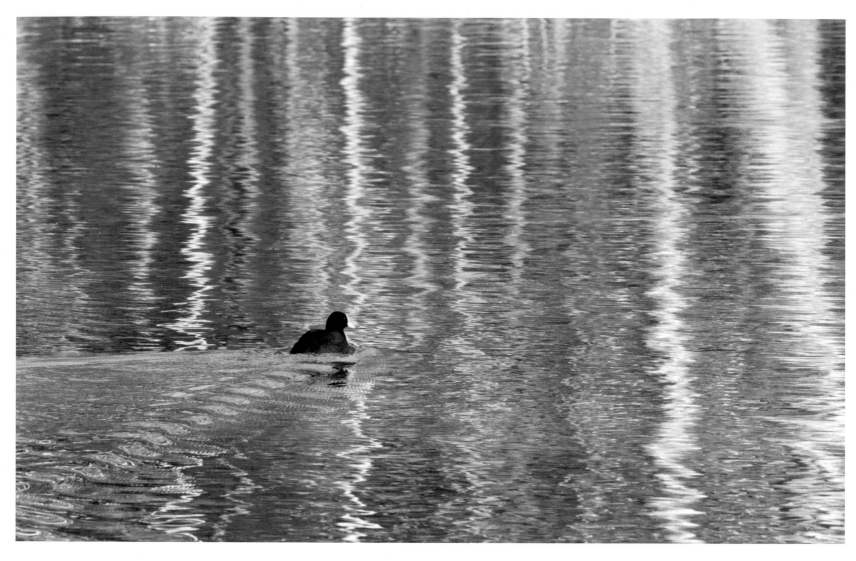

Rule of Space

Related to the sense of physical space that we glean from a photograph is a rule that most of us are familiar with—that of "nose room" (also termed "leading space," "lead room," or the "rule of space"), which states that a subject should have "active" space to move into in the direction that they are facing. We can, of course, opt to break this to create some tension or a sense of the subject being confined or restricted in some way.

Visual Intelligence

Through our photography we can purposefully manipulate the viewer by playing on the tendency we have to retain a sense of three-dimensionality, and by further understanding the processes of our "visual intelligence." This intelligence involves the application of knowledge and experience of the physical world to abstracted phenomena (such as a photograph) to derive meaning, usually in accordance with established norms of our species. As we shall see, it not only incorporates interpretations based on the culturally influenced meaning of symbols, signs, and icons, but also the influences from our individual expectations and past experiences together with our needs.

Above & Right: In this example, the "nose room" rule appears to be overridden by the importance of balancing the three athletes around the central one. He, as the main subject, still has adequate room to run into if we crop a little off the right to center him better in the frame (right).

Left: The wake behind the swimming coot reinforces the direction the bird is moving in, while plenty of space is left ahead of it to maximize the beautiful "tapestry" pattern on the lake's surface.

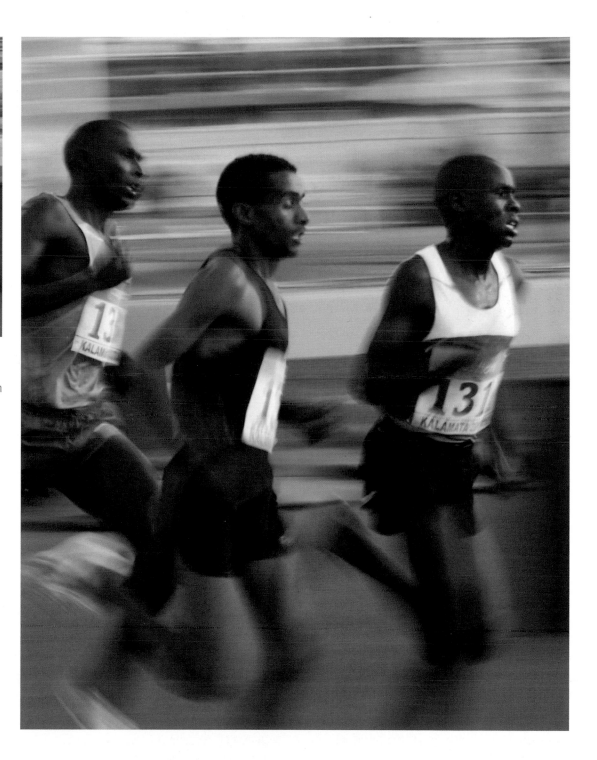

Gestalt Theory

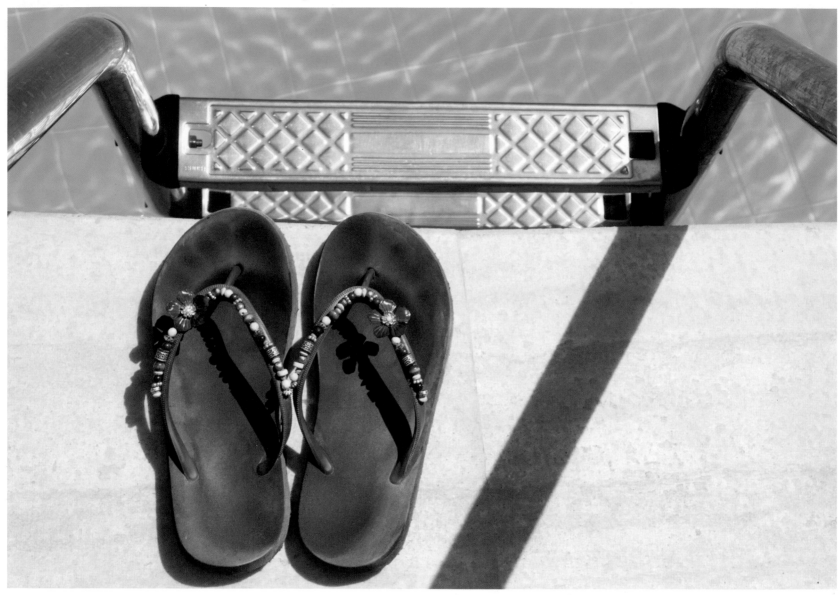

Above: The association between the flip-flops, the pool, the steps, and the evident warmth gives the picture a different meaning to that that would be derived from viewing these individual items in isolation.

The quest of psychologists to understand and define key principles underlying this "visual intelligence" resulted in a theory that will be familiar to many photographers.

The term "gestalt" used in this context refers to a configuration or pattern having properties that cannot be derived from the summation of its component parts. This relates to the underlying observation that the brain will tend to perceive visible objects in their entirety rather than perceiving their individual parts. German psychologist Kurt Koffka expressed this notion when he stated, "The whole is other than the sum of its parts."

What this means for us is that while each of the individual parts of a picture has meaning on its own, taken together, the meaning may change. In interpreting the "whole," a cognitive process takes place—the mind makes a leap from comprehending the parts to realizing the whole.

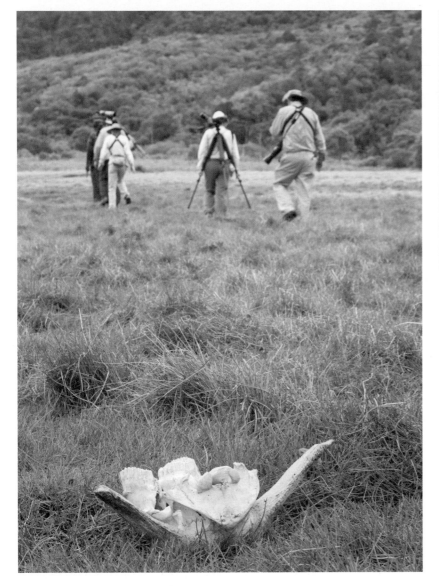

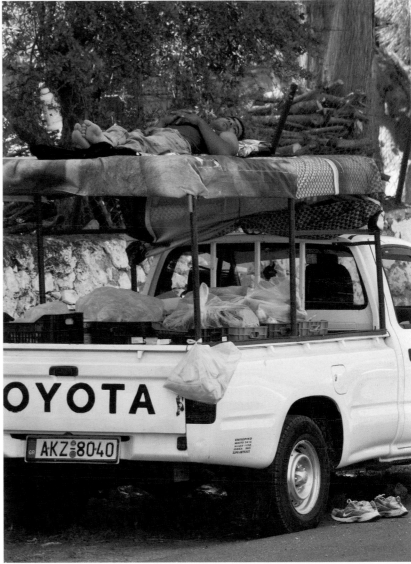

Above: Taken as a whole, rather than as a collection of separate entities—the figures equipped with camera equipment, the fragment of animal carcass in the foreground— this image might ask the viewer questions about the impact of tourism on the wildlife in Tanzania.

Above: The relationship between the various elements in this image—the man, his vehicle, the crated produce, and his shoes—tells you more about this street vendor enjoying his siesta in Greece than you would glean from the component parts either in isolation or in a different arrangement.

The Law of Prägnanz

Another fundamental principle of Gestalt Theory is the Law of Prägnanz, which states that our psychological processes attempt to make order, harmony, symmetry, simplicity, and structure out of what initially might appear as seemingly disconnected bits of information (or "chaos"). For example, because we tend to relate what we see to our own bodily reactions to situations in space, simple shapes on a two-dimensional image appear to fall or be pulled by gravitational forces and thus carry "visual weight." They can therefore appear to lean over, to fly, to move fast or slow, to be trapped, or to be free. In addition to coming from our own bodily reactions and the natural world around us, our gestalts are also constructed from the societal and cultural influences that surround us. The architectural patterns we are exposed to will affect our interpretation of lines in an image, for instance.

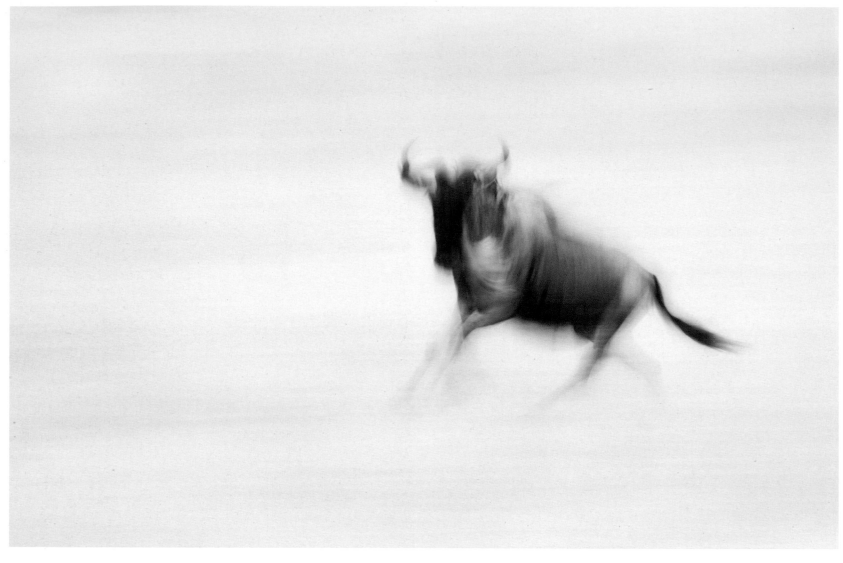

The Six Principles

Following on from these fundamental observations, Gestalt Theory went on to attempt to refine them and further describe how the mind tends to organize visual data. Observations were made regarding how we identify subject matter within the field of a picture, focusing our awareness upon it. Also described were our tendencies to perceive relationships between distinct elements from which we can derive meaning and order. To this end, six principles have been identified as Figure/Ground; Similarity; Proximity; Closure; Continuity; and Symmetry. These are illustrated on the following pages.

1 Figure/Ground

We have a tendency to separate whole figures from their backgrounds based on variables such as contrast, sharpness, color, size, and so on.

There may be one or more figures in an image, and as we look from one to another they each become the "figure" in turn. Everything that is not figure is termed "ground." Ground usually includes the background, although the background can become the figure. This is because as our attention shifts, the ground also shifts, so that an object can go from figure to ground and then back again, depending on which part of the image we are focusing our awareness on.

Above: Even though this image is blurred to convey motion, the "figure"—the galloping wildebeest—is clearly defined from the "ground." Panning with a slow shutter speed has increased the distinction between figure and ground by blurring the background more than the subject.

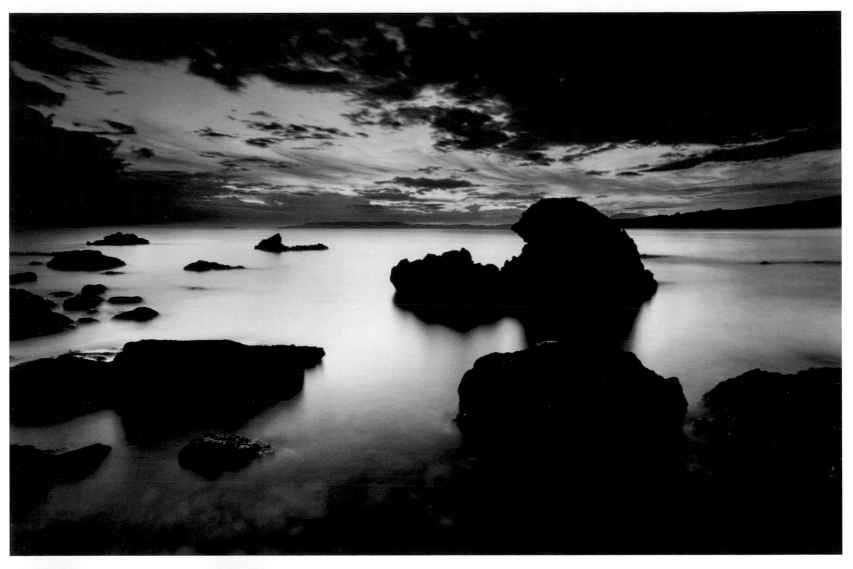

Above: As we look at this photograph, the "figure" can change from water, to rock, to sky with the remainder forming the "ground."

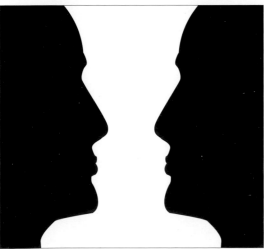

Left: The classic "vase or two faces" image illustrates the concept of "figure/ground" nicely. One moment we perceive the white vase in the center as the "figure" and then suddenly the "ground" becomes the "figure" and we see the two dark faces eyeballing one another.

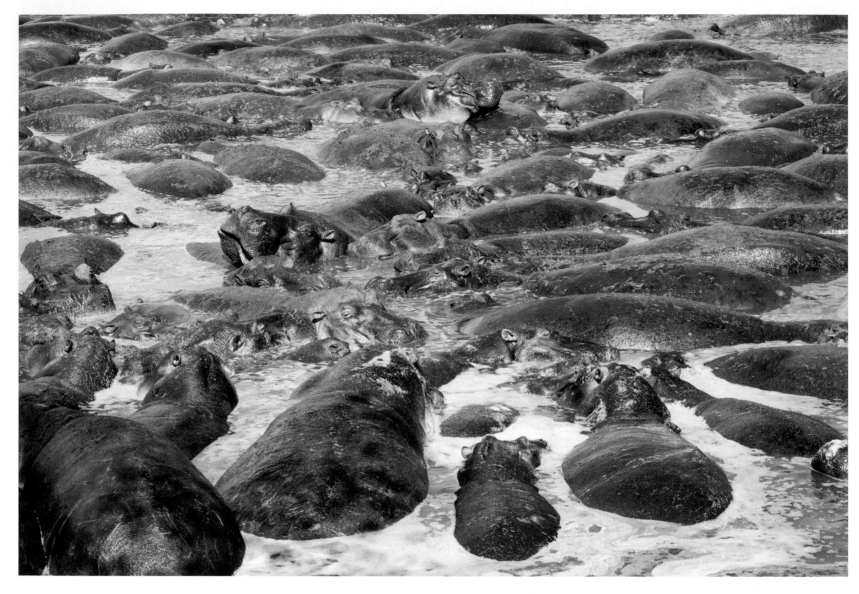

2 Similarity

We have a tendency to see things that share visual characteristics such as shape, size, color, tone, texture, or value as belonging together. That separate objects in a picture belong together or are related in some way appears to be a pleasing conclusion for the viewer to come to. Many "pattern" images rely on this and involve arrangements of elements that are the same or share enough in common to be perceived as being related. We also derive pleasure from identifying the odd one out in these sorts of pattern image that also include an element that

starkly breaks the pattern by being dissimilar in some way. A deliberate use of similarity in composition can also impart meaning that is independent of the subject matter of the image. Here we may perceive a relationship between two elements in an image that was not in fact there. This is a ploy used in many a "clever" image. Like all these principles, the principle of similarity can be applied in different measures. A subtle use, involving only a slight degree of similarity can be enough to stimulate the viewer in some way by implying a connection between elements.

Above: The similarity in color, tone, and shape, together with their proximity, tells us that these rounded masses are all hippos and that they belong together. This is further helped by the apparent contentment on the visible faces!

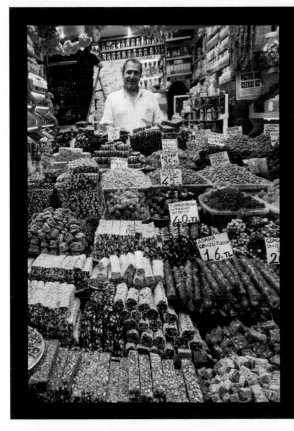
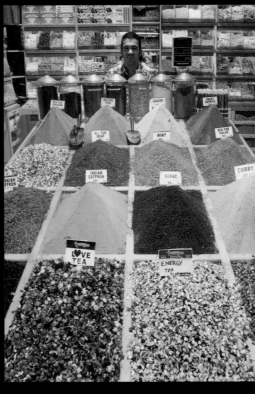
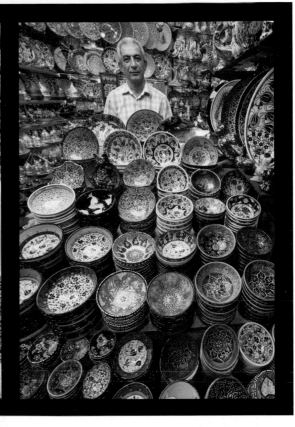

Above: We may choose to display separate photographs together as a single unified image as in the case of a triptych. Similarity will often play a key role, as it will ensure that the images are perceived as belonging together. I had this triptych in mind as I went around the bazaars in Istanbul. I tried to use a similar viewpoint and focal length in each case and made sure that the stallholders were centrally positioned just beyond their produce.

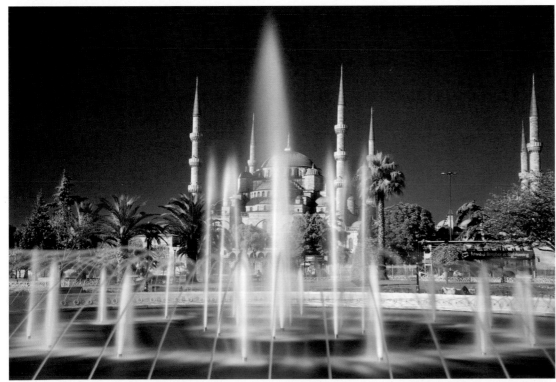

Left: I believe that this image of the Blue Mosque in Istanbul gains strength from the discerned similarity and thus relationship between the minarets and the columns of water of the foreground fountains.

REPETITION AND RHYTHM

The repetition of shapes or colors in a picture is generally pleasing, just as rhythm is in music. The forms don't have to be identical, though—even if they vary to some degree, the correspondence is still likely to be perceived. Similarity or repetition in an image often has connotations of harmony and interrelatedness, or rhythm and movement. So, in addition to conveying meaning in terms of the relationship between elements, good composition will also make some use of similarity for aesthetic advantage. Note also that an object can be emphasized if it is dissimilar to the others. This is a ploy called "anomaly," which is often utilized by photographers.

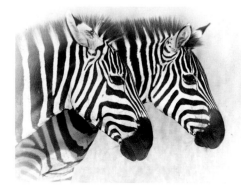

Above: The processing of this image, which removed any potential distractions and simplified the shapes and patterns of the zebras, further enhances its potency related to their similarity.

Right: Similarity and repetition conveyed in a diagonal line provide a pleasing "rhythm" for the eye to dance along.

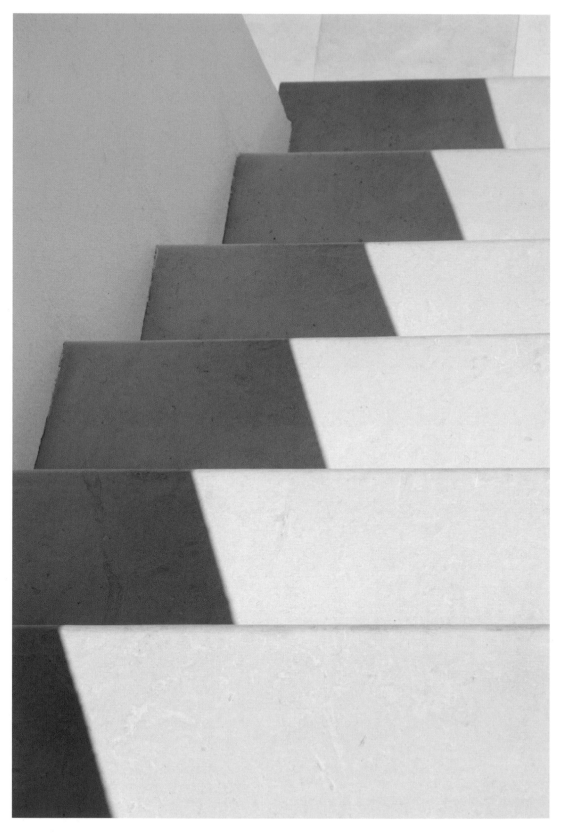

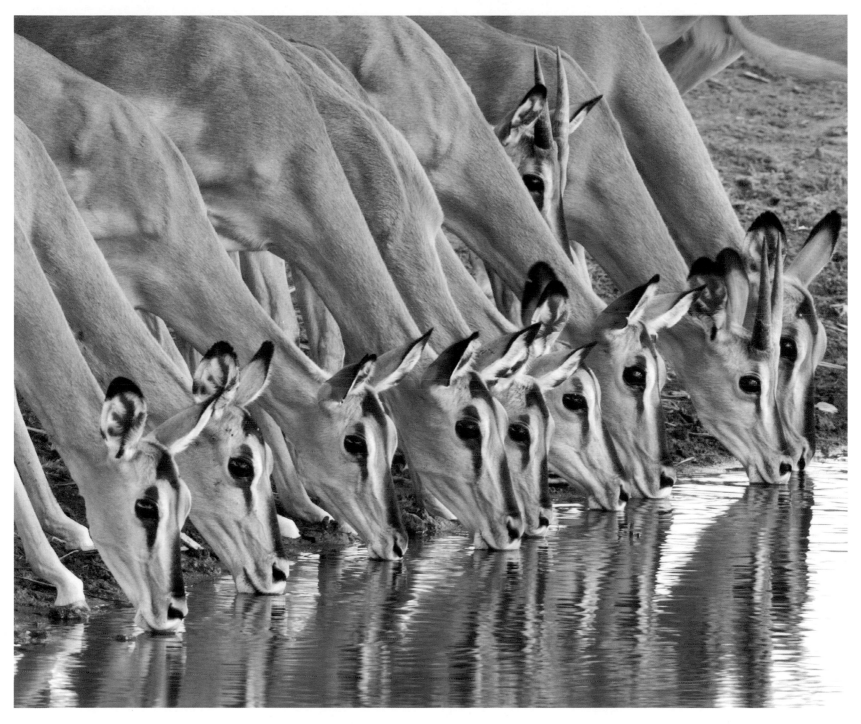

Above: These black-faced impala lined up drinking
provide a good example of how similarity and
repetition can be so pleasing. Note how "anomaly" also
emphasizes the individual wary of lowering its head.

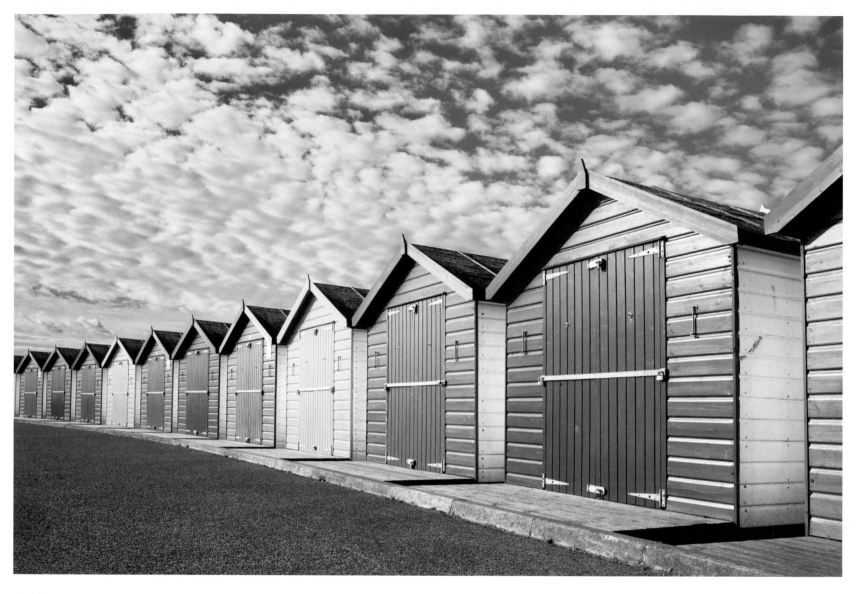

3 Proximity

We have a tendency to perceive objects or shapes that are close to one another as belonging to the same group. Even if the shapes, sizes, and objects are radically different, they will tend to appear as a group if they are close together. On account of this "grouping" effect, the collective presence of a set of elements can become more meaningful and evident than their presence as separate elements. Elements grouped together can therefore create the illusion of a composite shape in space, even if the elements are not touching. An example would be an image of a flock of birds that takes on the shape of a sinister hand reaching across the sky.

Of course, the principle can also be used to imply or emphasize a lack of relationship between elements. By composing so that two objects are well separated we can ensure that they are perceived as distinct elements.

Above: Regardless of their radically different colors, we still group these beach huts together on account of their proximity, form, and alignment. Collectively they form the convergent line that makes the photograph.

4 Closure

Our brain has a tendency to "fill in the gaps" and provide missing details to complete a potential pattern or shape. Once resultant "closure" is achieved, unnecessary details are eliminated to further establish a pattern match. Thus we can tend to see complete figures even when part of the information is missing. For example, we will tend to enclose a space by completing a contour and ignoring the gaps in the figure.

Our tendency to do this is triggered by the suggestion of a visual connection or continuity between sets of elements that do not actually touch each other in a composition. So, elements in a composition would need to be aligned in such a way that the viewer perceives that the information could be connected. Imaginary lines called "vectors," or shapes called "counter forms," are generated even

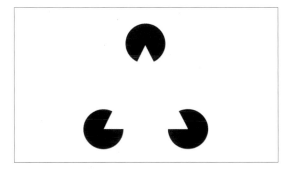

Above: In this image of three circles with missing segments our tendency to strive for closure leads to us seeing a triangle.

though there is nothing there. Vectors and counter forms exert forces and tensions as if they were actually there.

We can see, therefore, how a negative space (an area of the image that would otherwise be inactive) could affect the completion of the composition by being transformed into a counter form or a medium conveying vectors. Counter forms can be important in terms of reinforcing positive visual elements through the principle of similarity, for example. They can also create powerful supports and connections between visible elements.

When the viewer establishes the "closure," a sense of pleasure will be derived. It's also worth noting that if an image is more ambiguous and the closure is not so readily achieved, the viewer may spend longer interacting with the image, which can often be a good thing.

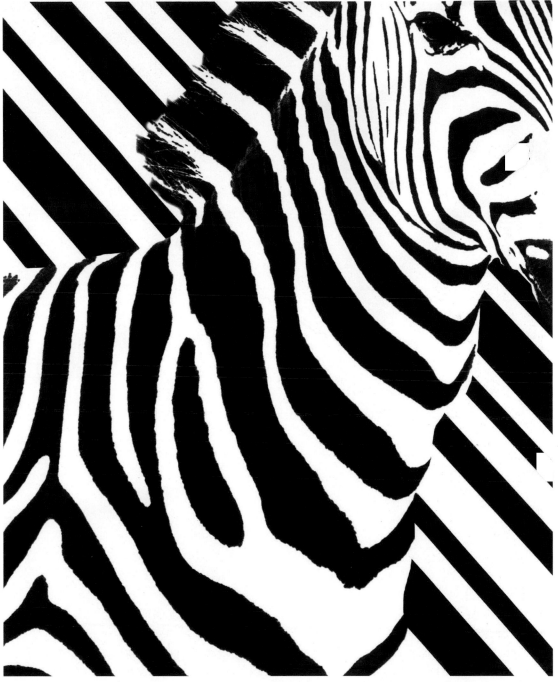

Above: Despite the confusion of black-and-white stripes in this image, we achieve "closure" remarkably rapidly by defining the contour and identity of the subject matter.

Left & Above: Our tendency to continue contours can also be made good use of by using the resultant "vectors" (above) to lead the viewer's eye to points of interest in a scene.

5 Continuity

This is very much related to the previous principle. It is the observation that we tend to continue contours (and thus shapes) whenever the elements of the pattern strongly establish and imply a direction for our minds to continue them. The edge of one shape can be perceived as continuing into the space and meeting up with other shapes or even the edge of the picture plane. We can make good use of this in our photography to suggest relationships between separate elements of subject matter or to lead the viewer on a path of discovery through the photograph.

Lines and shapes out there in the world are not always as we want them to be perceived, but fortunately, due to this tendency, when we view a photograph we will often overlook minor interruptions and deficiencies.

6 Symmetry

We have a tendency to try to organize visual data to make it as symmetrical, stable, simple, regular, consistent, structured, and ordered as possible.

Symmetry suggests that the viewer should not be given the impression that something is out of balance, or missing, or wrong because if an object is asymmetrical the viewer will waste time trying to detect the problem and this will distract and prevent them from perceiving the intended message of the image.

A well-ordered arrangement of elements can be perceived either positively or negatively by a viewer depending on the purpose of the communication and the viewer's personality. Some viewers may associate order with institutional rigidity or allegiance to social dictates and thus be unimpressed by such images as a result. Conversely, others will be accustomed to receiving information in a systematic manner and will be frustrated by cluttered and messy pictures that require a lot of working out. As a result, the tolerances and programming of your intended audience may need to be considered.

For an image to provide quickly comprehended and clear instruction, it will help if it is inherently well ordered. Traffic signs often reflect this principle.

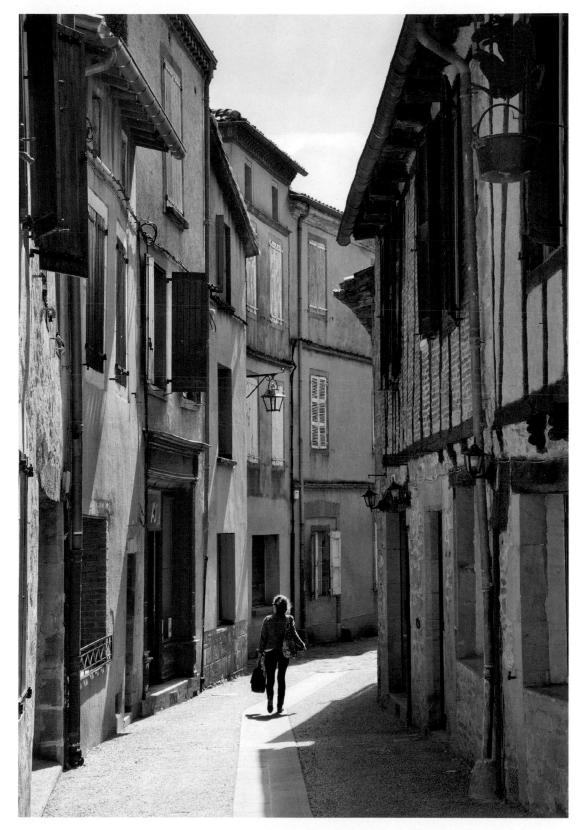

Right: Although this image of a street in southern France is quite complex in terms of its tones and the details of the buildings, its interpretation is made easier by the symmetry achieved by my position. The timing of the shot also ensured that the lone figure is central and in a position that makes her stand out against the background.

Associated Phenomena

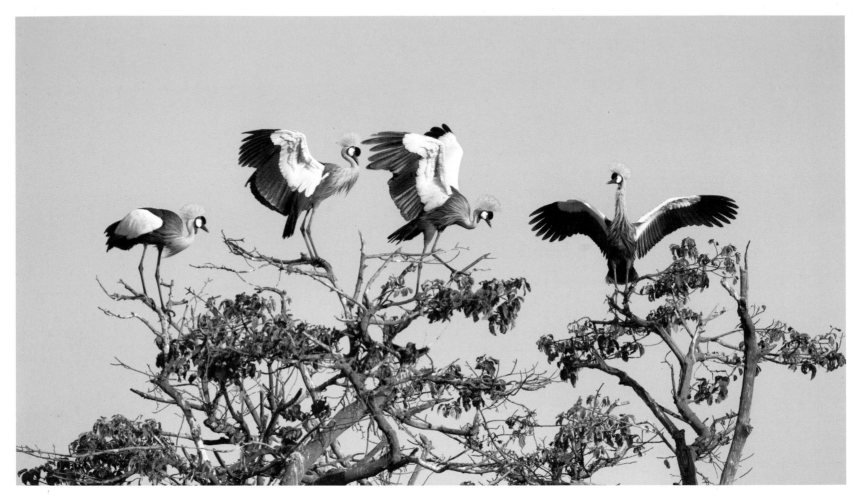

Equivocation & Continuance

Gestalts can lead to a variety of phenomena. They can result in perceptual ambiguity (termed equivocation) where a picture can be seen in two or more ways. Alternatively they can encourage us to make connections between similar components and phenomena in an image to construct a timeline through the elements. This gives us the impression that they create a sequence (termed continuance).

Constancy & Invariance

Gestalts can also result in the phenomenon of "scale constancy"—two cars in an image, one 100m away and one only 10m away, are both perceived as cars.

There is also a related concept of "color constancy"—the grass on a lawn in a photograph is perceived as being the same green throughout, even though half may be in dark shade. These phenomena are related to the principle of "invariance," which states that geometrical objects are recognized regardless of their scale, rotation, translation, deformations, different lighting, and so on. A "key" appears as a key whether it is near or far from us, upside down, bent, or viewed by candlelight, for example.

Above: The sequential postures of these crowned cranes tend to make this image mimic a time-lapse sequence due to our tendency to construct a timeline around such phenomena.

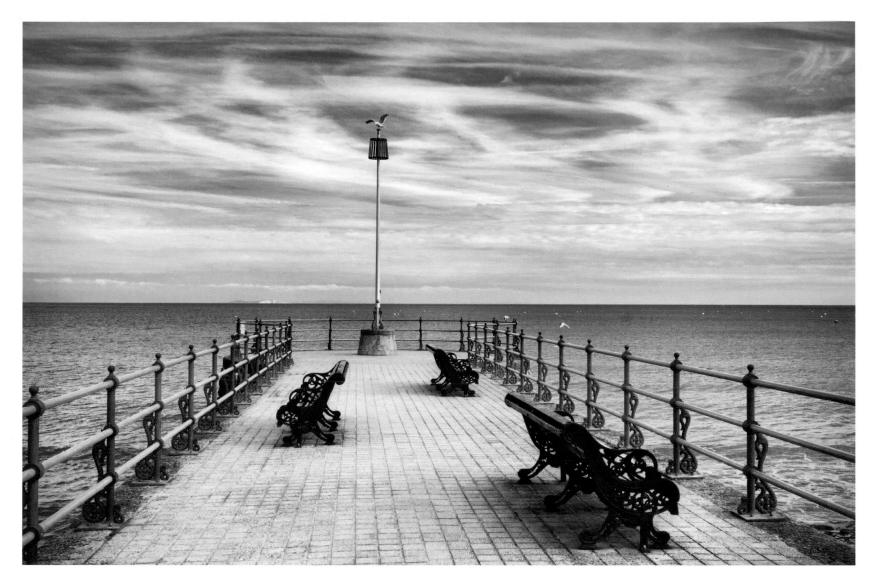

The Law of Past Experience

Gestalt Theory also defined other associated phenomena and principles with some degree of relevance to us. One such is the Law of Past Experience, which suggests that under some circumstances visual stimuli are categorized according to past experience.

Elements tend to be grouped if they were often together in the past experience of the observer, particularly if these visual experiences had short time intervals between.

Emergence

Emergence is the process whereby we suddenly perceive what the subject is: the zebra in the image on page 31 is suddenly recognized and perceived as a whole, all at once.

Reification

Reification describes the constructive and generative tendency of our perceptual processes, whereby we perceive shapes and objects that are not there, such as the triangle in the earlier example (see page 31).

Above: Scale constancy can help create a sense of depth as in this image of a pier in Swanage, United Kingdom. We know that the shrinking benches and posts are actually the same size, so therefore they must be progressively further away.

Multistability

Multistability is about our tendency to switch back and forth between two possible perceived images when there is ambiguity between them—the "vase or two faces" image on page 25 is a case in point.

Perception in Practice

Ordering Images

For our purposes, all of the psychological principles and the related phenomena previously described are potentially relevant when we come to construct a photograph. Furthermore, it is interesting to consider how these psychological processes are relevant not only to our presenting a single image to the outside world, but also when we show grouped images in exhibitions, albums, or slideshows. In these situations, the relationship between separate images can be just as important as the merits of each photograph considered individually. You may choose to order and arrange the images in such a way that effectively supports the transference of the message you hoped to convey throughout the project.

Guiding the Eye

To close this chapter let me stress the importance of acknowledging the likely journey that the viewer's eye will take through the image. For example, it may be that positioning the subject at the right of the frame may engage the viewer for longer, since most of the readers of this book are likely to be used to reading from left to right when confronted with a two-dimensional graphic (perhaps this would be different for those used to reading Arabic).

Also, the eye tends to begin at the bottom of a picture and work up. This is probably due to our association of the bottom of the picture with "nearby" elements: there is more urgency for us to discern those first on account of their proximity. For these reasons, in landscape images it's often effective to

Above: Although each individual image in this triptych was taken and composed in isolation, they have been grouped to make a statement about similarity and subtle variance. The proximity of the three images within the frame is no doubt important, together with the alignment of vertical and horizontal lines, which gives them a sense of belonging together. Hopefully, the effectiveness of this grouping is greater than the sum of the parts (of each individual photograph being viewed separately).

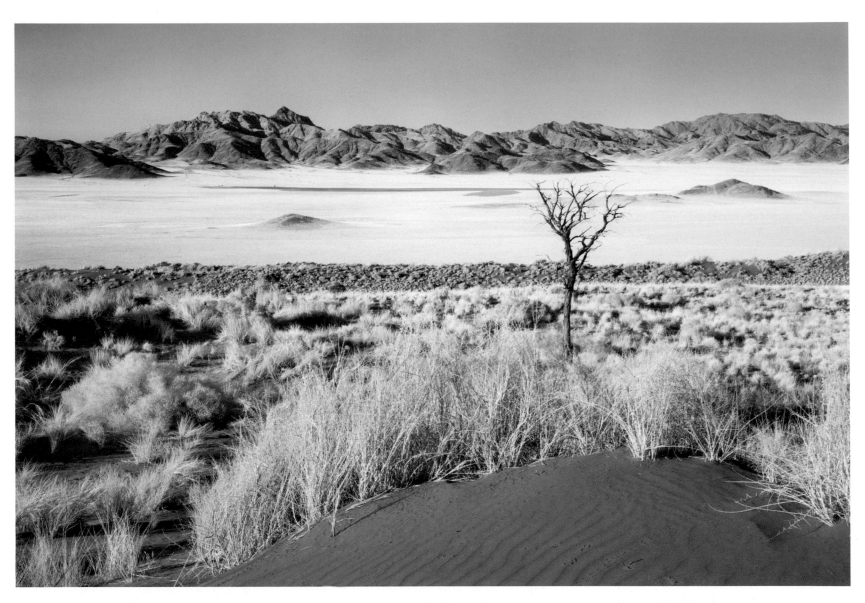

place a key element toward the top right, so that the eye takes in most of the scene before reaching the focal point. This ensures that the attention of the viewer is held for longest. It is also a simple illustration of how composition can be used to delay the viewer's gratification. A cleverly placed starting point for the journey is also important, as it can actively invite the viewer into the image. An effective way of doing this is to include some foreground interest in the scene. As well as helping convey a sense of depth, this will provide a convenient entry point for the eye.

Having examined and taken on board these principles, we are now ready to look at some other terms and concepts relevant to the process of composing a photograph.

Above: In this Namibian desertscape, including the foreground piece of sand dune provides the viewer with a platform to "step out onto" and view the scene beyond. It helps to give them the sense that they are actually there.

Chapter 2
Principles, Rules & Guidelines

This chapter aims to cover some of the insights gleaned through history that are now at our disposal as photographers and can help us to divide the picture space and position elements within it. Let's turn firstly to a few rules based on simple geometric principles, including ones identified by Greek mathematicians and various Renaissance artists.

Right: I spent some time raising and lowering my camera on the tripod before opting for this position. It seemed important to balance the windmill and distant island as the two dominant elements along the horizon line. This angle also clarified the windmill's outline against the clear sky.

1 Rabatment of the Rectangle

This is a simple compositional technique used as an aid for the placement of objects or the division of space within a rectangular frame. The principle is that every rectangle contains two implied squares based on the short sides of the rectangle. The process of mentally rotating the short sides onto the long ones is called "rabatment," and often the imaginary fourth line that is created producing each square is called "the rabatment." It has been argued that often a pleasing result can be obtained by positioning a key element or line along the rabatment.

Above & Right: In this image, the position of this lady in a Greek village scene is on "the rabatment" (right), the imaginary fourth line that is created by mentally rotating the short sides of the rectangle onto the long ones.

It may be that squares are such a simple, primal geometric shape that the brain looks for them automatically and will try to complete this rabatment. When a composition uses elements of the scene to match the line that would complete the square, the square feels complete in itself, producing a feeling of harmony and satisfaction when it is studied.

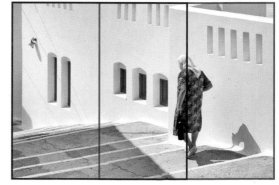

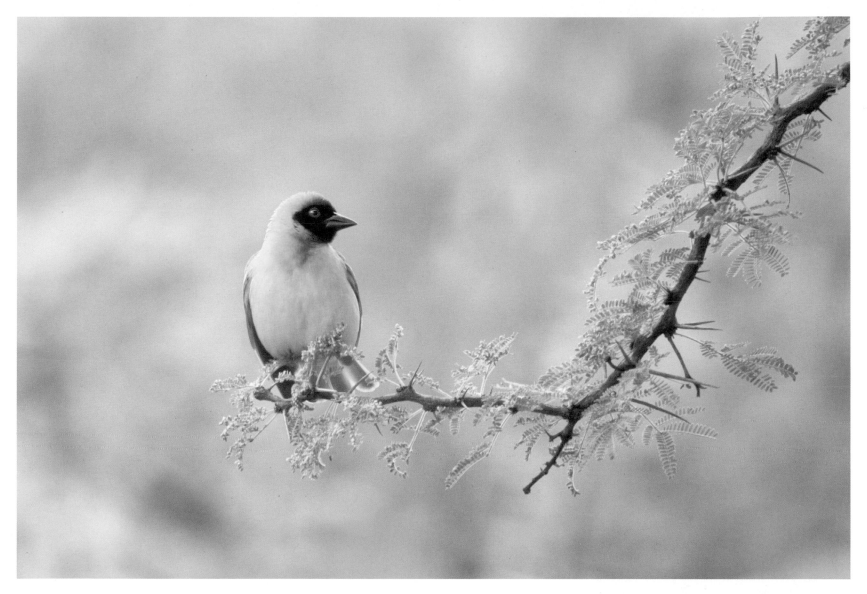

2 The Rule of Thirds

John Thomas Smith, painter, engraver, and antiquarian, first wrote down this longstanding "rule" in 1797. The principle is that the frame is imagined as being split into thirds both horizontally and vertically. Points of interest are then placed on the thirds lines that create these divisions, or at one of the points where the lines meet (the "intersection of thirds"). Of course, more than one element in the image may be placed accordingly, and these lines also tend to be good positions to place any strong lines in the scene including the horizon.

Above & Right: Quite a lot in this image of a weaver bird perched on a branch conforms to this rule. In addition to the positioning of the bird itself, the part of the branch it is perched on is also placed along the thirds line. The gaze of the bird creates another "optical" line extending to the right, which almost completes the central "box" formed by the lines marking out the third divisions.

3 The Golden Mean

This compositional device has many names ("The Golden Mean," "Golden Ratio," "Golden/Medial Section," or "Divine Section/Proportion"), but is based on the observation that planes or lines divided according to a specified proportion are supposedly more aesthetically pleasing and harmonious. A line of length c is divided into two parts, a and b, whereby the ratio of a:b is the same as the ratio of b:c. As we have seen, this ratio approximates 1:1.618.

This can lead to the identification of four

Above & Right: In this example just one element is placed at one of the Golden Points. Of course, an image may also contain multiple elements or lines placed according to these guidelines.

"Golden Points" within a rectangular picture frame, which are good points at which to place elements of interest.

Application of the Golden Ratio can also give rise to the concept of a "Dynamic Section" and "Golden Triangles," whereby a rectangular frame is divided into three triangles using two lines—one obliquely

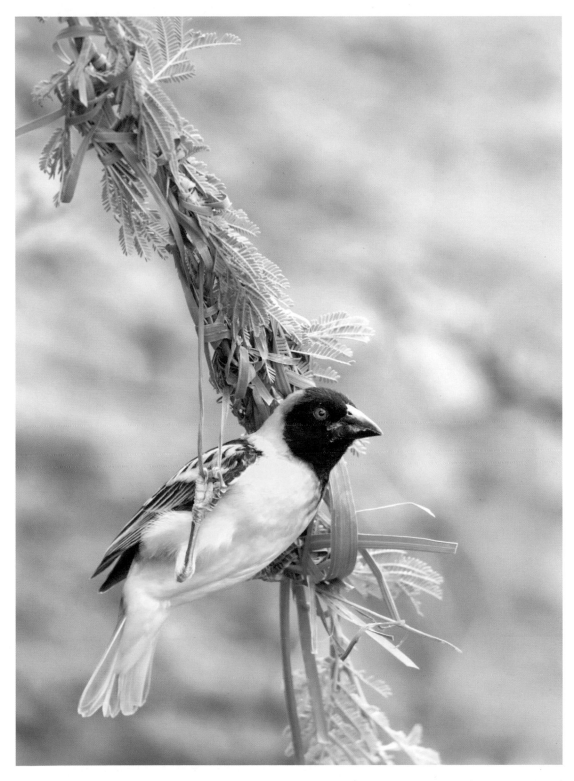

Above & Right: The cropping of this image of a black-headed weaver bird starting to build its nest has resulted in the lines of the bird's body and the branch dividing the frame into similar triangles with a pleasing result.

from corner to corner and the other from one of the other corners to the first line meeting it at a 90-degree angle. If the rectangle is of appropriate proportions, the point of intersection is at the Golden Mean of the oblique line.

Elements or lines can be positioned to be at the intersection point or to follow these lines to aid harmony. Again, the concept creates the possibility of four points within the rectangular space and even if the rectangle of the picture space is not a "Golden Rectangle" (see below), the rule still tends to apply. Another way of applying this concept is to place subjects or pictorial elements so that they tend to divide the image into similarly-shaped triangles.

Finally, the Golden Ratio can give rise to the concept of the Golden Rectangle. This is a rectangle of such proportions (approximately 8:5) that if it is divided into a square and a smaller rectangle, this division will occur at a proportion equal to the Golden Ratio and the line formed appears to be a good position for placing items of interest.

Left & Above: Spirals where the coils "open out" or expand at an ever-increasing rate as you follow them outwards from their centers are frequently seen in the natural world. Many, such as that of this snail shell, approximate the Golden Spiral, and allowing the eye to follow their course is rewarding.

4 The Golden Spiral

This is like the spiral we see if we cut a section through a snail's shell. It is not an uncommon spiral in the natural world. It also has a relationship to the Golden Ratio—it is a logarithmic spiral whose growth factor is related to the Golden Ratio.

Again, elements or lines can be placed on or aligned to follow this line. It would probably, however, necessitate having a clear picture of this spiral in mind and a lot of careful planning to actively fit elements in your photograph to this design. Nevertheless, it's certainly worth looking out for ready-made spirals of this sort in your environment.

5 The Diagonal Method

Edwin Westhoff discovered this method whilst doing some research in relation to the Rule of Thirds. He noticed that artists were intuitively tending to place details of importance on bisection lines derived from dividing each of the 90-degree corners of a piece of work into two equal 45-degree angles.

These lines are also the diagonal lines across the two overlapping squares that form the rectangular picture space. According to Westhoff, the Diagonal Method is a tool concerned not so much with making "good" compositions, but with finding details that are important to the artist in a psychological or emotional way.

He goes on to stress that a key distinction between this and other "rules" of composition is that the positioning of these details on these lines is done in an unconscious manner, whereas people use rules such as the Rule of Thirds to consciously place subjects. Moreover, photographers use the Diagonal Method to place details that have an important meaning to the narrative of the photograph, or which are important to the photographer in a psychological or emotional way, rather than placing elements of little or no importance to the image, such as streetlamps or the horizon.

Furthermore, he notes that people viewing the images appear to notice these details along the bisection lines sooner than details placed elsewhere in a photograph. This may be related to the way the eye tends to scan a two-dimensional image. Westhoff goes on to argue that "The overall intuitive framing of a picture is always more important than the placement of details. With the Diagonal Method, the overall intuitive framing and the placement of details are done at the same time, because both are done unconsciously... Rational manipulation is sometimes necessary, but the combination of intuition/feeling and thinking is always paramount in getting good compositions."

For more details and examples of the diagonal method, see www.diagonalmethod.info and www.edwinwesthoff.nl.

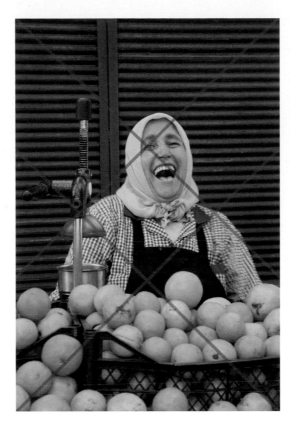

Above: In this picture, the diagonal lines pick out the emotive parts of this market trader's face, while another key Ingredient—the juicer—is also located at a junction of the lines.

Above: A number of key elements appear to align themselves with the diagonals in this close-up of a praying mantis cleaning its talons: the eyes, the mouthparts, and the tips of its forelegs.

Other Considerations

However, despite the many and varied principles and "rules," we should take care not to get too obsessed with applying them, as repeated use could lead to predictability in our work. Instead, it is worth holding them in the back of our minds and experimenting with their application, particularly when we are learning the ropes. Furthermore, it's important to acknowledge that there are plenty of other factors to take into account in our quest for good compositions.

Our perception of beauty will often depend on our detecting a measure of harmony in the relationships between the various elements in the picture space and not just on one element being positioned according to these rules. That is to say that it is important to also consider how all the major and minor elements we see through the viewfinder relate and work together.

Unlike painters, we rarely have the freedom to position elements precisely where we want them, so much of what we do involves compromises. As David Bailey once said, "It takes a lot of imagination to be a photographer. You need less imagination to be a painter because you can invent things. But in photography everything is so ordinary; it takes a lot of looking before you see the extraordinary."

Visual Weight

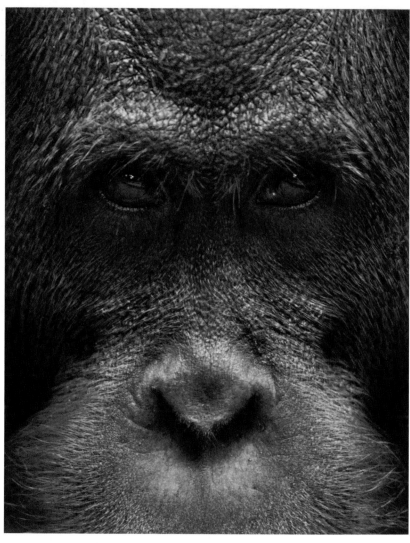

Hopefully you will by now be actively considering the relationships between and proportions of various elements in the picture space as well as their positioning. Particularly important here is the concept of "visual weight." Sometimes this term is used to describe how much an element within a picture tends to draw the viewer's eye. Something with high visual weight will draw attention strongly to itself, while simultaneously detracting attention from the rest of the image;

for example, our eyes are naturally drawn to faces or to writing in an image, so these can be regarded as having a high visual weighting.

However, the term can also be used to describe the impression of actual weight that an element appears to have. Since we experience gravity, we tend to look at a picture with the subconscious assumption that the different elements in it could have a tendency to fall to the ground—even clouds carry an element of

Above left: A typical portrait with head and shoulders centered in the frame.

Above: The gaze and eyes of this orang-utan are what this portrait is about, so the face is precisely centered in the frame with a square crop to enhance the symmetry.

this "visual weight." Our sense of balance profoundly influences our reaction to visual imagery and our desire for equilibrium explains our search for balance in everything we see.

Center of Gravity

The center of gravity for entire compositions is often at the center of the frame, so the obvious way to create balance in an image is to place the subject in the middle of the photograph. The center is the combination of all forces: it has the highest pull toward it, but once there the elements are stable. As our eye will travel to a subject placed at the heart of the image and stop there, this can be an effective ploy particularly in portraiture.

However, when your eye has nowhere else to go, having been directed straight to the center, it can drift away from the picture in search of further stimulation, or the viewer will quickly turn the page. So it is not surprising that we usually only want perfect symmetry or a perfectly centered subject if that is the message we wish to convey.

Instead, we will often elect to position the key element away from the center, but the further away from the center it is, the more the viewer is likely to look for some justification for this positioning. The justification will often come from the relationship of the subject to other elements within the frame, including how these elements balance one another in terms of their visual weight. Generally it seems that offsetting an element further from the axis may impart more weight to it, so it may help to visualize a set of scales whereby you position elements on the

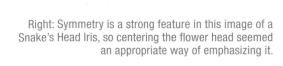
Right: Symmetry is a strong feature in this image of a Snake's Head Iris, so centering the flower head seemed an appropriate way of emphasizing it.

balance arm at various distances from the fulcrum to achieve balance. By this means, a small, relatively insignificant element near the edge of the picture may balance a larger, more dominant one that is only slightly off-center. Multiple elements may also work together to balance others.

The concept of visual weight tends to manifest particularly in the horizontal plane with a left-to-right imbalance being particularly unsettling. It also operates in the vertical plane, but to a lesser degree. This is probably due to the perception of depth that is retained, even in a two-dimensional image.

Right & Left

Also of interest here is that various symbolic attributes have been associated with the right and left sides of pictures. These do not appear to relate to the right and left hemispheres in the brain or handedness, but rather to the way we read text. For those of us who read left to right, for example, the left half of the picture plane tends to signify "the past, definition, nearby, and real/actual/tangible." The right side by contrast symbolizes "the future, the undefined, far away, freedom, and the not-specific." Hence movement suggested within a picture toward the right is seen as being toward the future.

A movement to the right will also be perceived as less challenging, because it aligns itself with the habituated tendency of the eye to move in this direction. It will be experienced as more fluent and "going with the flow," whereas movement in the opposite direction will appear stronger because it has to overcome this flow. Accordingly, the energy of the movement may be perceived very differently, depending on its direction: it may be perceived as faster from left to right, but stronger from right to left. Clearly, where these associations are an important component of the image, a photograph will have a very different meaning if it is mirrored about a vertical axis (flipped horizontally).

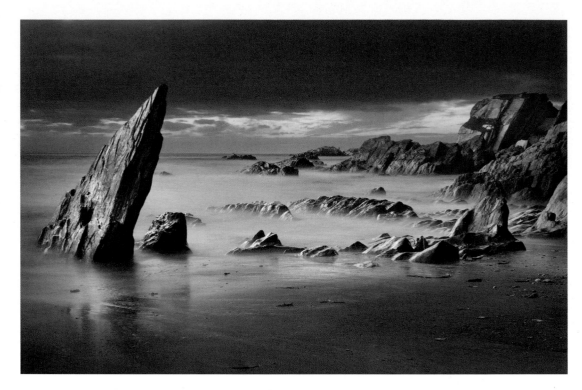

Above & Below: It can be an interesting experiment to reverse a carefully balanced image (above). In this case, I think most people would feel that moving the pointed rock to the right (below) makes it too heavy and upsets the balance of the picture.

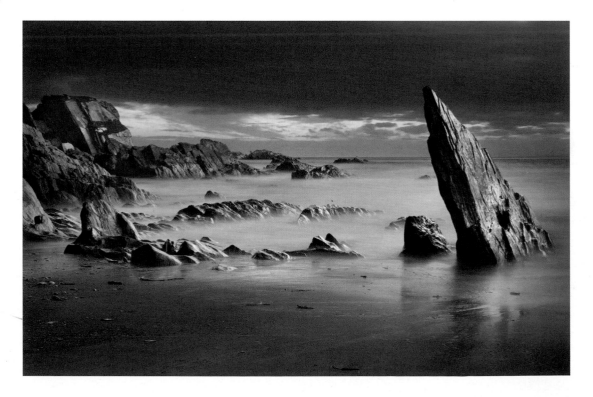

WEIGHT FACTORS

An element's weight depends on a host of factors:

- All else being equal, a larger element will be heavier than a smaller one.

- Different colors appear to carry different weights. Red, for example, is heavier than blue. Brighter colors also tend to be heavier so, as when arranging flowers, we may have to consider which colors we choose to include in our arrangement; the overall proportions of the different colors; and how we spread, group, or intersperse them with other colors.

- An element will appear heavier if its shape is regular and simple, if its form appears compact and if it is vertically oriented.

- Tone is also a factor: a black element must be larger than a white one to counterbalance it. This may partly be due to the "glow" around light objects that makes them appear larger.

- The position within the picture plane is important, not just the offset from the central axis. Elements toward the right of the image carry more visual weight than those to the left. This may be related to the direction we read text, so have some cultural conditioning. In societies where we read from left to right, we have a tendency to identify with a subject on the left more so than with one on the right. Elements on the left will appear closer and less heavy than those on the right because we feel psychologically closer to the left. To create a sense of balance, we may need to place disproportionately heavier elements on the left.

- A unit in the foreground has less apparent weight than the same unit in the distance. Units near the top of an image tend to be perceived as heavier.

- A unit in a relatively empty space has more weight on account of its isolation.

- A unit contrasting strongly with its surroundings will carry more weight. The amount of contrasting space around it will also affect its weight.

- An element that has more "interest" will also appear heavier.

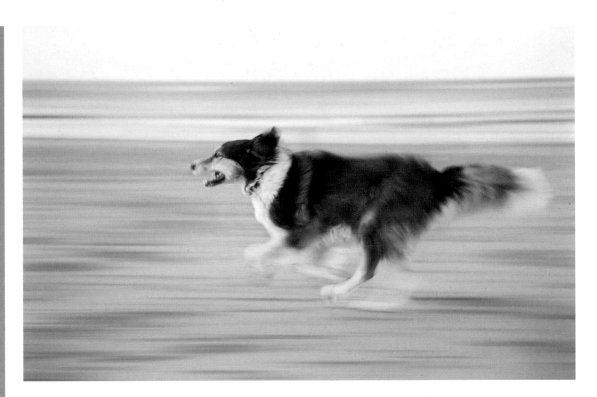

Above & Below: In theory, for those of us who read left to right, the running of the dog toward the left should be perceived as being more challenging for both dog and for us. See what you think.

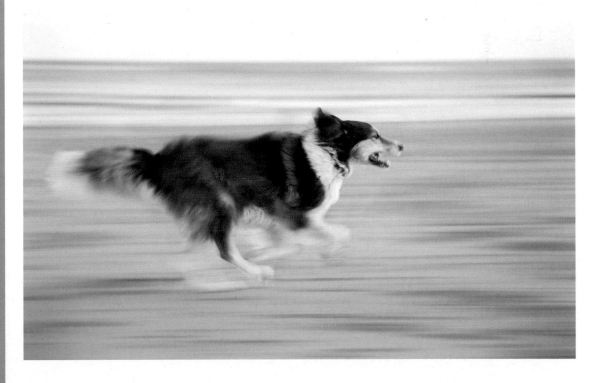

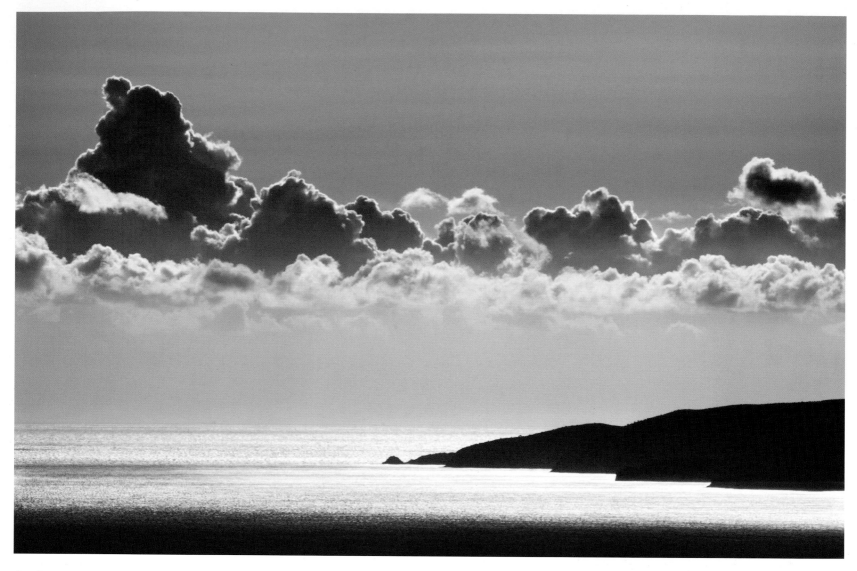

A Question of Balance

Because of all the factors of visual weight, we can see how a small object might be balanced by a large one, a light one by a dark one, and a negative space by a visually full space. With regard to the latter, in an extreme example we may have a situation where there's a visual element on one side of a picture while the other side may appear pictorially empty. In this case the reason for including the negative space would probably be for balance alone. Space without detail may possess some weight because suggestion or implication has imparted some "attraction or interest" to it.

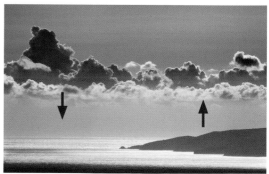

Above & Top: In this minimalist seascape the lofty brooding clouds in an otherwise featureless sky carefully balance the dark shape of the landmass.

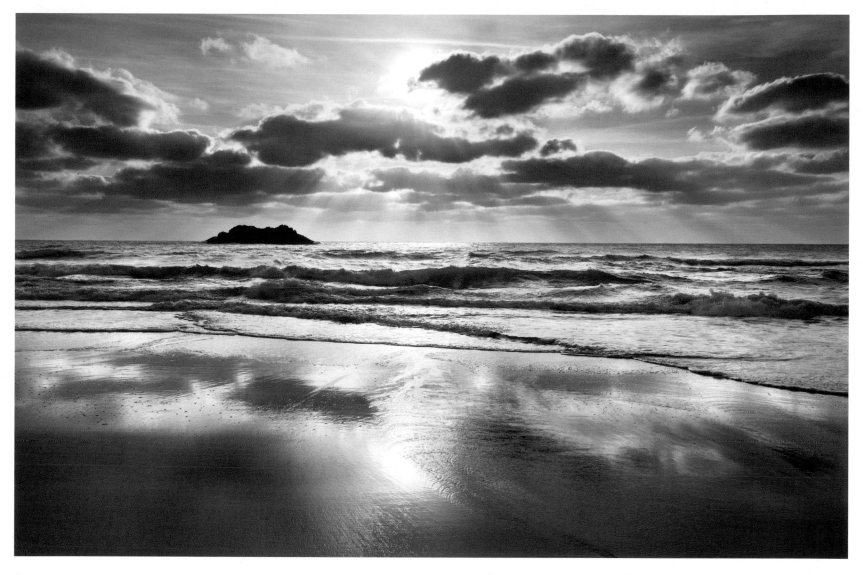

Off-Center Elements

As we can see, placing elements off-center in the frame gives us the opportunity to work with the concept of visual balance. Perhaps also due to our quest for balance, odd numbers of individuals in group photos often work best. This is an interpretation of the "Rule of Odds," which states that an odd number of subjects in an image is more pleasing than an even number. This is partly because even numbers produce symmetries that can appear less natural.

The rule also suggests that it is better to frame the object of interest with an even number of surrounding objects; due largely to the balance that this provides of the secondary elements around the primary one. Thus including three or five individuals in the frame works well for small groups as there will be two or four secondary elements respectively to balance around the central primary one.

Placing elements off-center can also create tensions that make us look for relationships between these elements and other pictorial elements. This can help with our storytelling or to convey feelings such as pleasure and harmony or uneasiness and discomfort.

Above: In this photograph, a small, very dark element— the island—is balanced by open or "negative" space at its right.

Pyramid Form

A variant of the Rule of Odds is "Pyramid Composition." In this, a large object is placed at the center of the image with smaller objects arranged in balanced proportions to the sides. This was a common strategy employed in works of High Renaissance art.

A further ploy is to create equilibrium by grouping several elements on a common axis. In a peaceful landscape, for example, we might see the important elements aligned in a balanced way along the horizon.

TIP

AN EXERCISE IN COMPOSITION
It can be interesting to play around with a few objects on a large rectangular tray, experimenting with them in various positions and relationships. Try a banana and an apple, for instance, and see how positioning the apple within the curve of the banana gives a very different effect to placing it on the other side of the banana—on the outside of the curve.

Below: Balancing groups of similar elements may not come solely down to their numbers. In this case I feel there is a nice balance of the approaching "armada" of swans around the central one. There are four to the right and five to the left, but the relative sizes of the swans in the picture plane no doubt comes into the reckoning, particularly as the composition depends largely on two contrasting tones. The direction of gaze of the dominant swans may also be a factor and some might argue that the exact center of the frame falls between the two central swans.

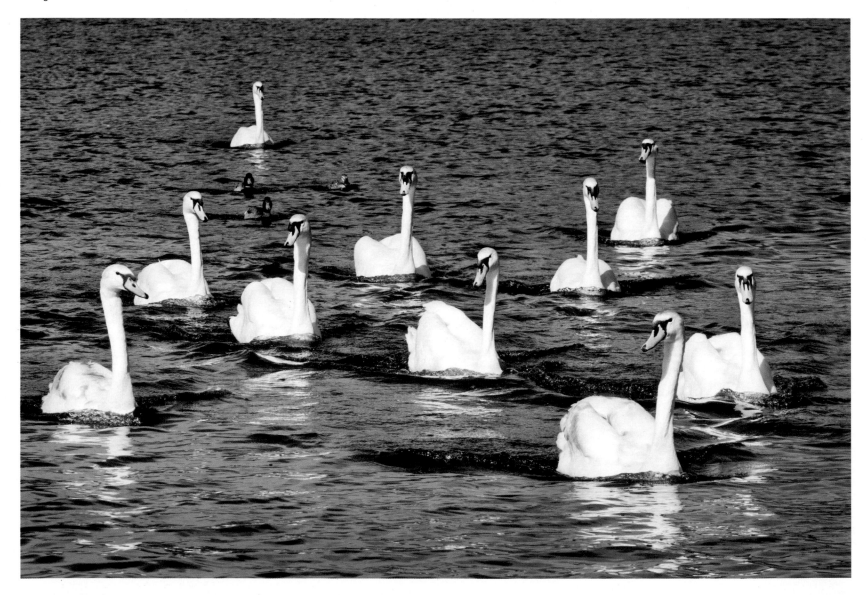

Points of Attraction

Finally, on the concept of visual weight, a note about "points." Any shape that is small enough will act as a point. Because of their simple shape and concentrated form, points attract the eye with extreme force!

Points can also provide an axis for another element to rotate around, so can be constructively used to act as a fulcrum in balancing a composition.

It's also worth bearing in mind that elements and factors outside the frame of the photograph can also influence our decisions regarding where to place the subject matter within the image space. Often, for example, the subject clearly has a relationship to something beyond the image itself: if it is a person or animal it may be gazing at something that is not in view. This may make it natural for us to offset the subject slightly, away from whatever it is relating to.

Above: Any small, simple shape can act as a point of attraction, drawing the eye powerfully toward it.

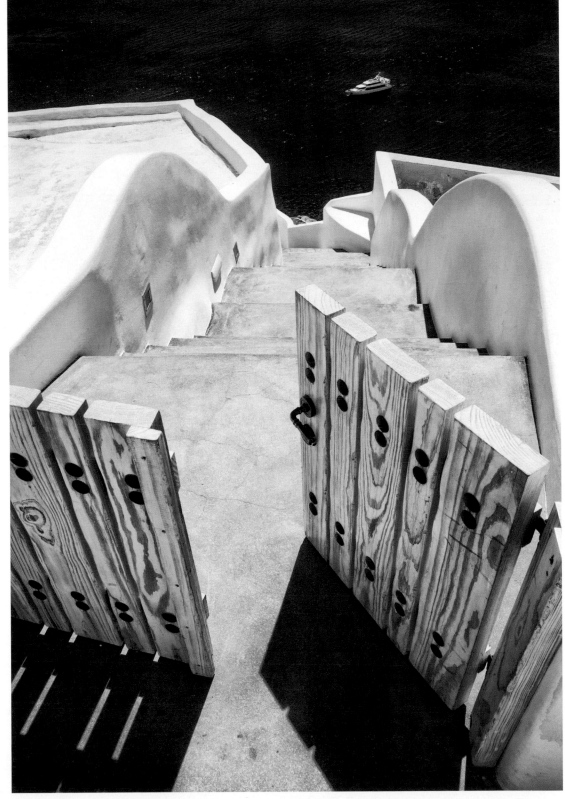

Right: An example of an image where an object, in this case the distant boat, is small enough and distinct enough in tone to actively draw the eye. The path and lead-in lines also take the eye there with the open gate acting as a symbolic invitation to the viewer to enter the scene and make the journey.

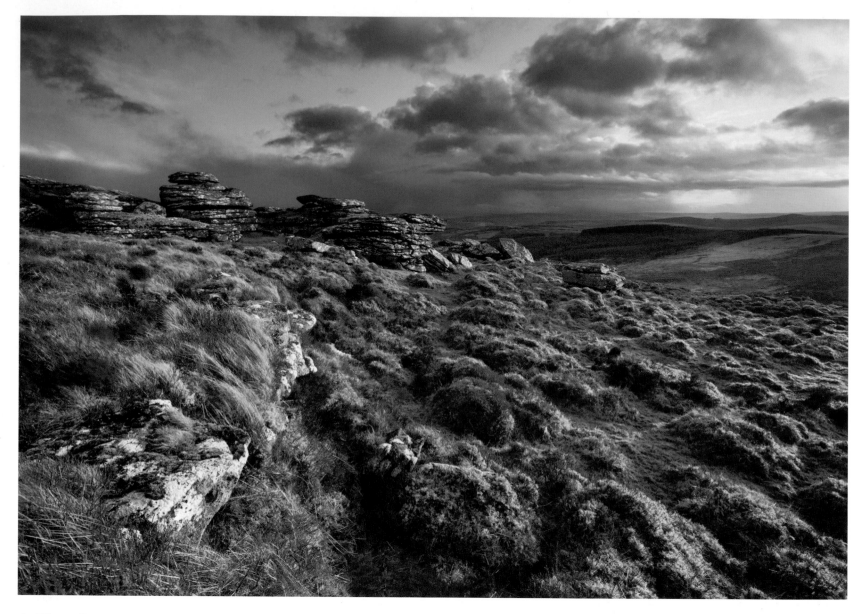

A Fine Balance

Clearly there is far more to arranging and positioning the elements within the photo frame than simply spreading them around evenly to avoid large areas of negative space. The situation is complicated further by the fact that associated with visual weight is a perceived force of attraction between elements. Rather like gravitational pull, there is the sense that one element is being drawn toward another. This . is perhaps why in the "banana and apple" exercise just proposed, if the apple is placed within the

Above: In this example we can see how the sun, even though it is out of frame, is still involved in the composition. The arrows indicate leading lines drawing the eye toward the tor.

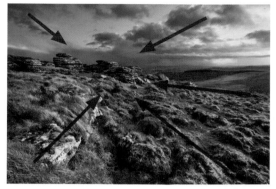

curve of the banana it appears to be connected to and embraced by the banana, whereas placing it outside the curve of the banana gives a sense of it being repelled and excluded. The corners and center of a picture also appear to act as "magnets" to some degree, which further complicates our efforts to balance elements within a frame. In detailed

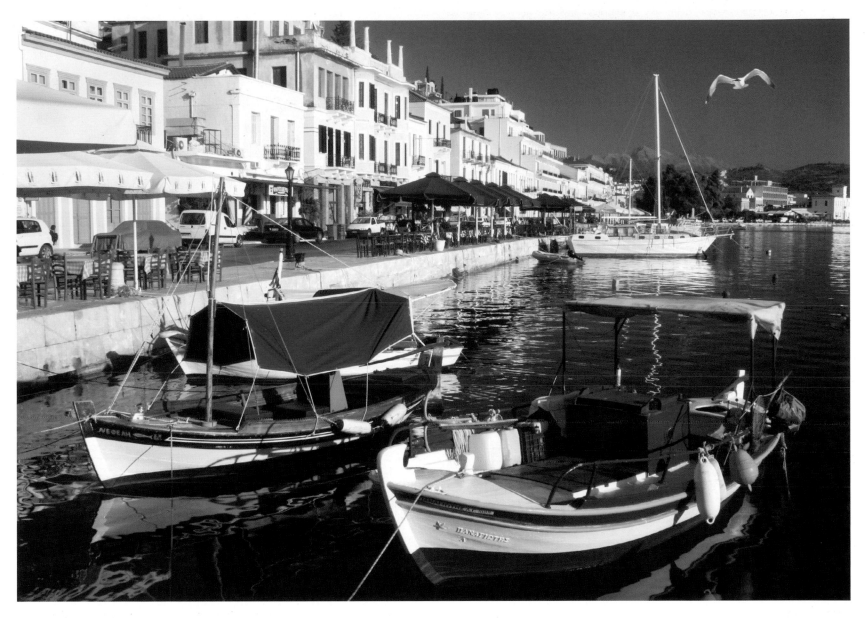

Above: Although tiny, the flying seagull has a large impact on this scene and is critical in balancing the image overall. Without it the weight would fall to the left.

analyses of compositions interpretation of these lines of pull can get very complex with various axes and vectors being proposed. Fortunately we all have our own inbuilt meter for measuring balance—our "gut feeling." We tend to instinctively know when something feels balanced, but it is necessary to listen to this and use this meter as we set up our photos.

Often in life we are dealing with situations where some of the elements are on the move, and others are static. One strategy we can use in these cases involves taking the time first to carefully compose the static elements and then wait for that moment when the moving element comes into the precise position to complete the balance of the composition. An ability to visualize how the scene will appear and to predict the course of the moving element—together with a good measure of luck and patience—lie behind your success in these situations.

It is sometimes worth setting your camera to continuous shooting mode to fire off a sequence as the moving element enters the scene to ensure that you catch it in precisely the right place.

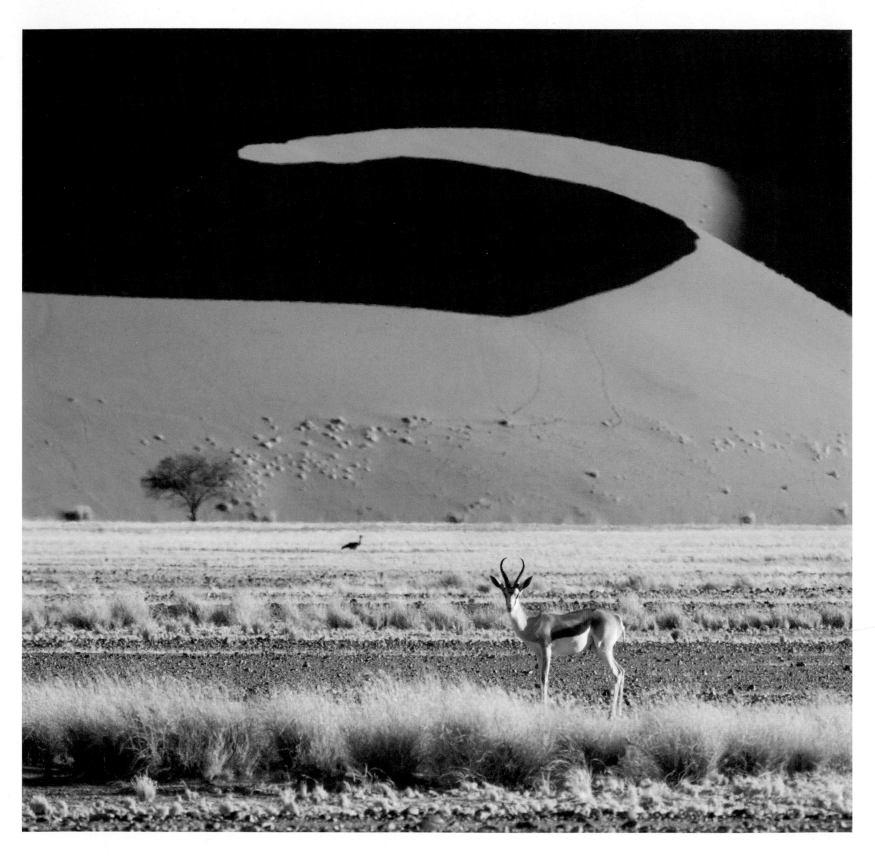

Left: The fixed component of this scene in Namibia was the dramatic sand dune providing the backdrop. I waited for the solitary springbok to work its way in from the right and fortunately this coincided with the distant kori bustard being out in the open between the antelope and the tree.

Overriding Factors

It's worth remembering that a moving element can have a very different impact on your composition to a still one. Even if "frozen" by the photograph, a moving object will still be perceived as carrying some momentum in a particular direction. This imparts a vector that may need to be taken into account in terms of it needing space in a particular direction as we have seen through the rule of "Nose Room." Also the moving object will have a perceived drag on other elements that surround it, potentially altering their requirements for space. To complicate the issue, we also have to bear in mind that emotional, directional, and narrative factors may also exist in the image. For example, many pictures depend on the sequential arrangement of elements to convey a story. These sorts of factors can override the importance of achieving precise balance in the image simply based on the nature of the individual elements: inverting such an image or altering the sequence may result in a complete loss of meaning.

Right: In busy scenes such as this in the Sultanahmet region of Istanbul, there are so many mobile and transient compositional factors to consider, including variables such as color, shape, and eye-contact between the elements, that all you can do is fire off a few frames and select the best compromise afterward.

Picture Formats & Proportions

Above & Above Left: A simple scene shot in both horizontal and vertical orientations. Neither is "wrong"— the horizontal shot gives a greater sense of space, while the vertical shot has more sense of depth.

Having considered the arrangement of elements within a space, let us now turn to the issue of formats and the proportions of the space itself. The frame of an image can be considered as a further "element" in the picture, at least in terms of its impact on other elements and their consequent arrangement. Indeed the orientation (vertical/portrait or horizontal/landscape) and the proportions of the frame will have their own subconscious impact on the viewer.

Aspect Ratios

The aspect ratio is a numerical way of describing the frame shape by stating the horizontal and vertical measurements together as a ratio. Most imagery tends to be of a slightly elongated form, with the most common aspect ratios being 3:2 and 4:3.

Over the years cameras have been manufactured to output a variety of ratios, with larger format film cameras offering 7:6, 5:4, or even 1:1, but the 3:2 ratio became the most commonly used format, due to the 36x24mm frame size of 35mm film. There doesn't appear to be a clear aesthetic reason for this ratio, but certainly a slightly elongated frame offers compositional creativity that would be difficult to achieve with a square or circular frame. There is more scope for using a left-to-right or bottom-to-top vector in the image to convey a sense of depth, for example, or to allow the eye to scan a scene in an ordered way. It also offers potential for telling a story by sequentially placing elements across the elongated space.

The horizontally elongated view also conforms more closely to our natural "take" of the world. With our eyes on the front of our heads we tend to see the world with a horizontally stretched field of view.

Of course, there is no "frame" as such confining our visual field, as we view a scene by paying attention to local specific parts of the scene and then moving our eyes on to scan other details. However, we do have a tendency (if our heads are fixed) to view the world as a horizontally elongated oval with blurred edges.

The 4:3 ratio is now increasingly popular, with many consumer digital cameras being made to provide these proportions. The advantage here is that it conforms to many monitor displays and printing papers. There is also the slightly more compressed 5:4 ratio, which offers another relatively common standard.

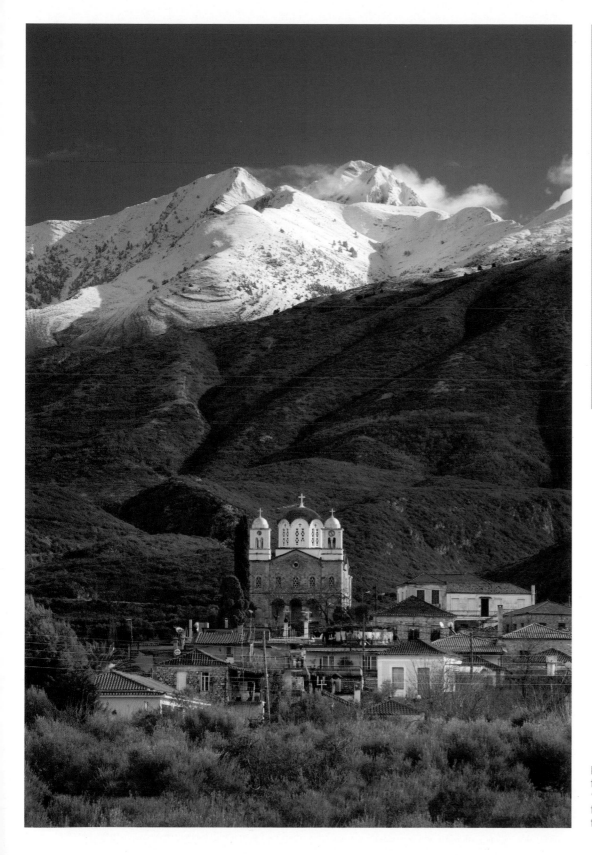

HORIZONTAL OR VERTICAL?

When choosing orientation ask yourself:

- Does the shape of the subject matter naturally suit a particular orientation?
- Which orientation will avoid including unnecessary clutter?
- Are there foreground elements that you wish to include that will help support the message?
- Do you want to convey a sense of space or depth?
- Are there relationships between elements that you want to emphasize?
- Is there a journey that you wish the viewer's eye to make or a sequence of elements that you want them to notice?
- Are there lines and shapes in the scene that can actively contribute to your composition?

Left: Height was the message to be conveyed here, together with the juxtaposition of the church with its "white peaks" mimicking the mountain beyond. A telephoto lens aided the juxtaposition by providing a tighter crop.

Panoramic Views

At the other end of the spectrum are panoramic images, which are becoming increasingly popular due to widescreen televisions and software that enables multiple images to be stitched together. The impact of a panoramic image often depends on it being printed "big," as this enables the details across the scene to be seen clearly. Simply cropping a single image for a "letterbox" view risks reducing the file size to a point where large prints are not viable, whereas combining a number of images maintains the pixel count and resolution.

Prior to digital capture, the standard panoramic format was 17x6cm (a ratio of approximately 3:1), although 12x6cm (2:1) and 24x6cm (4:1) were also available. By working with a specialized panoramic-format camera, you can, of course, capture the image with just one shot, which is useful if you are photographing a scene with moving elements such as waves or clouds. In general, these extended format images are particularly appropriate for naturally elongated scenes, when there is a strong linear element to the composition with a lengthy journey for the eye to travel through the scene.

It's worth noting that if panoramic images are large and viewed from close to, we can only really consider one part of the image at a time as it is harder to quickly survey the entire image for points of interest. Our viewing process therefore tends to be slowed down, as it would be were we scanning the actual scene in front of us. This can be a good thing for certain images.

These elongated formats are, as you might expect, used most commonly in the horizontal orientation. This is no doubt largely due to our binocular vision and to the ergonomic demands of the cameras themselves, which tend to be designed with horizontal shooting in mind. However, the landscape/horizontal image orientation can also be used to convey a good sense of space in our images.

The Portrait Orientation

For shots involving portrait/vertical orientation, the different ratios can all have their benefits dependent on the subject matter and the compositional

The Square Format

intentions of the photographer. The slightly elongated 3:2 ratio, for example, can suit more elongated subjects such as the standing human and tall buildings. It can assist with conveying a sense of height and also depth in landscape images, and perhaps the relationship between very near objects (including the viewer) and distant ones.

In deciding whether to rotate your camera, judgments also need to be made regarding the best orientation to employ to make use of the impact of lines and shapes in the scene you are photographing, and how best to balance the elements. It can be an interesting exercise to assess how many horizontal shots you have taken after a day's shooting and how many vertical.

The 1:1 ratio or square format offers symmetry in itself that will help instill a sense of balance and tranquility. The symmetry of the sides and corners keeps reminding the eye of the center, making it a particularly good format to use for perfectly symmetrical subject matter or for "pattern" images where there is no directional component to the frame. This format will encourage the eye to move more freely in all directions to explore the pattern.

However, the square format is difficult to use as a standard, as few subjects are without a linear component. It is natural for us to align the longer axis of objects with the longer sides of a rectangular frame. A few film cameras use this format, but

Above: There is a strong linear element in this image as the eye follows the ridge of the sand dune from bottom left toward the top right. A panoramic format seemed appropriate.

generally it is to be achieved by cropping a rectangular image. Allowing a little extra space at the sides and top and bottom of your composition gives you a little freedom to get the cropping spot on, as precision is often an important part of the success of square images.

Of course, most photographers will only have one camera at their disposal, producing images of a fixed dimension (typically 3:2). So, unless you are "stitching" images together to produce panoramic images, the format of your final images will be determined by

Left: The portrait orientation often suits landscape images where the foreground features are a strong part of the picture and contribute actively to a sense of depth.

cropping. This means that rather than fitting the image material to a predetermined and preset picture shape, we can select a picture shape to suit the image after it has been captured. We needn't limit ourselves to the standard formats, either, as we can choose whatever shape we feel is best for each picture.

Image Size

As well as the shape of the frame, the size of an image also has an impact on its composition. It's ironic that now that we have digital cameras that are capable of outputting large, high-quality prints many of us view photographic images on-screen. Our demand for convenience and instant gratification means the screens we use are also shrinking, with laptops and notebooks replacing desktop computers, and tablets and smartphones now increasingly used to view images.

It is interesting to consider what is needed to give such small images impact. Generally, they need to be simple and graphic, as complex images with fine detail can't be studied as easily, so won't be appreciated as much in this form. Images are also often viewed fleetingly in sequence with hundreds

Right: The symmetry of this salsify flower and clear background suits the square format. The radiating lines of the petals and sepals both draw your eye inward, toward the center, and outward toward the periphery.

of others, so need to have a message with instant perception and recognition. In short, they need to have "punch."

There is, however, a risk that we might become lazy in capturing our images through operating in this environment. You can get away with radical cropping of images, as artifacts such as noise and poor focus are not going to be so evident at a small size. Fortunately, most people still appreciate viewing quality images in print at large sizes, either in publications, or displayed in galleries or on the walls of their home. For your own satisfaction you can't beat seeing your images printed "big" and displayed so that you can take time to study them and reflect upon them.

Right: A vertical format was the obvious choice for this view along the Rindomo Gorge in Greece. The viewer's eye naturally follows the path of the gorge toward the mountains and brightest part of the image formed by the rising sun.

An Exercise in Cropping

This series of photos of two ducks "sailing" past some posts on a misty lake illustrates how subtle cropping can tidy up our compositions.

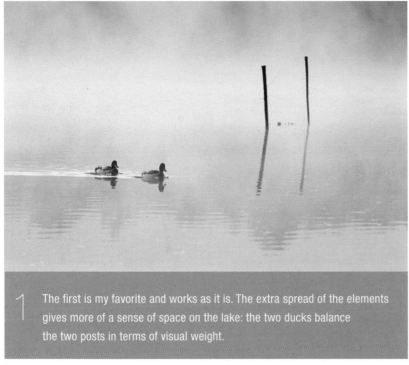

1 The first is my favorite and works as it is. The extra spread of the elements gives more of a sense of space on the lake: the two ducks balance the two posts in terms of visual weight.

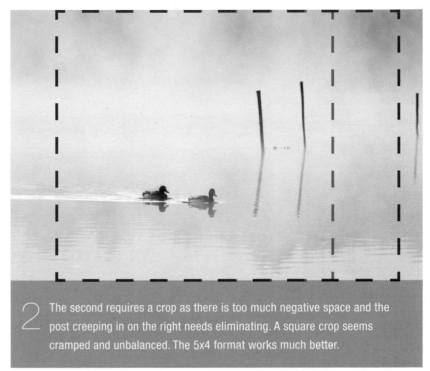

2 The second requires a crop as there is too much negative space and the post creeping in on the right needs eliminating. A square crop seems cramped and unbalanced. The 5x4 format works much better.

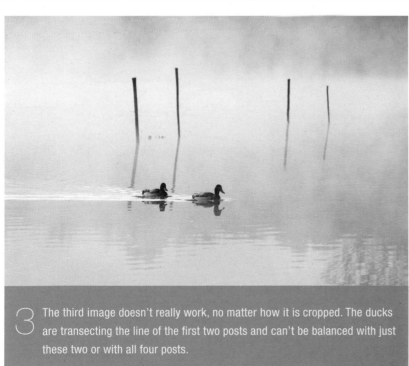

3 The third image doesn't really work, no matter how it is cropped. The ducks are transecting the line of the first two posts and can't be balanced with just these two or with all four posts.

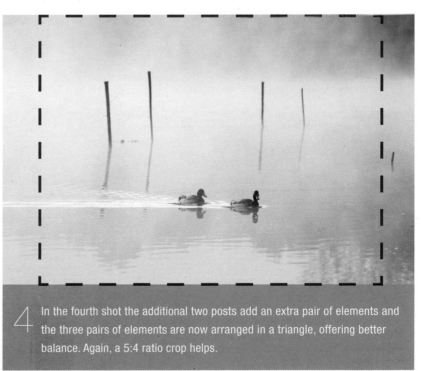

4 In the fourth shot the additional two posts add an extra pair of elements and the three pairs of elements are now arranged in a triangle, offering better balance. Again, a 5:4 ratio crop helps.

Framing the Picture

Having considered the format of the image plane, let's turn our attention to the impact of the border of the image and its role in our compositions. We can use the frame to support our compositions or contribute to them in subtle ways. We might choose, for example, to align strong lines in the image with the edges or corner of the frame to give them extra strength and emphasis. This is a ploy that is often used in architectural photography.

The frame edges also provide a reference for the orientation of other lines within it; by rotating the frame we can turn a tranquil level horizon into a dynamic diagonal, giving a sense of imbalance and confusion. In this case it isn't the horizon that has tilted, but the frame, yet it has a similar effect.

Demanding Attention

The edges and corners of the frame also each seem to pull and push on elements, causing tension. For example, an element lying on the edge seems stuck to it, which draws more attention to the edge than the element itself. If the elements are floating freely within the frame, the frame itself is less apparent and we tend to see through it like a window without being aware of its existence. If the frame markedly and deliberately crops an element (as opposed to just accidentally nicking the edge off it), the frame is also less apparent, but it is not as invisible as it would be if the element were floating freely within the frame.

Right: A graphic study of sunlight and shade. The frame edge helps to support the strong vertical and horizontal lines of the steps.

Close to the Edge

As with positioning objects slightly off-center, placing objects very close to the edge can lead to distracting ambiguity. The viewer is left pondering whether this was deliberate, rather than being immersed in the message you are wishing to convey. This also applies to the corners. Generally it's best to avoid leading the viewer's eye to the corner because it will probably leave the frame. These are all reasons why it's worth scanning the edges of your viewfinder to check for "border mergers" (where part of an element is cut off by the frame) before releasing the shutter. At times it is necessary and appropriate to crop off part of an object, particularly if the image is trying to reveal detail in a portion of that object. If this is the case, it is generally best to do this boldly avoiding the inclusion of extraneous details that could make the viewer question the crop.

Right: In this photograph of frescoes in a tiny chapel in Greece, an important component is the encompassing arch at the top. It was critical that I avoided cutting into this arch, allowing a tiny bit of breathing space above it.

Partial Framing

Objects and shapes in a scene can also be used to provide a natural frame for the subject. In effect this creates a frame within a frame (sometimes termed a "compositional frame"), which provides the viewer with a stronger "window" to peer through. This can help to enhance the subject matter, localize it, and draw attention to it. Doorways and nearer buildings and, in the natural world, trees, branches, and rocky overhangs typically serve this purpose. This internal frame does not have to completely frame the subject; it can work with the picture's borders to do this. It is often important, however, to select your internal frame so that it matches and complements the subject matter or further supports the story. Using the frame to obscure part of your subject matter can serve to stimulate the viewer's imagination or help draw attention to the nature and role of the frame itself. Your choice of position will also affect the relationship between subject and frame. Try not to encompass any superfluous elements as these will compete with the subject matter and obscure the message. Focal length will also alter the relationship: a longer lens will tend to reduce the apparent distance between a nearby frame and a distant subject.

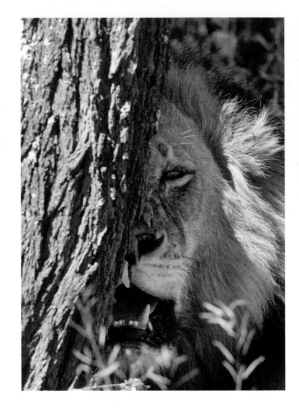

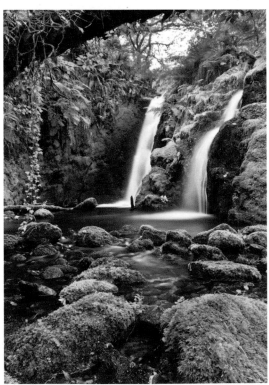

Right: Four examples of what is in effect the use of a partial frame to help isolate part of a subject and put it in some form of context.

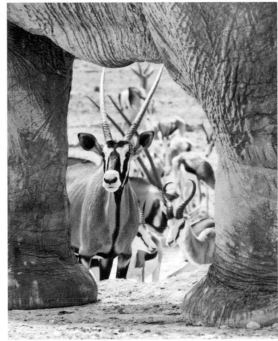

Above: A gemsbok staring at me through the legs of an elephant at a waterhole in Namibia. The frame is relevant and adds to the "story."

TIP

EXTERNAL FRAMES

When displaying our images as prints, our compositional considerations can be extended to include the color, texture, nature, width, and shape of mounting/mat boards and picture frames. These become additional elements, which can affect how the image itself is perceived. Chosen well, they will complement and support the image rather than compete with it or distract us from its content and message. In general, their purpose is to draw attention to the image, isolate it from its surroundings, and focus our attention on its content.

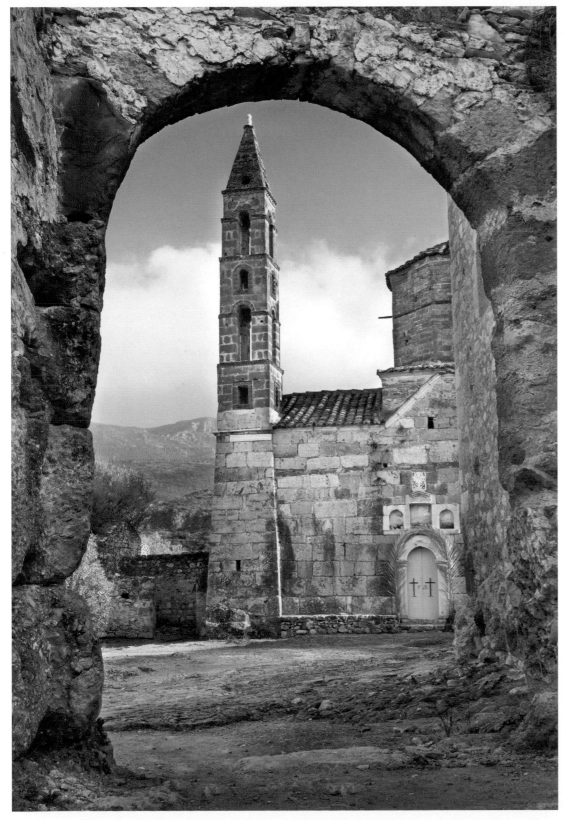

Left: The camera was only a few inches from the ground to frame the church in Kardamyli, Greece in this archway.

Dynamic Tension

A Sense of Disharmony

As mentioned previously, beauty is not always the intended perception and there may be times when we want to convey a sense of disharmony in a photograph.

Knowledge of the rules and principles of composition can still be employed here, even if it is a matter of consciously breaking or defying them. Positioning elements in an unbalanced or unconventional way, even if it is simply by tilting your camera slightly, can be used to convey a sense of "dynamic tension."

In a sense, this is the opposite perception to the one of harmony, balance, and order. It will probably invoke a sense of slight unease in the viewer and potentially give the imagery more of a sense of movement, toppling over, friction, or energy and,

Above: This spider's rather diagonal off-balance posture gives it a sense of motion, as if it is hurrying toward us.

through this, "dynamism." Understanding the intent behind a "rule" can help us to consciously and constructively subvert it to create an alternative response in the viewer.

Above: The random positions of the three figures in the frame, the orientation of two of them facing out of the frame, and their unbalanced postures create dynamism and a slightly disturbing sense of panic. This is appropriate for the image, and the apparent confusion of the figure in red in terms of where to go further adds to its potency. Photo by Mark Shuttleworth.

Chapter 3
Elements of Design

With experience, the placing of pictorial elements becomes more intuitive and is made in relation to many considerations including those discussed and others such as the power of certain colors in the frame. We will come on to the influence of tone and color in the design of our photographs in the following chapter, but first let's take a look at some of the other elements of design at the photographer's disposal. These include line, shape, form, texture, pattern, space, depth, and perspective. The process of composing an image can involve the inclusion of any of these elements, often using and arranging them according to the psychological principles discussed and various principles of design such as repetition, pattern, rhythm, balance, contrast, scale, proportion, movement, and direction.

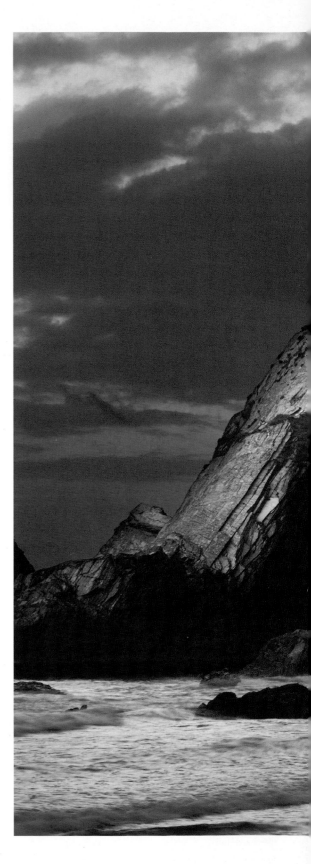

Right: The lighting on these rock formations emphasizes their pyramidal shapes. The pyramid form of a structure tends to be associated with a sense of stability and permanence and a feeling that this structure has endured the weathering over millennia. This helps to impart a sense of timelessness to this scene.

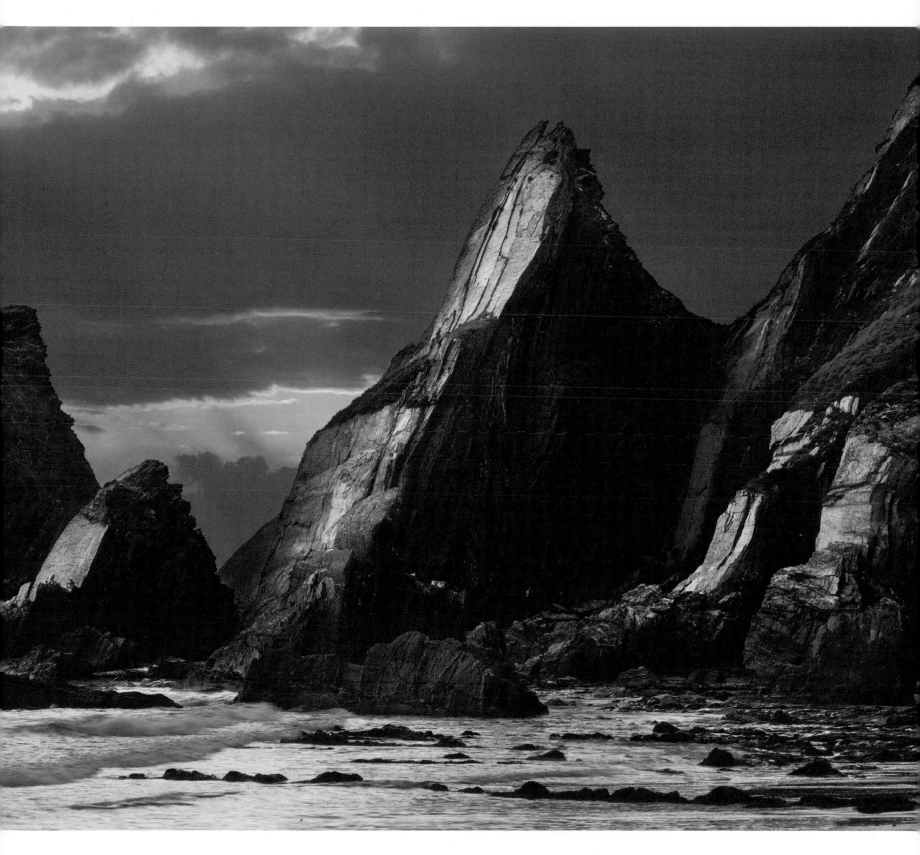

The Power of Lines

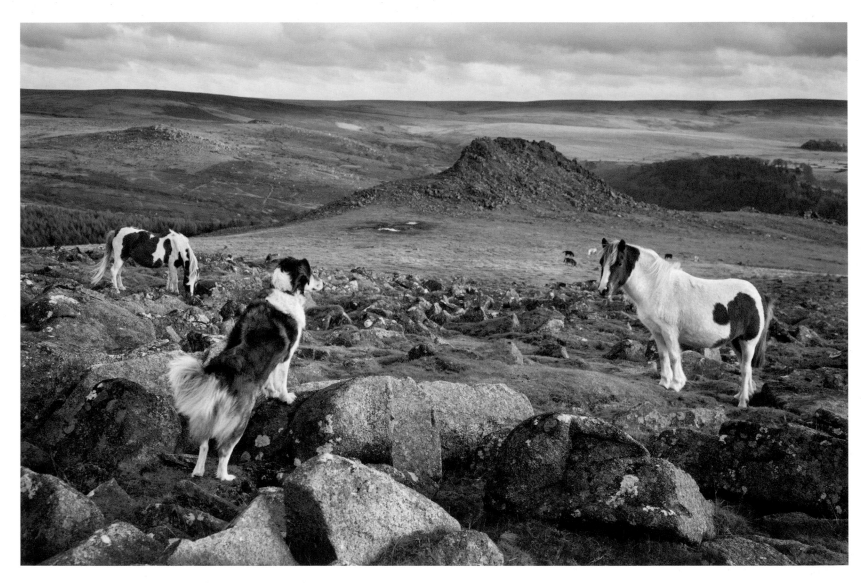

Above: In this image, taken near Leather Tor on Dartmoor, England, our eye tends to follow the gaze from the dog to the horse and back again with a little detour via the second horse. The similar coloring of all three adds to the sense of relationship between them.

Directional Lines

Lines have the power to direct the viewer's eyes through the picture space, so look at how you can use any lines present in the scene: "leading lines" are a great way of drawing the viewer's attention to something in the picture space, for example.

Don't forget that the line doesn't always have to be an actual or even a continuous line; when there are multiple elements in a picture space,

the viewer's mind will tend to try to create shapes and lines from their arrangement. A row of objects can act as a line, for example, and lead the eye in a particular direction. This is an example of the Gestalt principle of Good Continuation. There is also the potential for the viewer's eye to travel along a "virtual" line between two separate elements (or "points") in a picture.

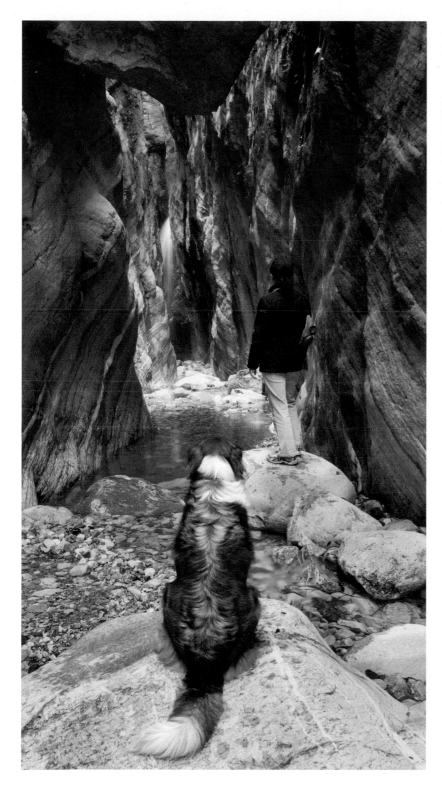

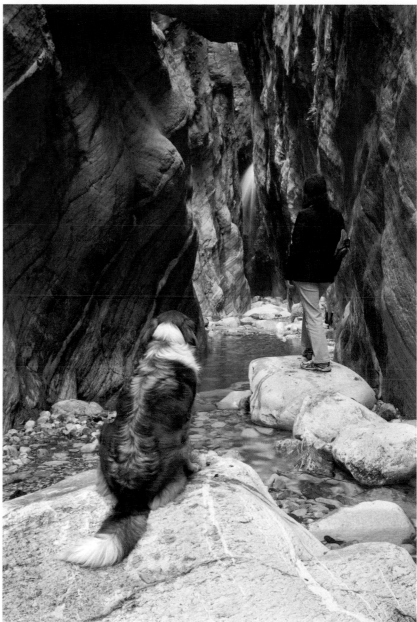

Left & Above: In the depths of this gorge there are various leading lines formed by the striations in the rocks and the gazes of my wife and our dog. They all serve to channel your eye toward the cascade of water beyond. In the image to the left, the dog acts as an obstruction to the path of the eye. Offsetting her slightly in the image (above) invites the eye in more readily.

Assumed/implied lines (which are also known as "optical lines") can be very potent factors in our compositions. Even the line of view of a person or animal can be construed as a leading line and we can use the direction of their gaze to direct the viewer to an intended target. The strength of these lines will depend on many factors, such as the likeness in terms of form and appearance, or the contrast in tone between the two or more elements generating them. Other lines may also serve to reinforce them.

Natural Lines

Strong lines are prevalent in the manmade world, but actual or "optical" lines can also be found readily in the natural world. Here, in particular, their use as leading lines will often be a compromise in our compositions, since we cannot adjust their precise direction. Fortunately, it's usually enough that they lead the eye to the vicinity of the point of interest, and not necessarily directly to it. Again, because of our tendency to fill in gaps, any interruptions in these lines will not markedly affect their potency.

A particularly powerful effect in relation to "leading lines" can be obtained when multiple lines lead in to a point of interest from different directions. They tend to reinforce one another, drawing the viewer's attention rapidly and strongly to the subject matter that lies at the point of intersection of the lines.

Right: The conveniently placed log draws the eye along the intended path—bottom left to top right—in this dry riverbed.

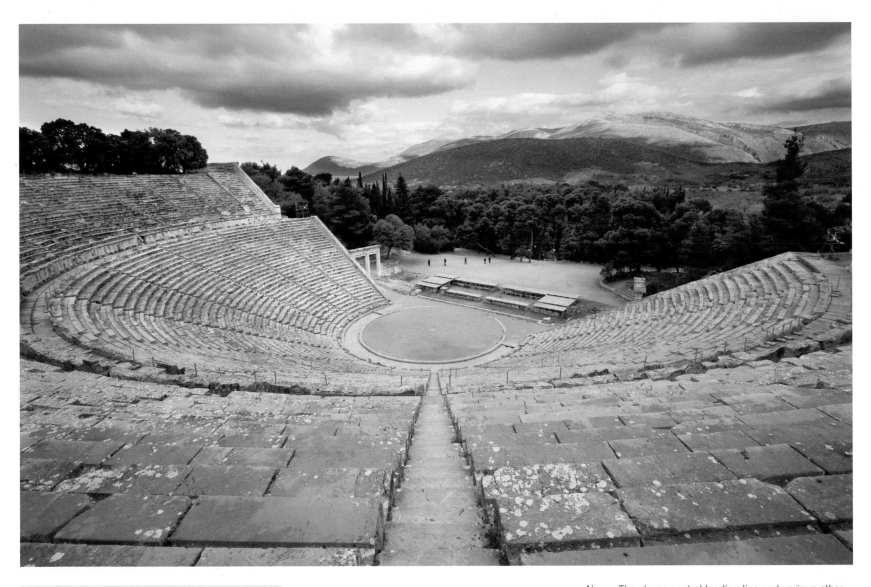

Above: The strong central leading line and various other convergent secondary ones lead the eye down to the centrally positioned stage in this wide-angle view of the ancient amphitheater at Epidavros in Greece. Although it is an interesting study of the theater itself, the image would probably have been stronger if there had actually been something occurring on the stage to engage us.

TIP

ROADS TO NOWHERE

If the lines lead the eye strongly to a region of a photograph, it's important that there is some significant content there—unless, of course, the lack of it is the desired statement. Leading the eye too close to the edge of the image could also be a mistake, encouraging the viewer's attention to focus on the frame or even to leave the composition.

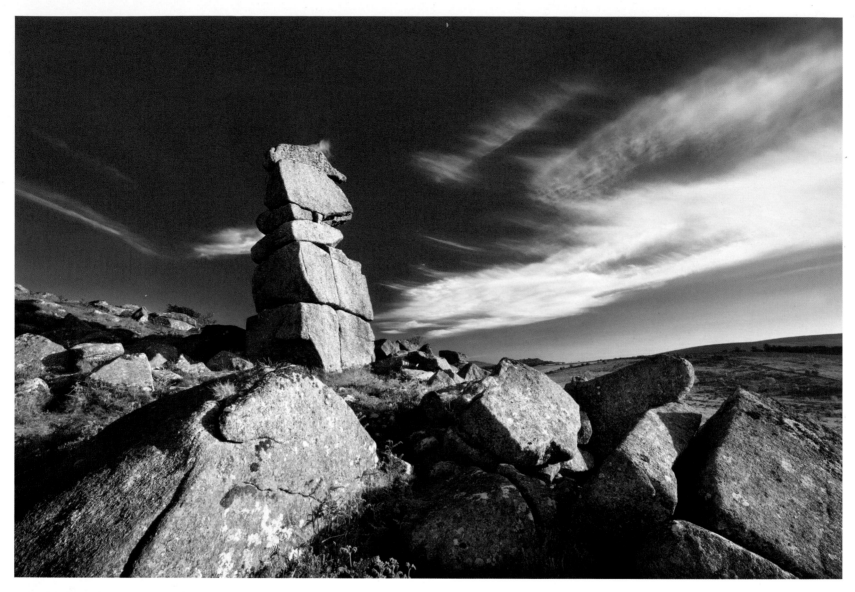

Above & Left: This rock stack, known as Bowerman's Nose, is one of Dartmoor's best-known features. The cloud formations and rocks in the foreground all channel the eye toward the subject standing proudly above us. The "figure" appears to have a relationship with both the sky and surrounding land. The composition gives it the sense of stability and grounding in its surroundings that I wished to convey.

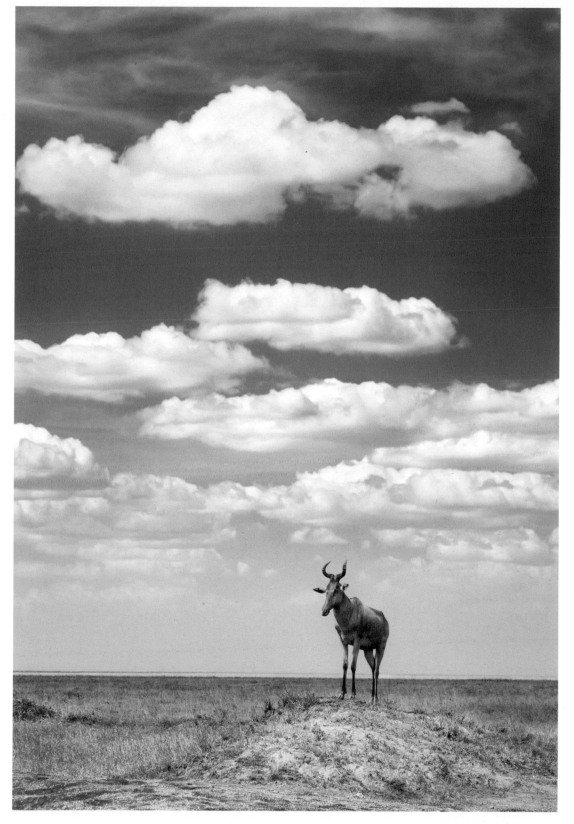

Above & Left: This photo of a hartebeest on an anthill in the Serengeti also illustrates the concept of the hourglass. The anthill and hartebeest form one cone with its apex at the head of the antelope. The expanding clouds above form another cone again with its apex at the point of interest. The ears, nose, and horns also create a star-like form, further drawing the eye toward the animal's head.

The Hourglass Effect

In the three-dimensional world, this is like an object being placed at the narrowest part of an hourglass —where two cones, or perhaps pyramids, meet. The cones act to channel our attention to the point of convergence. Due to our tendency to retain a perception of depth in a two-dimensional image, a sense of this can be conveyed in our photographs and can give them a particularly strong appeal. In addition to focusing our attention on the subject matter, the convergence creates a strong sense of depth. I have coined the term "hourglass effect" to describe this.

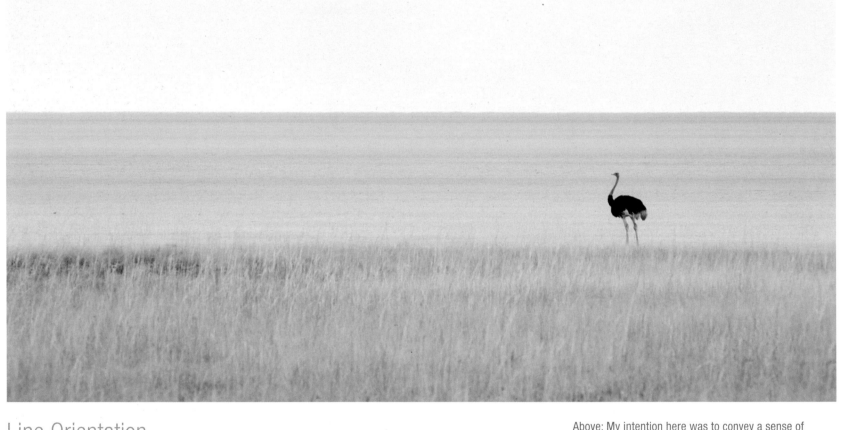

Line Orientation

Continuing on the subject of lines, it is important to be aware that different types and orientations of lines have their own connotations due to how they affect the viewer subconsciously. These emotional connotations are not fixed, since our emotional responses depend on a host of other factors too, but certainly the tendencies toward them seem to exist.

Straight lines in engineering tend to bestow rigidity and structure. Similarly their presence in an image tends to suggest the same qualities. If they lie horizontally they convey a sense of calmness, tranquility, and stability (I have heard it termed "cold rest") and often a sense of breadth or width and, by extension, space. Using a horizontally elongated picture format will support their ability to generate this perception.

Vertical lines have more energy and are more assertive and direct ("hot rest"). They give a sense of height and grandeur, and generally this can be reinforced by use of a vertically elongated format.

Above: My intention here was to convey a sense of open space with this lone ostrich walking out onto the immense dry salt lake in Etosha National Park, Namibia. The two strong horizontal lines are important and allocating a largish portion of the picture space to the sky further helps to give this sense. In retrospect, perhaps I should have made the ostrich even smaller although I would have run the risk of losing his "presence."

Dividing Lines

Generally we try to avoid lines (horizontal or vertical) across the center of the frame as there is a risk of them splitting the perceived image into two. Of course, if your intention is to display symmetry between the two halves of the picture space, this division of the frame into equal parts can be used to support your message. However, if symmetry is not the goal, it is usually preferable to position any obvious lines off-center.

The horizon is such a strong horizontal line that it is worth avoiding potential conflict with other key elements by ensuring that it does not appear to run through important features such as the faces of your subjects.

Interestingly, it is generally more acceptable to the viewer for horizontal lines to lead out of the picture space. This is probably largely due to our acceptance that the horizon, which is such a dominant horizontal, leads out of our field of view. However, vertical lines leading out of the frame are more challenging as they are generally very active and our eyes are particularly compelled to follow them. Also our experience of them in the world (such as with street lights, tall buildings, trees, and so on) is that they usually do "stop" at both ends—either where they meet the ground or are curtailed by the forces of gravity.

Right: These two columns at Ancient Olympia in Greece are a typical case of vertical lines providing a sense of height. Shooting from a low view point with a wide-angle lens has helped exaggerate the convergence of the lines, further providing a sense of height and depth, and also a sense of the relationship between the two columns.

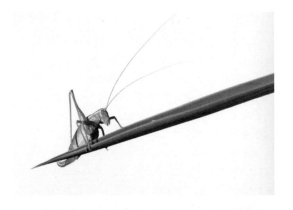

Diagonal Lines

Diagonal lines help convey depth as they suggest distance and perspective; indeed, many diagonals that are seen in images are due to perspective effects. Diagonal lines have more energy than horizontal and vertical lines, producing a dynamic energy, where "dynamism" is equivalent to the illusion of motion. This partly arises from the sense of imbalance that the diagonal gives. Think of it as being like a tree trunk: if the trunk is diagonal it is neither standing nor fallen, but falling. Diagonals also tend to move the eye through a scene more rapidly, so can dominate and interfere with your composition if used incorrectly.

Our eye movement when viewing an empty rectangle tends to be similar to reading text, so for most people reading this book it wants to go from left to right across the page and top to bottom. However, elements in the picture can influence this and deviations from the "usual routine" evoke reactions in the viewer.

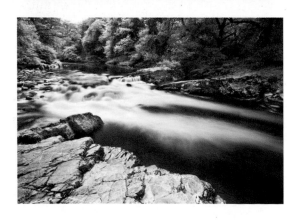

Diagonals

Above: Gives order, but little dynamic impact, therefore tranquility.

Above: Dynamic, giving power, forcefulness, and movement.

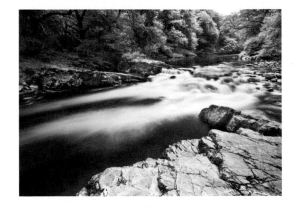

Left & Right: It can be an interesting experiment to try "flipping" some of your "diagonal line" images horizontally to see the slightly different effect this creates, as the series of images on this page illustrates.

Dynamic Impact

Diagonals have great directional value and can also lead the eye away from the usual course, which is why the direction of the diagonal affects how it influences us. If the diagonal runs from top left to bottom right, it is closer to how the eye is accustomed to scanning the page, so will be easier to follow and serves to give order to the picture, but little dynamic impact. In this form diagonals can convey tranquility or even melancholy. If, however, the line runs from bottom left to top right, it is more challenging and dynamic, and gives power, forcefulness, and movement to the picture.

Zigzag lines can be viewed as "extreme diagonals" that understandably suggest tension, whereas curves—while still conveying movement—bring a sense of restfulness, softness, and flow to an image. If positioned well, sweeping curves can help convey a sense of balance and harmony, while wavy, sinuous lines give a sense of flow, fluidity, and sensuality.

TIP

HORIZONS

A word here in relation to horizons. Generally speaking, you should aim to make sure that your horizons are straight. I say "generally" because sometimes, if the scene is a little flat or static, you could try rotating the camera a little to get a quirky effect. This can also give a sense of movement as you introduce the emotive effect of diagonal lines; this effect tends to be more potent when wide-angle lenses are used.

Above: The angle of view here has created an interesting "Z" shape from the relatively horizontal blue elements in this interpretation of architectural components on a Greek island.

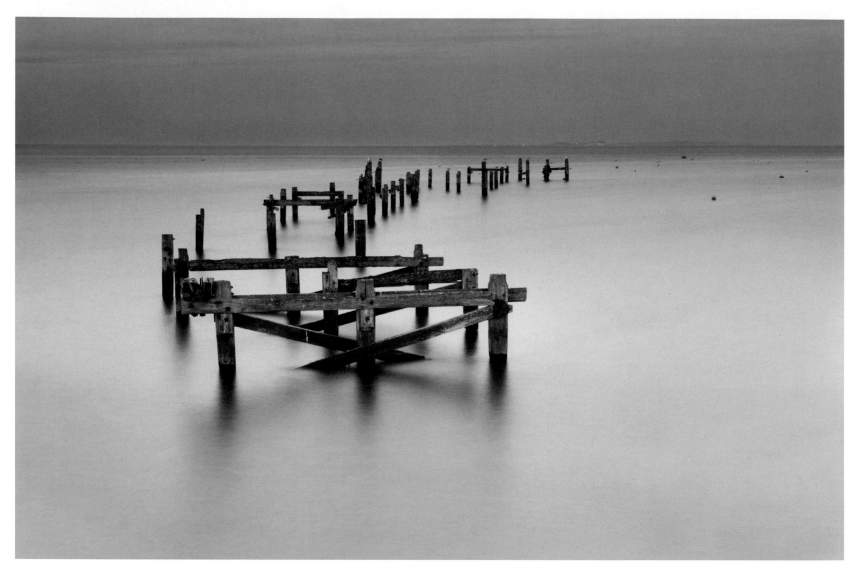

Converging Lines

Finally, remember that converging lines can be used to add a strong sense of depth to our photographs. This perception comes about because we know that a road or railroad track, for example, is the same width along its course even though it appears to narrow as it leads away from us. Therefore if we see two lines converging in an image or a single line narrowing we assume that it is because the lines or line are running away from us into the distance.

It is also important to remember that a slight change in your viewpoint can radically alter the course, angle, and degree of convergence of lines in your image. We will come back to these considerations when we examine perspective later in this chapter.

Above: The old pier at Swanage in Dorset, England. The gentle curve adds to the tranquility of the scene. The convergence in terms of the width of what remains of the pier diminishing into the distance gives a good sense of depth to the image.

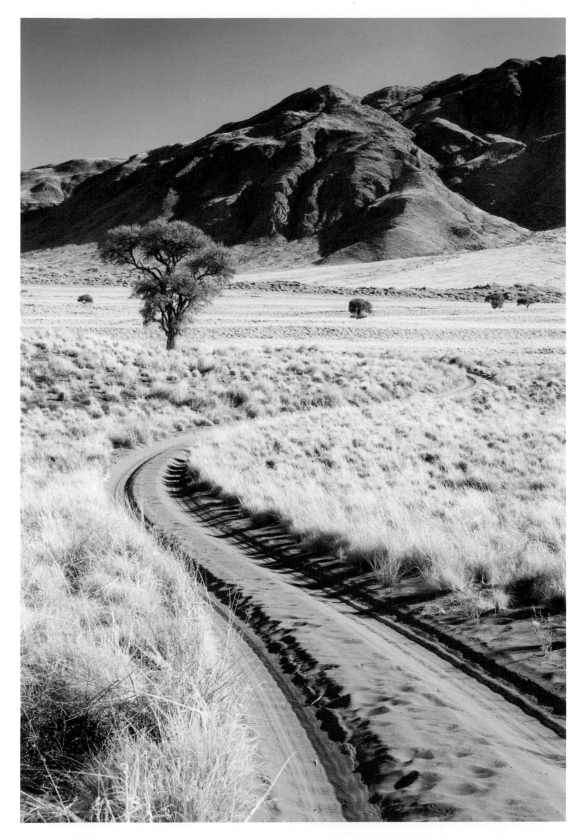

Above: We can also have rather random meandering lines acting as very important elements in our photographs! Photo by Mark Shuttleworth.

Left: The S-shaped curve of the leading line formed by this track affects the whole mood of this scene. Again the convergence, this time of the two strong lines formed by the vehicle tracks, conveys a powerful sense of depth.

The Impact of Shape

Dominant Shapes

As we have seen, in Gestalt Theory there is the acknowledgment of the impact of different shapes on the psyche. So, in addition to lines we need to be looking for shapes and how they can be used to support what we wish to say. Shapes needn't be considered purely in relation to those of the objects within the picture; equally powerful shapes can be formed by the spaces between elements, or by their shadows. As a result, both negative spaces (empty or "non-subject") and positive spaces ("subject matter") can contribute to the formation of shapes in a photograph.

Remnant Shapes

In fact, the success of some images relies heavily on what we might term "remnant shape." These are images where the dominant form/shape that we perceive is formed more by what would initially appear to be negative space or "ground," rather than the subject matter, or "figure." If the shape that it forms carries some symbolic meaning then it can even rise above the subject matter to become the dominant theme of the image. This occurs because of our tendency to seek out and perceive the simplest forms.

Right: This photograph taken at the Holocaust Memorial in Berlin by Edwin Westhoff is an excellent example of "remnant shape." Edwin's carefully chosen viewpoint, looking up at the monument and the sky, reveals a remnant shape that can be perceived either as an airplane or the powerful symbol of a Christian cross.

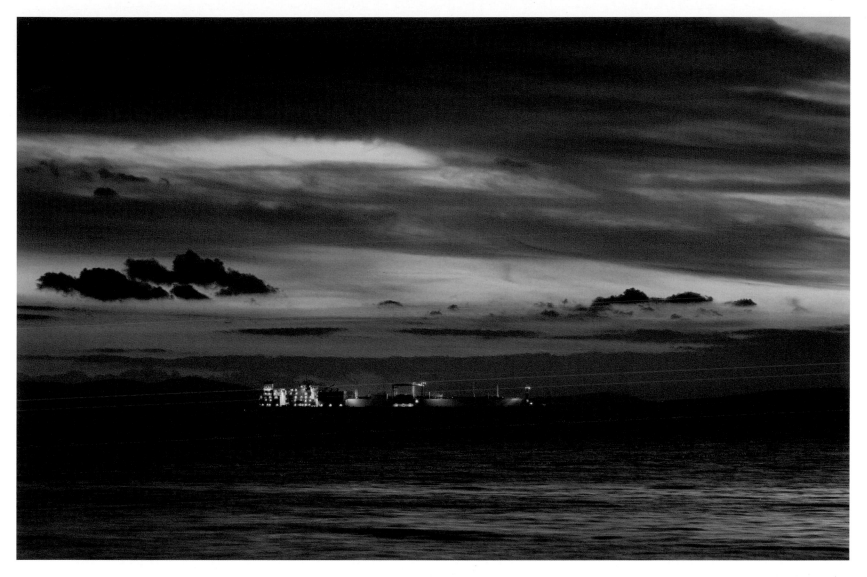

Balancing Elements

So, look at the contours formed throughout the image and how they can delineate shapes. The shapes don't have to be precise in order to be seen, as our perception will often fill in the gaps or make the shape conform to what is in our minds. Note also that by simply placing key elements on points of a geometric shape, you can often create a nicely balanced composition. If you have three elements, for example, try placing them at the points of a triangle within the picture plane. This simple approach to positioning and balancing elements to form a pleasing relationship is sometimes termed "triangle composition." Of course, opportunities to arrange larger numbers of elements to give an impression of more complex geometric shapes will be encountered more rarely, but may still present themselves on occasion. Precise positioning at the corners of a square or hexagon or rim of a circle isn't usually necessary; it's enough to convey that impression.

Above: This beautiful dusk sky was crying out to be photographed as I drove home one evening. I spotted the ship and positioned myself so that it was more or less equidistant from the two dominant patches of dark cloud in the sky, effectively creating a triangle between the ship and clouds.

Bold Shapes

Understandably, bold shapes will serve to create bold images. Angular shapes are also more dynamic and grab our attention more than rounded, smooth shapes. Different shapes have associations with different qualities, no doubt based on where and why they appear in the world around us. Precise, rigid shapes tend to be associated with the creations of mankind. I have heard it declared that a square is "the icon of man's dominance over nature"—a sad reflection of our arrogance, but true perhaps. Rectangles in general represent structure, solidity, and precision, whereas triangles represent strength,

endurance, unity, trust, stability, and permanence. They have associations with pyramids in this regard, and understandably an upside-down triangle will convey less stability. Circles on the other hand represent wholeness, purity, and potential. They also have an enclosing or encompassing effect on elements within them, which can be used to good effect in our compositions.

Above: The diagonal line of these steps leads the eye up to where it is captured by the solid, stable shape of the tiny window.

Right: "Gecko on the Moon" (actually on a globe light on a pathway in Borneo!).

Expression in Shape

In nature and wildlife photography there is perhaps a tendency not to pay much attention to the emotional impact of different shapes, as perfect circles, rectangles, and triangles are rare. However, pyramidal-shaped mountains in the background, circular eyes, and even more abstract shapes such as the space between an elephant's legs as it walks, can all be used to aid your expression. In architectural photography, by contrast, strong lines and shapes abound and give great scope for compositional creativity. Here converging lines readily form triangles and other strong shapes.

We have already touched on how the movement of the eye between elements in the picture space, in effect joining them up, can create a strong sense of "implied" shapes within the image. Three prominent centers of interest will tend to create a triangle, for example, particularly if they are similar in content, tone, or size.

So, remember to look for these types of shape too in your surroundings and consider how they could make a statement in themselves or add to the balance of your composition.

Above: Church domes on the island of Santorini provide an example of the prevalence of strong, potentially symbolic shapes in architectural photography.

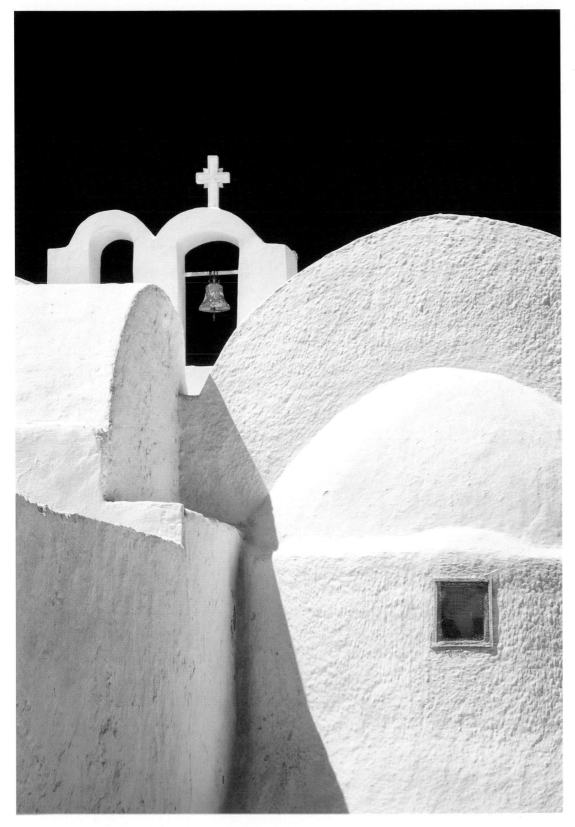

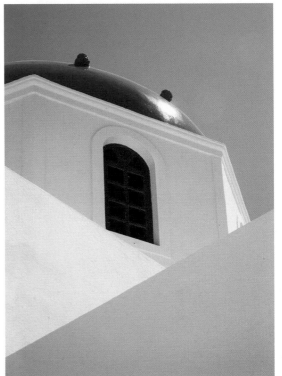

Left & Above: Further examples drawn from images of Cycladic structures show how architectural images can provide strong lines, curves, shapes, and patterns.

Scale, Form, Pattern & Texture

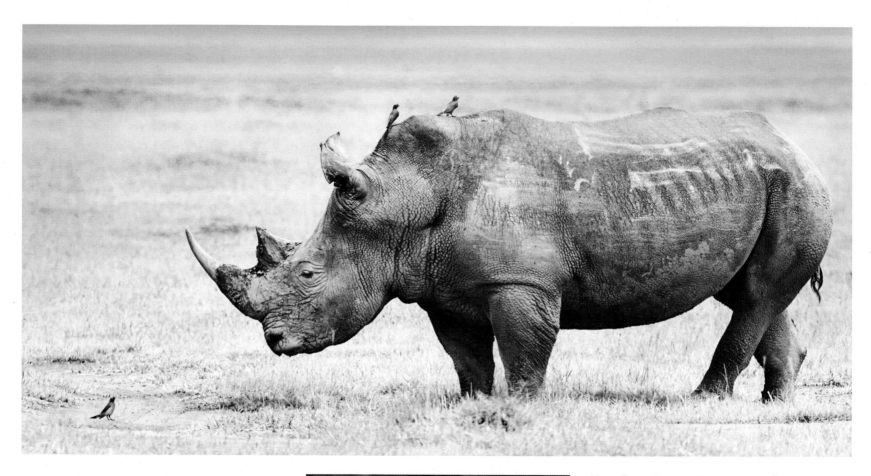

Scale, form, texture, and pattern are further perceptions we often wish to convey through our photographs. Intelligent photography with good compositional skills can also enable us to effectively depict these and other concepts such as "unity," "alignment," "conformity," and so on.

Scale

Scale is often declared by the inclusion in the image of a second object, the size of which is well known. The scale of an alpine vista, for example, could be revealed by the inclusion of a hiker on a mountain path. The message might be more obvious if the hiker were wearing a red jacket to draw attention to himself as the measure of scale in the landscape.

Above: The momentary interaction between this white rhino and the tiny bird makes a strong "scale" statement.

Above: A simple and direct statement about scale—this tiny tree frog in Borneo is compared to the finger nail of a little finger. We can see instantly that it is a little less than a quarter of an inch long.

Shape

Form

Form

"Form" can be thought of as a term for three-dimensional shape. As you can see from the illustration above, subtle gradations of light and shadow are the key to our perception of form. Chiaroscuro in art is an Italian term that literally means "light–dark." In painting, the description refers to clear tonal contrasts (usually created by strong directed light illuminating key parts of dark scenes), which are often used to suggest the volume and modeling of the subject(s) depicted. This meaning has now extended to other visual arts including photography. It is a commonly used strategy in "figure" photography where it is used to emphasize the form of the human body.

Good use of side-lighting could be employed to emphasize the rounded bulk of an elephant, for example. Composing the image to contrast the elephant with a tiny mouse could make a further statement about its mass as could shooting from a low vantage point with a wide-angle lens. Selective focus techniques could also be considered to help emphasize not only the distance between elements, but also the front-to-back length of the animal in this case.

Right: This illustrates how strong, direct lighting can reveal contours and shapes. This is particularly evident in the jacket sleeve of this gentleman's outstretched arm.

Pattern

A useful strategy for conveying patterns is to completely fill the frame: the mind's eye will assume that the pattern continues way beyond the edges even if it doesn't.

It's important to be aware, however, that rigidly dictated compositions, including patterns, may be unappealing as they represent inescapable conformity. By breaking up some compositions the space then becomes activated and more inviting. A break in a pattern, misalignment, or overlaps within an image or part of an image can help to activate an otherwise rigid, impenetrable space. Including something to break the pattern also serves to allow the eye to rest as it studies the pattern and so breaks the monotony.

Remember also what Gestalt Theory tells us about patterns, and how concepts such as unity, alignment, scale, and so on can all be communicated by the association of elements into groups.

Above & Below: In these two pattern shots I resisted the temptation to extend the patterns right up to all edges of the frame by cropping more tightly. I felt that including the sinuous curves of the boundaries added to the images in some way, and that the juxtaposition of the two colors in the sand-dune image enhanced the picture.

NEGATIVE SPACE

As an aside, it's interesting to note that a negative space can be activated by what is going on in the positive space. For example, if it appears as though the subject is about to move into the negative space, that will immediately give the negative space reason for being there, making it of interest to us. An image of a person stood on the edge of a pool and about to launch themselves into it may benefit, for example, from the allocation of a large amount of the picture space to the still water of the empty pool.

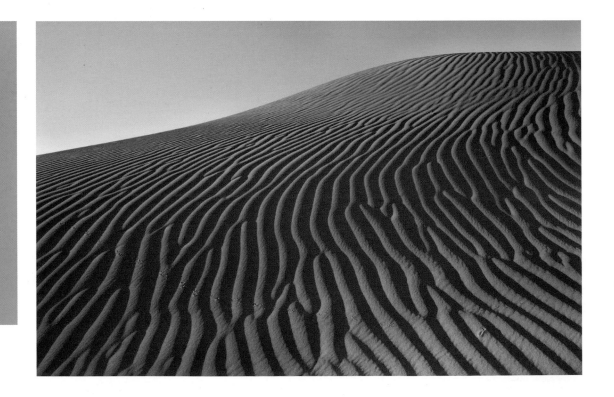

Above: A lovely example of a pattern image where the pattern is broken cleverly by a change in color, lighting, and shape. Photo by Mark Shuttleworth.

Texture

Another quality that we may wish to capture a sense of is "texture." This entails the involvement of our sense of touch, so our ability to do this through a photograph depends on the fact that senses don't generally operate in isolation. Each sense is informed by other senses as we explore the terrain that surrounds us. So, here it is a case of conveying through your photograph a sense of what it might feel like to touch and run your hand over the subject matter. If you do this successfully, the viewer's perception of the image will also trigger their tactile perception, leaving them with a sense of touching the subject too. As this involves an appreciation of the three-dimensional attributes of the subject matter (its "form"), lighting can be the key to conveying this. So, low side-lighting may work well, for example, for the harsher, more rugged structures, but sometimes diffuse light works better for softer, subtler textures.

SENSORY PERCEPTION

It is interesting to consider how this potential for recruiting other senses into the perception of your images can give your images extra impact. For example, a blurred image of a speeding police car is likely to muster up the sound of a siren blaring, leading to an emotive response in the viewer. There are many ways in which an image could tempt the senses and this is no doubt made good use of in advertising images in the food industry.

Left: We get a sense that the script on this stone in the Hagia Sophia museum in Istanbul extends well beyond the edges of the frame. A relatively large aperture has provided some measure of selective focus, which serves to activate a portion of the text allowing the eye to come to rest there to study the finer details.

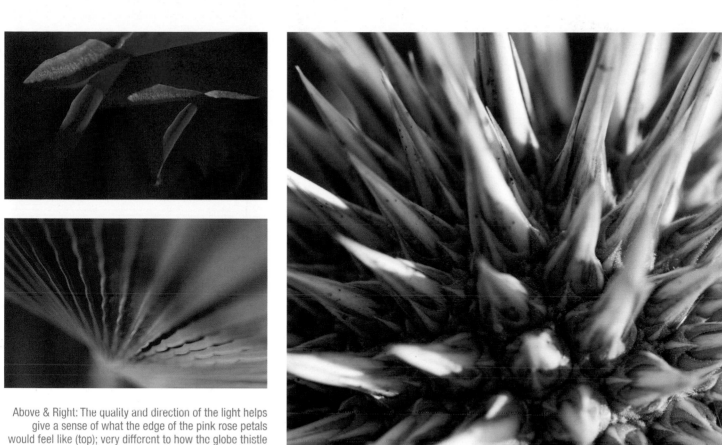

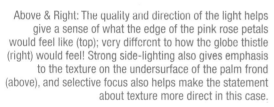

Above & Right: The quality and direction of the light helps give a sense of what the edge of the pink rose petals would feel like (top); very different to how the globe thistle (right) would feel! Strong side-lighting also gives emphasis to the texture on the undersurface of the palm frond (above), and selective focus also helps make the statement about texture more direct in this case.

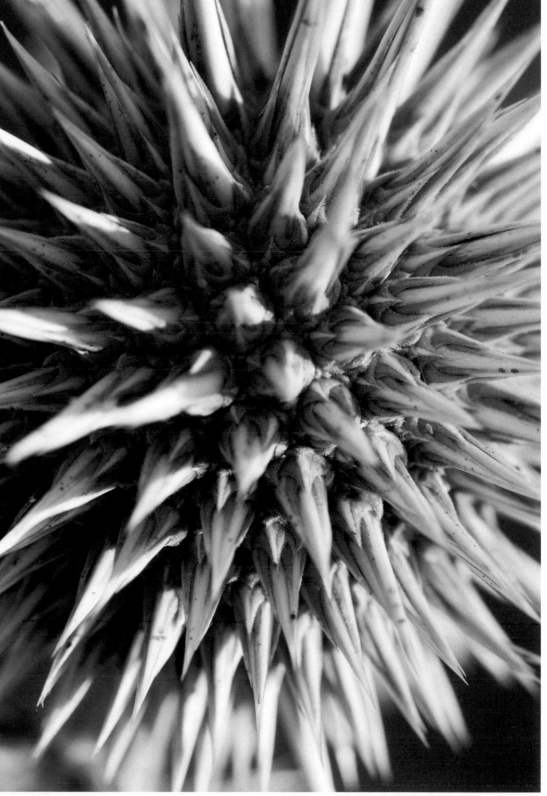

Perspective & Depth

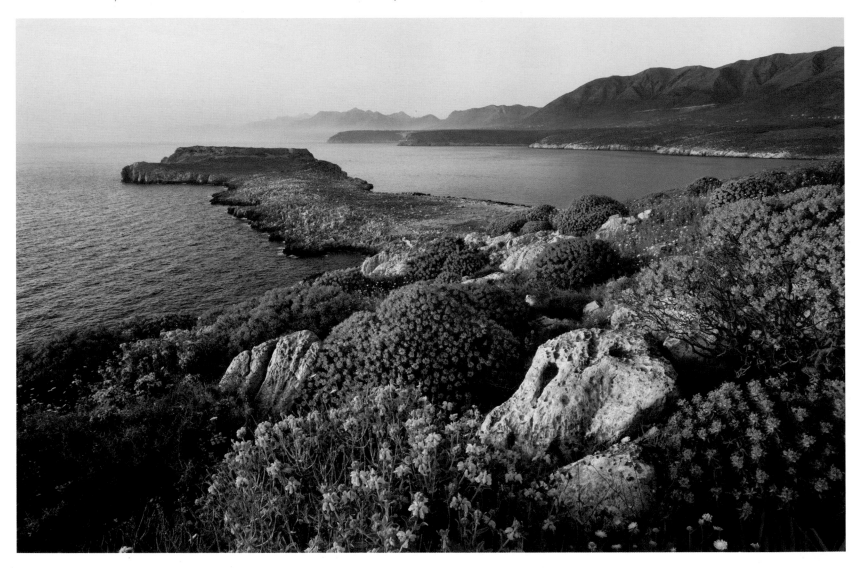

Aerial Perspective

The impression of depth is essential for the impact of many images, giving them the sense of reality that enables us to relate to them. Photographs only really have two dimensions, so the third dimension—that of depth—has to be implied if it is to be perceived by the viewer. Perspective is the art of suggesting three dimensions on a two-dimensional surface. It involves recreating the spatial relationships that objects receding into a scene present to the eye. In

taking a photograph one shouldn't need to recreate these spatial relationships as one would have to in sketching a scene. However, a photographer will need to choose scenes and viewpoints where these spatial relationships are clearly evident.

The more distant an object, the paler it appears due to particles of dust in the atmosphere, and we tend to assume that paler objects in an image are more distant. This is known as aerial perspective.

Above: This coastal landscape image derives its sense of depth from the inclusion of some notable foreground interest, the leading line formed by the rocky peninsula, and the lightening of tone of the more distant peninsulas due to the haze.

This effect is frequently made good use of in landscape photographs where layers of hills or mountains that recede into the distance become lighter and lighter in tone.

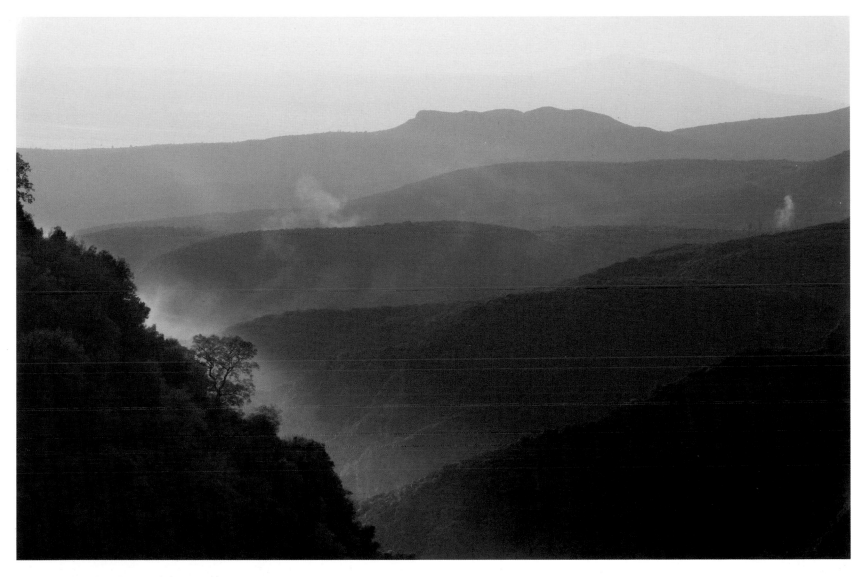

Above: Another example of the effect of aerial perspective. Smoke from bonfires helped to enhance the separation of layers of hills receding into the distance.

Left: In this example, strong shafts of early-morning sunlight help separate the layers of the mountainous terrain surrounding this gorge in Greece.

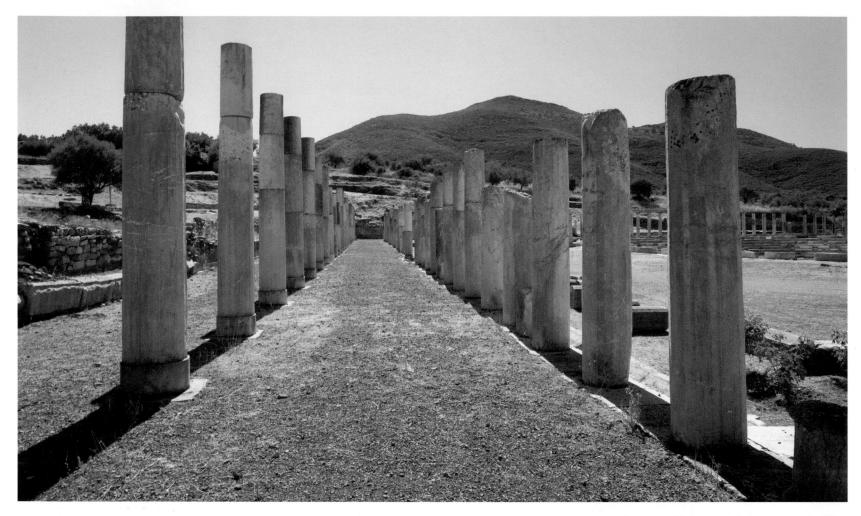

Linear Perspective

Linear perspective, by contrast, is based on the fact that we know that parallel lines receding into the distance (such as the tracks of a railroad) appear to converge toward the horizon. Wide-angle lenses tend to exaggerate this form of perspective and adjusting your angle of view in relation to the surface that carries the converging lines will alter its effect profoundly. It is worth noting here that perspective distortion does not arise because we are using a short focal length lens. Rather it is due to the tilt of the camera. In practice we do get more distortion with wide-angle lenses because we often end up getting much closer to the subject matter, so the camera is likely to be tilted up or down to contain the subject matter within the frame.

Above: The bases of these pillars at Ancient Messene in Greece are united by their strong shadows. They act as two strong lines that clearly converge into the distance, providing depth to the image.

An image can employ one-point perspective where two parallel lines converge toward a single vanishing point to one side. Alternatively, it can employ two-point perspective, where one set of parallel lines converges toward one vanishing point at the right, and another set of parallel lines converges toward a point at the left. Finally, there is three-point perspective where one set of parallel lines converges toward a vanishing point at the right; a second set converges at the left; and the vertical lines converge toward a third vanishing point.

1 One-point perspective
2 Two-point perspective
3 Three-point perspective

We can also create a sense of depth by including a series of objects of the same size that recede into the distance. Alternatively, we can make use of overlapping near and distant objects, which works particularly well if the two objects merging differ in

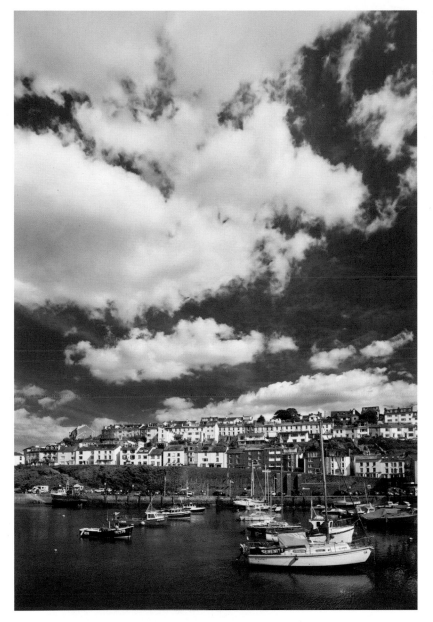

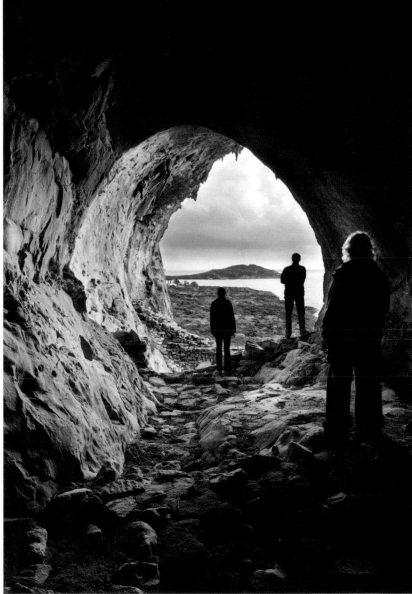

Above: The convergence of the two lead-in lines formed by the rows of boats helps in the composition of this colorful image of Brixham harbor in the UK. The diminishing size of the boats in the row at the right and a slight degree of overlap helps introduce a sense of depth.

Above: The tunnel-like nature of this cave creates a sense of depth in itself, with the eye being drawn toward the light outside. The diminishing size of the silhouetted figures furthers this by giving the viewer a sense of the distance within the cave.

tone or focus due to their different distances. Depth can also be conveyed by differential focus simply because we know that if one thing is in focus and another isn't they are at different distances. So, here we ensure that near and distant objects are in different degrees of focus rather than striving for a maximum depth of field. Whichever of these ploys is utilized, opting to include elements in the foreground, mid-ground, and background can further give a sense of extended depth.

Chapter 4
The Role of Tone & Color

We have already acknowledged how tone and color are important factors in helping us distinguish between figure and ground. Tonal contrasts and strong or contrasting colors are used regularly to increase the salience (level of impact) of chosen subject matter by drawing focus to it and making it stand out from its surroundings. We may even go to the extreme of "color popping," which is the process of reducing the saturation of everything other than the subject, even to the point of rendering the image monochrome except for our chosen elements. The role of color in our compositions is, however, far more complex than this. An understanding and appreciation of how different tones and colors in an image can affect the movement of the viewer's eyes and their emotional response can further aid our ability to consciously construct meaningful images and ones with impact.

Right: The artificial lighting of these columns in the Basilica Cistern, an underground water reservoir in Istanbul, creates the high contrast and warm coloration that help keep our interest on the columns as they recede into the distance conveying a good sense of depth.

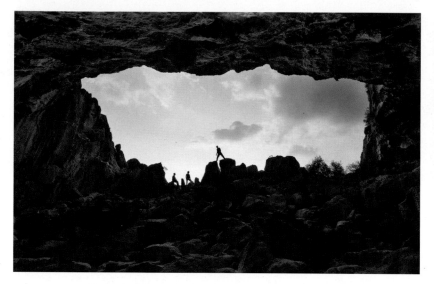

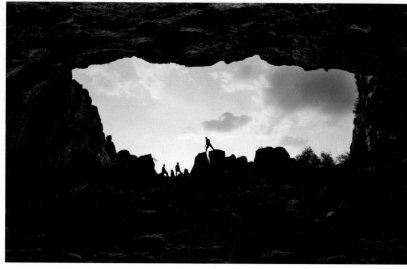

Left & Above: A simple gradient mapping exercise applied to this image taken from the depths of an enormous cave illustrates how the eye tends to take much more interest in the lighter regions.

Tone

One fundamental principle of paramount importance to us is what I will call "the light at the end of the tunnel" effect. This describes how the focus of our attention is drawn from dark to light areas.

This can be used to our advantage when the subject matter is clearly lighter than its surroundings. However, it also means that we need to be on our guard for lightly toned foreground or background objects that, even when blurred and positioned well away from the subject, may compete with or draw the viewer's attention away from the intended target.

With this in mind, when taking a portrait for example, you might choose to position your subject in front of something of a similar or darker tone and take time to scan the background for potential distractions. Being precise in your choice of exposure settings can also often ensure the potency of an image when the distinction between light and dark parts of the image is particularly relevant in the composition.

If the subject is surrounded by much darker surroundings, take care to take your exposure reading from the subject so as to get its exposure spot on. This will ensure that the darker surroundings are rendered particularly dark, helping direct attention to the subject.

Another example where you wouldn't use an exposure reading that averages the whole scene is when capturing silhouettes. These depend on tonal contrasts, and in general the aim is to reduce the tone of the subject matter, leaving little detail evident within it. This allows the viewer to concentrate on the subject's shape and outline, which will be set off by strong contrast with the surroundings. So, biasing the exposure strongly toward the surrounding brighter areas and highlights is usually appropriate.

Contrast

We have seen that areas of high contrast within a scene tend to draw the eye, but the overall contrast that an image displays will also have an effect on us. Generally, in an image with higher contrast the eye will tend to be drawn more forcibly around the scene, away from shadow areas and toward lighter tones. A high-contrast image therefore tends to appear to have more "punch" and energy. If the contrast is lower then the eye will tend to roam around the scene more freely, so a low-contrast photograph may instigate a gentler, more tranquil response from the viewer. There are no "rights' or "wrongs" as both have their merits in different situations dependent on the required reaction in the viewer.

Some scenes are also naturally more suited to a high-key or low-key interpretation. High key is where there is a predominance of light tones in the image field; low-key images contain a predominance of dark tones. We have the choice of whether to exaggerate the key of an image in order to emphasize certain compositional features, for example, by helping them to stand out from their surroundings. We can also influence the overall mood by biasing an image more toward high key or low key as part of our own interpretation of the scene. Subtle manipulation in this regard can be applied in the processing of digital images.

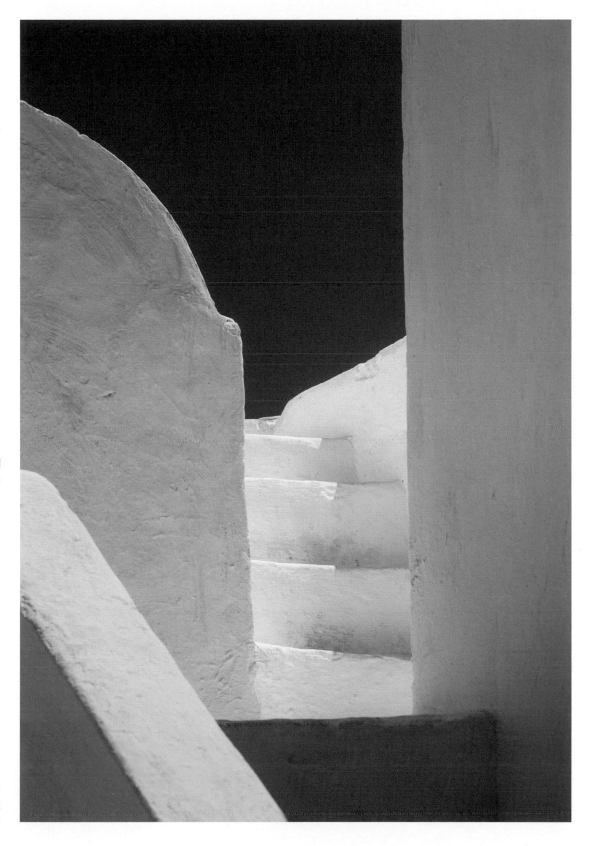

Right: The lightness of the more distant steps helps draw the viewer on an imaginary journey from dark to light along this passageway.

Color

Let us now look at how an understanding of the impact that color has on us can be a further ally. As with tones, different colors also have different potencies for grabbing the attention and so backgrounds also need to be scanned for potentially distracting colors. Certain colors, as we shall see, are particularly dangerous here.

Much of the subject matter that we are drawn to is brightly colored, so some understanding of the impact of color can help you use this to good effect. We may even choose to "dress" our subject matter in a certain color to make it stand out in relation to the colors that surround it.

Color has a direct link to our emotions and each color has its own connotations and associations related as much to culture and experience as to their physiological perception by the eye and brain. For example, yellow, the brightest color, is associated with warmth, summer, wealth, freshness, and friendliness and can also convey joy, happiness,

COLOR DEFINITION

Each color is defined by its attributes of brightness, hue, and saturation. You may come across the widely used Munsell Color System, which is an example of a system used to describe and categorize colors based on the following three dimensions:

1. Hue: The attribute of color that enables it to be classified as red, yellow, green, blue, or purple (with various grades between).
2. Value: Describes a color's lightness, classifying it somewhere between black and white.
3. Chroma: Describes the purity of the color and is related to "saturation."

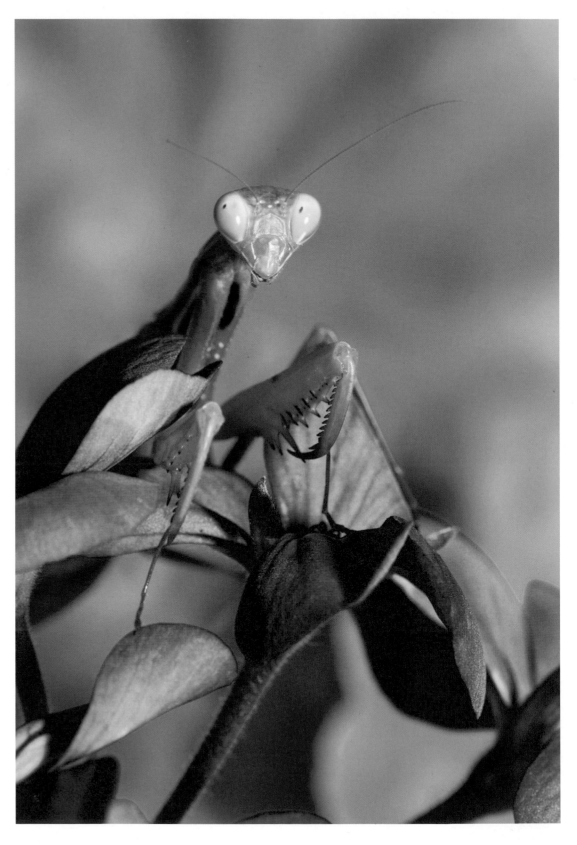

Right: A picture composed of two strong colors in more or less equal measure that complement one another: a bright green praying mantis supported by a similar background peers at us over a pink geranium.

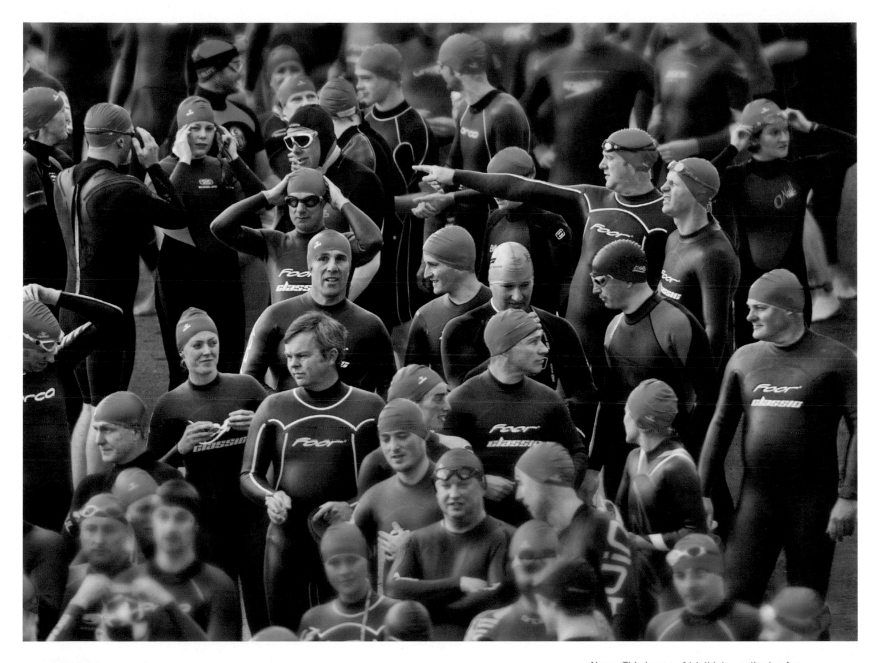

cheerfulness or, at the other extreme, aggression. As it is the brightest color it tends to "jump out" at you.

Advancing Colors

Red is also bold and energetic and conveys energy, vitality, power, love, lust, desire, passion, excitement, danger, fear, aggression, fire, and heat. Like yellow, red tends to "advance," meaning that it catches our attention and can dominate an image. Accordingly,

red needs to be used with caution in a sensitive composition. Orange is the other warm color conveying a sense of heat and energy.

Cool Colors

The cooler colors are blue, green, and purple. Blue is a less active color and has associations with the sky and water. It conveys wetness, airiness, coolness, mood, depression, desolation, and

Above: This image of triathletes gathering for a competition demonstrates how the color red grabs our attention. As we shall see, red and green are also considered to be complementary colors so work well together in a photograph. Photo by Mark Shuttleworth.

loneliness. It can also symbolize peace, tranquility, harmony, and calmness.

Green says nature, the environment, health, life, renewal, growth, hope, and youthfulness. Its negative statements tend to be of decomposition, decay, and sickness.

Finally, purple may suggest mystery and spirituality and, as with the other cool colors, it tends to recede relative to warm colors that demand more attention.

These lists of qualities are by no means complete, and associations may vary between cultures. White, for example, often signifies purity, peace, and innocence in Western cultures, but can symbolize death in Japan.

The Weight of Colors

It is also acknowledged that colors vary in terms of their visual weight. For example, red is thought to be heavier than blue, so you might only need a small amount of red to balance a larger amount of blue. Note also that a color changes character when placed with other colors. This is because our perceptions are constantly being changed and we adjust our thresholds according to the relative effects of neighboring colors. For example, red surrounded by blue will look "hotter" than the same red hue surrounded by yellow.

So, there is clearly much to consider when we are composing with colors in relation to how we match different colors with one another and balance their proportions within the image space. We can also consciously combine different colors within a photograph for certain effects. To help us utilize these effects constructively it's worth keeping in mind the image of the "color wheel" (below).

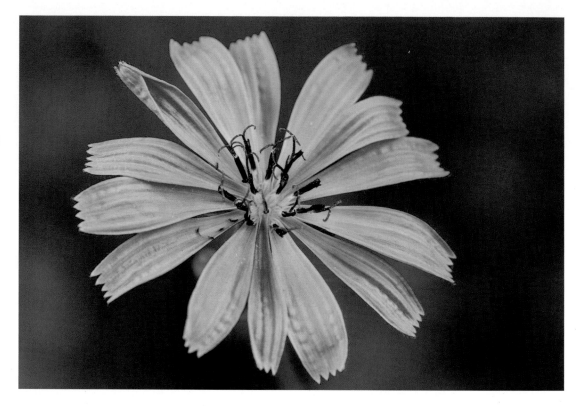

Above & Below: The cool and tranquil colors of chicory (above) and Barbary Nut flowers.

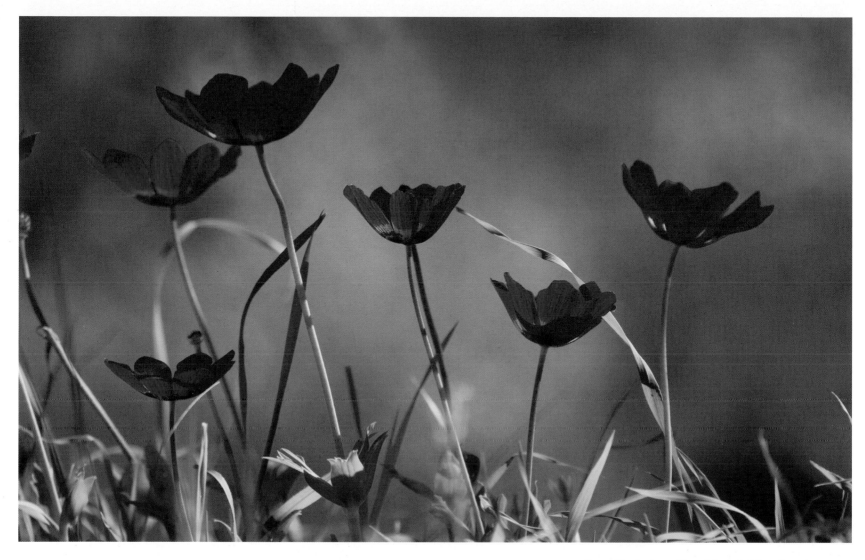

The three painter's primary colors are red, blue, and yellow, which in their own right have great visual impact. They are arranged around the periphery of the color wheel. Between them are the secondary colors, which are made by mixing the adjacent pairs of primary colors. These secondary colors are green, orange, and purple.

Complementary Colors

Pairs of colors lying opposite each other on the wheel are considered "complementary": these pairs are red/green, orange/blue, and yellow/purple. When put together they have an unusual optical effect and appear to "vibrate" more intensely due to quirks of the physiological process. If we look at an intensely colored object for a while and then at a blank card, we tend to see a residue image of that object in a different color.

Similarly, in an image with complementary colors, as we look from one to the other, focusing on one color for a while will increase the perceptibility of the other, so when our attention switches to the other its effect is enhanced. Photographs involving these pairs of colors do indeed often seem to have something extra. Perhaps this is also because the contrast of cool and warm colors in a scene seems to create the balance the eye seeks.

Above: The juxtaposition of these bright red anemones against the grass and muted green background creates a pleasing image.

Harmonious Colors

"Harmonious" colors are those that are related in hue (so are adjacent to each other on the color wheel). Their harmony comes from their similarity. When put together these have a less bold effect than complementary colors, but can be appealing and easier to tolerate for longer (useful for prints that are destined for long-term display on the walls of your home). So, yellow, green, and blue may work well together in this way, or pink, orange, and yellow. The concept of "autumn/fall" colors falls into this category.

Muted Colors

Finally, "pastel" colors are muted versions of the primaries and secondaries. Emotionally, they tend to be pleasing and have a quieter impact and again, therefore, are easier to live with. Thus a landscape photographer aiming to produce images to sell to the public at art fairs may benefit from bearing this in mind when capturing and processing images.

Above: After the sun has set colors become more muted, producing appealing pastel hues as in this dusk image of Santorini.

COLOR BY NUMBERS

Different colors also have different "brightness." Johann Wolfgang von Goethe, a German poet and playwright, ascribed numbers to each color to reflect this difference: yellow is nine, orange is eight, red and green are six, blue is four, and violet is three. Accordingly, when combining colors, one can balance the colors in relation to these values for a pleasing outcome. Classic color theory suggests combining the colors by using them to fill percentages of the picture space in inverse proportion to their relative brightness values. For example, if you are combining red (a value of six according to Goethe) and green (also six), you could allocate half the picture area to each of them to create a balance. However, for yellow (nine) and violet (three) you would need to use a proportion of 1:3 (with violet occupying the majority of the image) to create a balance. Again, this is worth bearing in mind when you are thinking about the proportions of different colors to include in a composition.

Digital photography gives us great scope to control the appearance of colors in our images and to adjust the balance to further support our intentions. Do we wish to conform or challenge? Do we want harmony or more active energy? Do we want to encourage a particular emotional response in the viewer? Depending on our intention we can adjust the image accordingly.

Left: The muted quality of the greens and blues in this image fits nicely with the story of an ancient tractor being put into retirement and nature slowly reclaiming it. Photo by Mark Shuttleworth.

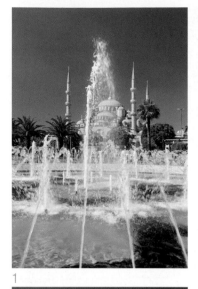
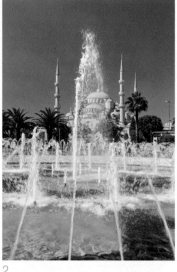
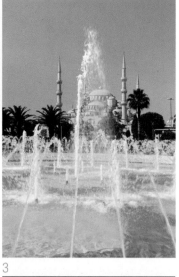

1

2

3

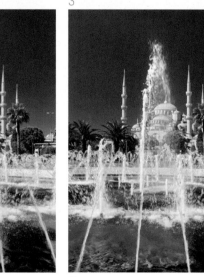

4

5

6

Left: This series of images of the Sultanahmet Mosque in Istanbul illustrates how the use of colored filters in black-and-white photography can impact your composition.

1 The original image was shot using a polarizing filter, which has already darkened the sky to help the minarets and water droplets stand out. It has also reduced the glare on the water, enhancing the blues in the fountain.

2 The second image is simply a monochrome conversion.

3 The third image has a blue filter added in Nik Software's Silver Efex Pro.

4 The fourth image is with a green filter.

5 The fifth image had a yellow filter added.

6 Finally, my preferred shot was achieved with the addition of a red filter. This has really darkened the blues, both in the sky and fountain, which makes the streams of water stand out. The lines of these streams are essential to the composition, leading to the mosque. It has worked a little better than the yellow-filtered one in this regard, as it has also reduced the difference between the dark and light blues in the pool that were a potential distraction.

Right: Some subject matter really seems cut out for a black-and-white rendition, as with the patterns on this group of zebras.

Black-and-White Images

It is interesting to consider at this juncture if there are compositional considerations of particular relevance to black-and-white photography. Black-and-white photography generally accepts a less literal interpretation of "reality" than color photography, but can provide more expression through the modulation of tones to define texture, shape, and form. Underpinning consistent success in the production of this type of imagery is an ability to previsualize how a color world will appear when rendered in monochrome. This undoubtedly comes largely from experience.

An appreciation of the range of tones in a scene and the balance of these tones becomes particularly important in producing a balanced composition with impact. As an illustration of the importance of learning to see in terms of the tones rather than colors, imagine the following scenario:

A series of elements of similar shape in a color photograph do not appear to relate to each other because their colors differ radically. However, if the image is converted to monochrome they may become the same tone. Provided their shape and

tone are close enough to trigger an association based on their similarity, they can become grouped together in our perceptions. This can, of course, work both ways with similarities based largely on color being more apparent in the color versions.

A related precautionary note when shooting in black and white is the importance of being on the lookout for "tonal mergers." This is when separate elements appear to merge with one another in a way that is detrimental to the composition because their tones—when converted to shades of gray—are very

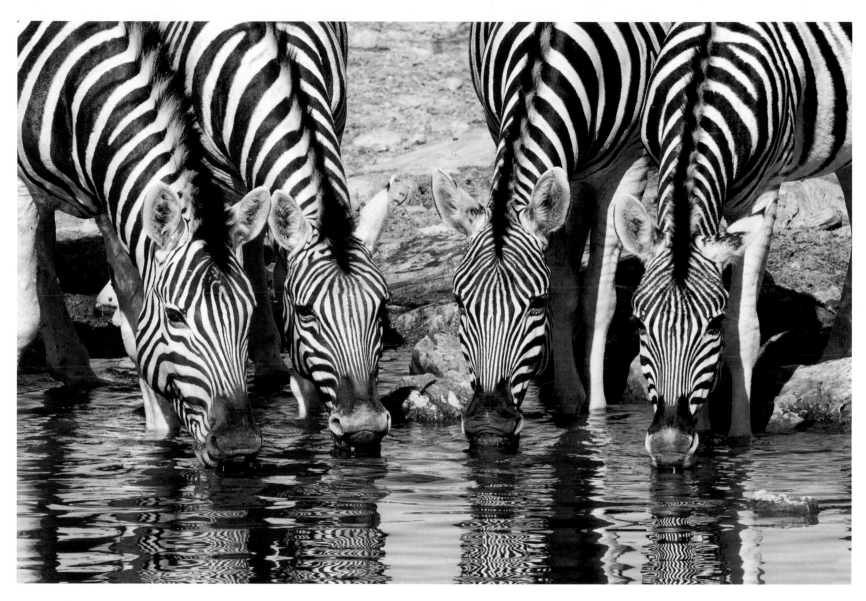

Dodging & Burning

similar. When viewed in color, this similarity can easily be overlooked as they differ sufficiently in color.

As already noted, in black-and-white photography color filters can be very potent tools, and experience in their use will enable more accurate prediction of their effect on the resulting image. Using digital postproduction software the photographer now has great scope to manipulate the tone at which any hue will be rendered in the black-and-white image, so these filter effects can be simulated with great subtlety.

Removing the influence of color will often simplify a picture and put more focus and attention onto simple shapes, lines, and patterns in the image. This in itself can mean that it's even more important that they are arranged well for the image to succeed. The processes of "dodging" and "burning" can be used to exaggerate differences in tone and to draw attention to features, and balance tone and "weight" within the image plane. This can, of course, also be done with color imagery, but seems particularly potent in black and white, where the tones are everything.

We can, of course, go on to reintroduce color in a subtle and controlled way through the processes of toning, split-toning, or even "color-popping" (coloring) where color from the original file is reintroduced to parts of the now black-and-white image. These are all useful forms of expression for conveying your message or reflecting a mood and in use will depend on your intentions in a given situation.

Chapter 5
Applying the Theory

We've covered a lot of theory at this stage and you are likely to be wondering what you can do with it all in practical terms. So, in this chapter I will try to summarize what has been covered and include some ideas and further examples of how you might apply the various concepts. I also include some checklists and simple guidelines that will hopefully help in your experimentation. Before we embark on this, however, let us return to the fundamentally important issue of the driving force behind our photography.

Right: A key element in this view is the distant cloud formation. In many ways it mimics the shape of the granite rock outcrops with its towering, rounded stacks. This furthers a sense of relationship between the key elements.

Intent & Mindset

Firstly, I'd like to further stress the importance of sitting back and considering what we as individuals are trying to do with our photography. Unless we have some understanding of this, it will be difficult to consciously use the compositional tools available to us to aid this process. If the intention is to produce "pleasing" images, their composition will also need to exhibit good visual design and balance. Alternatively, you might be looking to challenge the audience more and compose images with this in mind, deliberately placing elements away from the positions suggested by the Rule of Thirds, the Golden Mean, or any other related principles.

Here we might ask a few questions of ourselves. Are we aiming to sell our images? If so, through what means? Is our photography just a hobby, and if so, what do we hope to gain from it? Do we want others to see our photos? Unless we are involved in "Zen Photography," we are likely to be hoping that others see the resulting images in addition to ourselves. If

Left: This image of a martial eagle conforms to the "rules." The bird's head and neck are more or less positioned according to the Rule of Thirds. The line through the neck and right leg more or less aligns with a line produced by the process of rabatment of the rectangle of the picture space. Space is allowed for the gaze of the eagle, and the image has a satisfying balance in terms of visual weight.

Right: A simple, "pleasing" atmospheric landscape image. The two sides of the gorge are balanced and the diagonal line of the riverbed leads the eye from the dark to a lighter distant zone of the image.

Left: Apart from the positioning of the bell-tower, there is not much in this image that conforms to the "rules." The gate forms a definite barrier statement, but not one that is sufficient to hinder the passage of the eye into the scene. Perhaps this is why to me, as the person who took it, it still works: it was intended as a photograph partly about the decorative quality of this gate and its attempt at being a barrier despite its small size.

so, who forms the proposed audience, and how do we want them to react?

Spend some time considering your intentions regarding the message to be conveyed. Do this in relation to your photographic journey in general, and also in relation to each individual photo. Usually the intended message will depend partly on what presents itself to us, but it can also be the driving force behind what we go out looking for to photograph.

Developing Creativity

For most of us, our photography is multifaceted and this is probably a good thing. Even a professional would do well to balance their quest for saleable images with some time focusing on taking images to develop their own creativity. Some experimentation without concerns about the image conforming to commercial constraints and, perhaps more importantly, having some fun is crucial for our continued success and development as photographers. If we are not enjoying our work and there is no passion, this will show as blandness in our imagery.

What is going on within us will, whether we like it or not, be expressed in some way in our photographs. If we accept that great photos generally invoke an emotional response in the viewer, we can surely conclude that it helps if the photographer is emotionally connected in some way to the subject matter and the situation in which it is found. The emotive aspect of ourselves that we express in our photographs is bound to manifest more readily if we

are photographing for reasons of passion rather than duty. As a result, much of our best work will probably arise when we are being true to our vision in the broader sense of the word.

Mixed Genres

Dabbling with other genres of photography from time to time can prove to be a useful learning tool and serve to improve our skills in our normal field of interest. Those involved in reportage or street photography, for example, may claim that their photography is more reactive. Here anticipation is indeed particularly important, as the images need to be made in split seconds. However, indulging in some landscape, architectural, or still-life work, where there is more scope for exploration and experimentation may help these photographers in the development of skills, which if they become sufficiently ingrained, can then automatically or intuitively be applied during those split-second opportunities in their main work.

Vision and style are terms used a lot in photography and indeed in art in general. Vision in this context is more than our way of physically seeing the world. It is also about the extension of our sight through the imagination. It reflects our ability to picture in advance a finished image that can then be realized through our skills. This visualization is, therefore, an integral part of the process. It is important that we ensure that we pre-visualize an image that is a truthful and honest expression of the subject matter's impact upon us and that we also make attempts to get in touch with whom we really are and what we really want to express. To facilitate

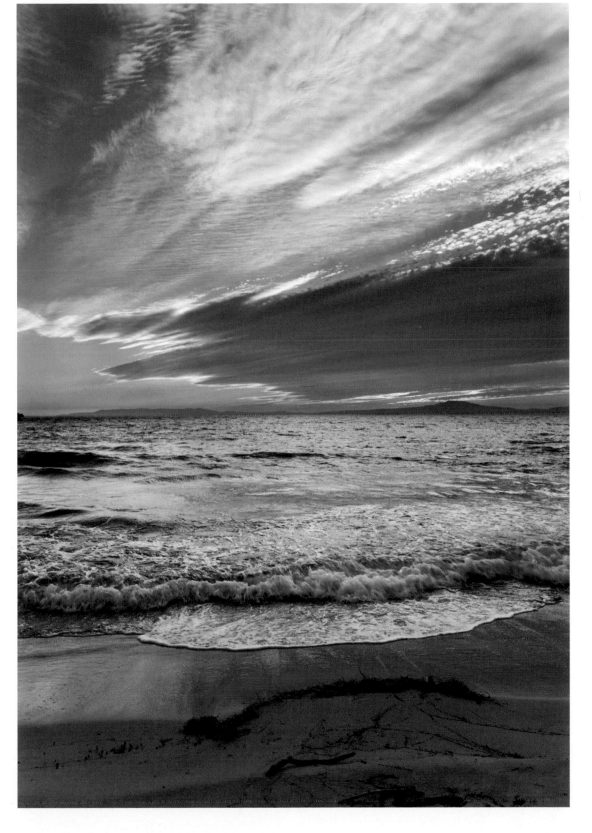

Right: Another nonconformist. The horizon splits the image across its center and the cloud streaks risk leading your eye out of frame to the left, but perhaps it works precisely for this reason. The weather and the sea appear unsettled and a little oppressive—the calm before the storm?

this we need to be present and "open" to fully experiencing our surroundings.

If you're a nature photographer, it can be helpful to spend time really immersing yourself in the natural environment in which you find yourself before even thinking about getting your camera out of your backpack. Roll on the ground, crawl on your belly, breathe in and enjoy the scents and sounds. Spend time watching the activities of the creatures around you as they go about their lives. Then your pictures will have something interesting to say.

Vision can be considered in relation to both the short and longer term. In the short term it is related to the moment; it is our vision for a particular photo or a particular photo shoot. In the longer term it can be viewed as our vision in general; it is related to where our photography is going and the statements we wish to make. Our vision is a reflection of our conditioning, perceptions, and emotional responses to events in the outside world, so is a product of our inner and outer worlds interacting.

Conveying Emotion

It is worthwhile pausing to consider your "vision" in the light of this. Is there a philosophy or viewpoint that you are hoping to support through your images? If so, what is the emotion that is evoked when you ponder the issues? This emotion will be conveyed in your images, and this may not necessarily be helpful to the cause. For example, you may be angry about some political injustice, but reflecting this anger in your journalistic images may not be inviting for the viewer to dwell on the wider issues.

Our style is how others might describe facets of our work and will relate to our vision amongst other things. Neither vision nor style is fixed—they evolve and to some degree are interrelated. We tend to develop a unique style and expression in time, and perhaps much of the process of our maturation as photographers is learning to express ourselves more effectively. In contrast to our "vision," perhaps we shouldn't get too fixated on trying to define "our style" so that we avoid the risk of coming to identify

HERE'S MY ATTEMPT TO DEFINE MY DRIVING FORCE:

"As is probably the case for many wildlife photographers, I am instilled with a deep passion and reverence for the natural world generated by the sense of wonder I feel when immersing myself in it. I respect and try to see wisdom and beauty in all the processes of nature—even those that at first sight might appear harsh and cruel. I feel an empathy particularly with suffering or threatened animals and especially those suffering impotently at the hands of humans. If I had to define what it is I want to say, it is best expressed in terms of wanting to open the eyes of others to the beauty around us and to draw attention to the plight of the natural world, particularly in relation to our human excesses. I would also want to inspire others to get out there, and witness and rejoice in the spectacle of the natural world and not to see ourselves as above or apart from it. Although I would hope that my photos communicate this beauty and design inherent in nature, I would also expect them to express some of the sadness I feel for what we have already done.

Above & Above Right: Two images that perhaps express some of the sadness I sometimes feel.

"I feel it is quite a privilege to be staring down a long lens at an animal. I often truly feel part of what is going on, almost getting lost in their world. It focuses my attention and I forget about 'my world.' In a sense, it is a rather meditative experience. I feel very present to what is going on. My heart races as I get excited from the sense of a perceived relationship with the animals—I see the emotions expressed in the eyes of the animals and follow their exchanges and interactions. To some degree, for me it is a process that reinforces itself. Viewing the world through the photographer's eye actually helps me further to become aware of the beauty and harmony that surrounds me. Things I'd previously have walked by now shout out to me, grabbing my attention. My wife shrugs it all off with, 'Oh…Richard's in the zone again.'"

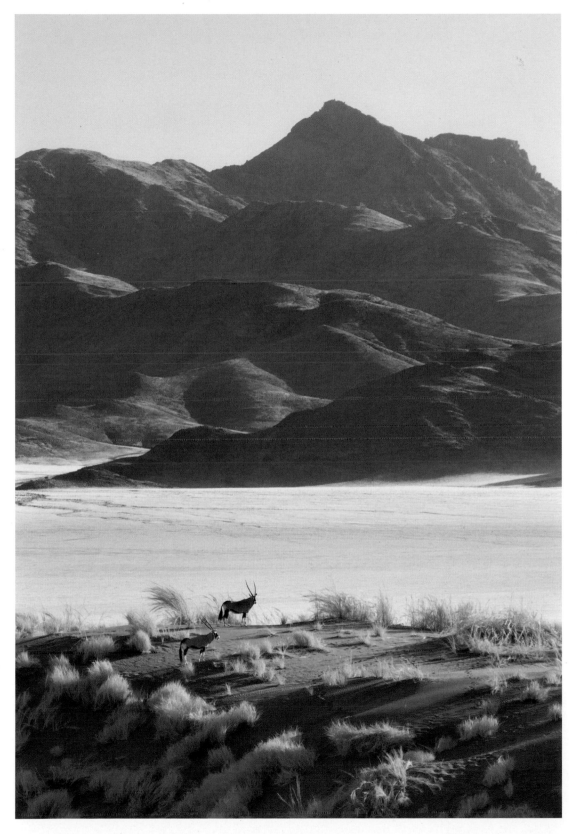

Left & Above: A special moment for me on one of my safaris. I had been hoping to capture some images of gemsbok in this dramatic scenery in Namibia and was visualizing this type of image. We spotted these two individuals coursing toward this sand dune and positioned ourselves in line with where they appeared to be heading. I set up my camera and long lens on a tripod, composed the shot, and waited fingers crossed. Fortunately, they had read the script and even stopped to pose on the crest of the dune in accordance with my vision for the shot! Interestingly, as you can see, they are precisely positioned on one of the lines drawn according to the Diagonal Method.

with it and becoming attached to it. Style should also remain free to evolve.

If there are commercial considerations, you may have to ask if there are any specific markets that the images should be designed to appeal to. The market place is constantly changing and evolving. It is interesting to look at what images are prevalent in the media at any one time and to contemplate why they are so popular. I once read an interesting article discussing the idea that our interest and

focus seem to be drawn to "edges," whether they be edges in terms of actual space or light, or in terms of constructs, such as the spectrums of dimensions or age of subjects.

Take a pride of lions, for example. Photographs of the biggest and smallest—the dominant male and the cubs—are likely to attract the most interest. Similarly, most photographs of people with wide appeal are of the most beautiful, the ugliest, babies, or the elderly—all at the edges or "extremes" of the spectrums. In terms of light, the edges manifest as the extremes of light—dusk, dawn, storms, and shafts of light. The edges of space and terrain tend to appeal more to the landscape photographer— where sea meets land, where rocks meet vegetation, the biggest mountains, the flattest plains, and so on. The edges or extremes of emotional expression also make for good photographs—a mother gazing

into the eyes of her newborn, mourners gathered around an open coffin, or the struggle for life as a wildebeest is pulled down by a pack of wild dogs. Knowing what we know now, perhaps we should be considering how we can use our compositional skills to emphasize the "edge" characteristics of this sort of subject matter.

A Different Approach

In this technological era we are surrounded almost constantly by photographic imagery, so if we want our images to stand out from the crowd they often have to be unique in some way. Consequently there is a strong pressure imposed on photographers for originality in their imagery. Beware though, as there is an obvious danger here if the photographer simply tries to be different for its own sake. Simply being different doesn't make an image good. Invariably, we

Above: If you're after a "cute" face, they don't come much cuter than this—a palmato desert gecko. Getting down very low so that the gecko appears to be peering over a ridge of sand helps draw attention to the face and also bestows upon it a sense of curiosity and inquisitiveness.

will end up putting our own stamp onto our images anyway as we develop our personal vision and style, which will give them some degree of uniqueness in itself. To close this brief discourse on the role of the mindset, remember that to free our creative juices we need to remove the filters that a stressed, distracted mind would impose on our work and develop an ability to focus intently on what we are doing, and to be totally calm and present as we go about it. Take time to get "into the zone." Engage the subject with a sense of awe and wonder, opening up all your senses to relish the experience.

Above: Another example of subject matter at an "edge." Sadly, due to poaching for ivory, elephants with tusks this long are no longer found in many parts of Africa.

TIP

HERE ARE A FEW MORE TIPS THAT MAY HELP IN THIS REGARD:
- Photo shoots rarely turn out as you expect or intend. So, be open to all eventualities and possibilities, and don't get too focused on one anticipated outcome.
- Retain a measure of flexibility in your approach to enable you to get the best out of every moment, particularly when you're working with others and are not in complete control.
- Don't lose your enjoyment. If you don't get too attached to outcomes, you're not going to open yourself up to disappointments. Closing off to one opportunity opens you to the possibility of encountering another.
- Encourage an awareness of, and consideration for, others involved in the process. Keep a sense of humor and, if necessary, respect and compassion for your subjects in particular.

Using the Principles & Guidelines

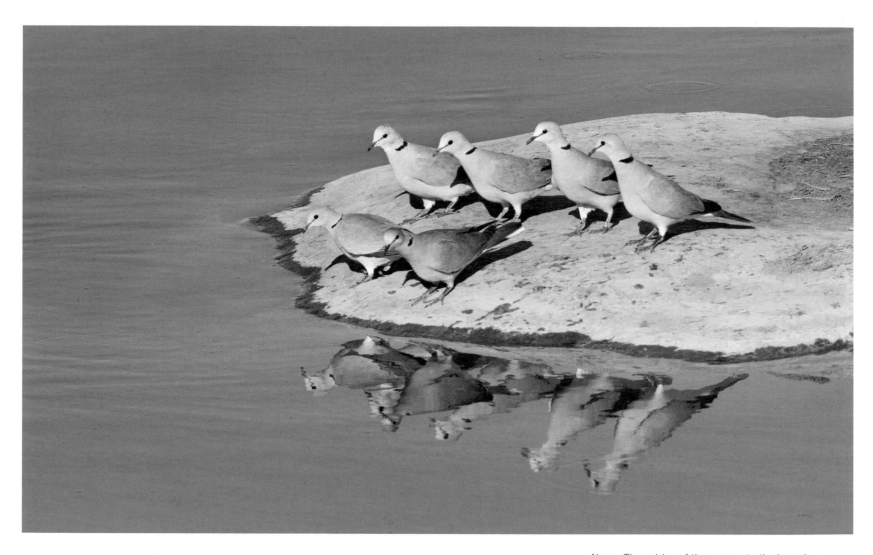

As Ansel Adams said, "There are always two people in every picture: the photographer and the viewer." So, having contemplated our input to the image-making process we can consider the viewer and the psychological processes that can occur when a picture is viewed.

We might also do well to temper our expectations with regard to the effect of our images, by acknowledging that all viewers are different and not all are likely to react in the same way. As viewers we all bring different agendas and life experiences to the table. If the camera is looking both ways— out into the world and back into the soul of the photographer—then perhaps the final image is also taking a peek into the soul of the viewer. We should embrace this chaotic and ambiguous part of our work, because it adds to the fascination and further serves to make it more of an art form than a precisely controlled science.

Above: The pairing of these cape turtle doves is immediately perceived by the viewer, along with the pattern formed by their reflections. It's as if they are coming in two-by-two to stare at their reflections. It isn't just a picture of six birds.

Planning & Composition

Let's now review some of the Gestalt principles and consider how we might incorporate them into the "seeing," planning, and composition of an image.

Firstly, we saw that while each of the individual parts of a picture has meaning of its own, that meaning may change when the elements are taken together. How the different elements in a scene are positioned within an image can therefore influence the whole meaning of the image, so we need to think about their relationship within the composition.

Those of us who enjoy landscape photography soon come to realize the importance of the sky in our compositions. Skies reflect weather, which undoubtedly affects our emotions, and many beautiful scenes derive much of their appeal from what is going on in the sky and a clever photographer will retain this crucial component using one or more ploys: gradient filters will help balance the exposure

Above: The wispy cirrus clouds form curves and lines, helping draw attention to the main point of interest—the terraced rock formations in this arid Namibian landscape. Conversion to monochrome and the application of a red filter has helped emphasize the cloud's contribution, while allocating a large portion of the frame to the sky helps convey a sense of open space.

of sky and land; a polarizing filter may help the clouds stand out from the blue sky, making them more active in the composition; elements within the sky and land portions of the scene will be carefully balanced in terms of visual weight; lines and shapes formed by cloud formations will be made use of if appropriate.

Connecting Elements

Indeed, the sky and land are in effect two elements in the image and the photographer will often try to make the two appear to be in close relationship with one another. Color, lines, and visual balance can all be used to connect elements within these two broader zones of

the image to assist this perception of relationship.

We went on to briefly consider the importance of the amount of space you leave around the subject matter and how it can affect the way in which the subject is perceived. When you are composing your next picture, ask yourself how you want the subject to feel—free or cramped? Then experiment with allowing more or less space around a subject to support this.

Creating Separation

With regard to the six Gestalt principles, we explored the relationship between "figure" and "ground," and how the figure can be separated from the ground using

Above & Top: In this Dartmoor scene, I wanted to link the landscape to the dramatic cumulonimbus cloud formation in the distance: the gaze of the dog and the lines in the foreground tor provide this connection.

contrast, sharpness, color, size, and so on. Depth of field and the lighting direction and quality can influence this, and we may also use filters, supplementary lighting, and digital processing to augment it.

Looking for Similarities

The principle of "similarity" describes our tendency to see objects that share similar visual characteristics as belonging together. We can use this actively when we look for shapes, repetitions, and patterns in our surroundings, which can often be used to produce pleasing images. We might also use it to create a humorous image in which two objects that we know to be different are perceived as being almost the same on account of some of their attributes. Furthermore we might be able to employ this principle to convey a concept or to strongly express a message.

Above: The similar postures of the conductor and violinist in this picture are a great asset. Together with their proximity it supports the fact that they belong together and are working together, even though they are not looking at each other and are otherwise fully engaged in what they are doing. The dark, clean background also creates a good figure/ground separation focusing our attention on the postures of the two figures. Photo by Mark Shuttleworth.

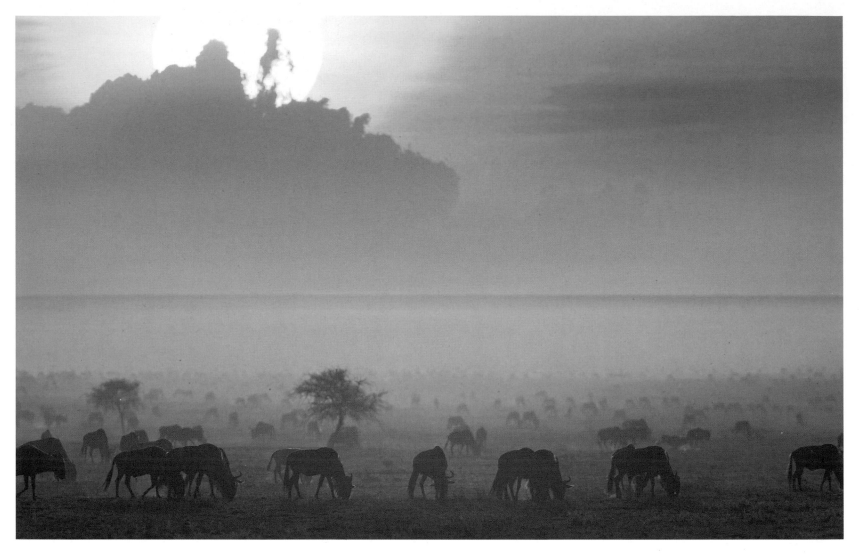

A Sense of Belonging

Knowing about "proximity" (that objects/shapes close to each other create a sense of belonging together) also allows us to look for false illusions that grouped elements might give regarding being related when they are not. Alternatively we can look for objects close together forming a composite shape: the shape formed by a dense flock of birds might be perceived as a rather sinister hand in the heavens, for example.

Seeking Closure

The next principle, "closure," regards our tendency to "fill in the gaps." This is triggered by a suggestion of a visual connection or continuity between sets of elements that don't actually touch. To activate this in the viewer we might look for imaginary lines (vectors), or shapes (counter forms) that have a message or story to offer. Look at how negative space can be used in this regard and how it can contribute to the harmony of the picture or support the elements within it.

Continuity

"Continuity"—our tendency to continue strongly defined and directed contours and shapes—is a concept we employ when we use lines that are broken or interrupted to lead the eye to a point

Above: The similarity of shape and tone of these dark shapes on the Serengeti Plain enables us to identify them all as being wildebeest. This helps draw attention to their sheer numbers.

of interest in the image. Again, we might become more ambitious and use this principle to create a photograph that challenges our perceptions or creates a clever illusion.

Symmetry and Order

Finally, how might the principle of "symmetry and order" influence our photography? To start with, we need to acknowledge that anyone viewing our pictures will have a tendency to try to create symmetry and order in them. Then we can take care to ensure that the viewer's energy is not diverted by trying to balance or bring order to an unbalanced or messy composition—unless that is our intention, of course!

A Question of Weight

The concept of visual weight comes in here, in relation to our quest for balance and order. Consider the relative weights of the elements in your image (taking into account their size, tone, color, and position in the frame, their "interest" and so on) and how positioning them differently might create a better sense of balance in the image as a whole. We could also consider creating an additional or alternative center of gravity off-center in the picture plane that could generate perceived forces and "pulls" on nearby elements. If relevant to what we see to be going on in that part of the image this can impart extra energy to that area. Consider what might be used

Above: The weight of this image of Cornwall's Land's End would normally be heavily to the right, but the inclusion of the sun and a little extra negative space formed by the water at the left helps lead to a balanced result.

to define such a fulcrum and how its position could be precisely defined—a "point" (a particularly small object or shape) may be the answer.

Perceptual Ambiguity

As we get more ambitious, we might even put some of this together to create a "clever picture" that depends on perceptual ambiguity or "equivocation" (its potential for being viewed in two or more ways). We might look for or set up the picture that tells a story due to the phenomenon of "continuance"— where the arrangement of similar elements makes the viewer construct a sequence in their own minds. "Humor" images often rely on contrasting two ideas within an image, creating ambiguity or what appears to be an absurd juxtaposition. Another strategy is to make use of the fact that a photograph freezes time. This gives you the option of setting things up to suggest that something could or does happen, even if it doesn't.

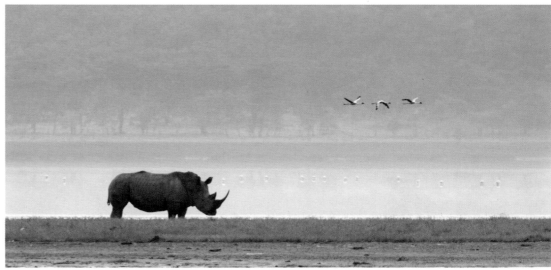

Above & Top: This white rhinoceros on the shore of Lake Nakuru is balanced by the three flamingoes flying toward it (top). The fact that the flamingoes are flying toward the rhino is important as it supports this relationship between these two elements. I have reversed the flamingoes to show how it would appear otherwise (above).

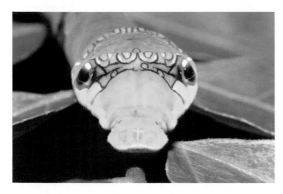

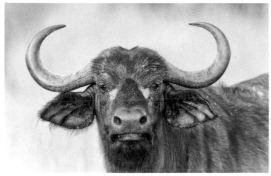

Above & Top: Precisely centering your subject will give you little scope for playing with relationships to other elements in the image. However, this can actually be the strength of the image, particularly in portraits. The viewer can't avoid studying closely the details of the face—as in the case of these face-markings on the rear of a caterpillar in Borneo (top) and this conventional portrait of a buffalo in Kenya (above).

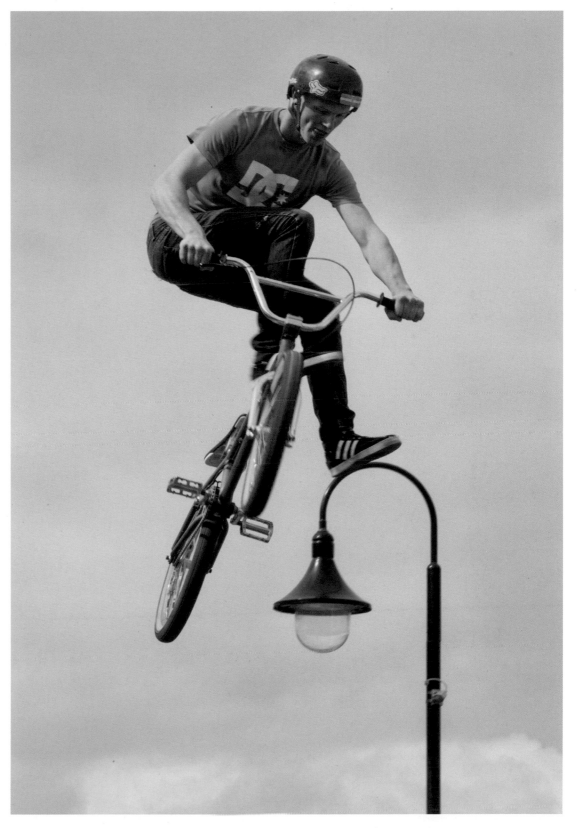

Right: In this case, the precise juxtaposition of near and distant objects creates the illusion of a remarkable balancing act. Photo by Mark Shuttleworth.

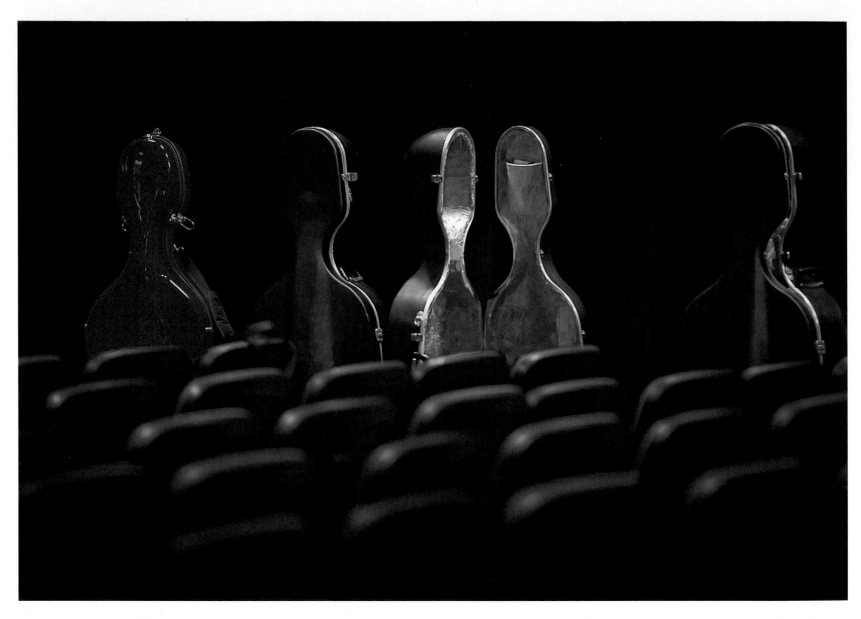

Directing the Eye

Moving on to the other facets of composition, we have discussed how important it is to be aware of the potential course the viewer's eye will take through the image. Do you want to make it easy for them and to direct their eye to a particular point? Do you want it to go there quickly or slowly?

Maybe look for a starting point; something that will draw the viewer's attention straight to it, but not so strongly that their eye can't leave it. Often, this entry point can consist of some foreground interest as this also serves to convey the relationship between the photographer and the scene—it firmly places you in the image as a viewer. Choose something interesting, simple, attractive, and if possible relevant to the scene, but don't let it dominate the shot.

Ponder whether a portrait or landscape orientation can be best used to encompass the journey required of their eye, and consider how any lines could be used to draw the viewer's eye to elements of interest. You might compose your shot so that the main point

Above: There's a clever use of our perception of shape in this image entitled "Audience participation." In the context of the rows of seats, these instrument cases are readily seen as head-and-shoulder outlines. Photo by Mark Shuttleworth.

of interest is at the right, as there is some evidence that positioning the subject toward the right may engage the viewer for longer.

Take care that your composition doesn't send their eye out of the frame too readily or draw their attention to the edge or frame itself. Look for elements too close or just touching or being clipped by the edges of the frame. Also keep an eye out for things that can be used to stop the eye from leaving the frame—at the end of a strong diagonal for instance. Also be on the lookout for elements that could take the viewer's attention to a corner from where there may be no escape.

"Compositional movement" is a term used when eye movement is changed and redirected by elements of the composition. There are many ways in which this can occur, including the use of strong lines. However, as Robert Henri, artist and teacher, stated: "The eye should not be led to where there is nothing to see."

Right: The steps in this photograph form a strong diagonal and lead the eye rapidly toward the top. The eye is then arrested and held on the little boy wearing red (red being a powerful color) and prevented from continuing out of the frame. Photo by Mark Shuttleworth.

Left & Above: This picture of the shadow of a bush cricket viewed on the underside of a banana leaf illustrates how the orientation of the cricket seems to influence the direction of movement of our eyes. An optical line is created that unites with the other strong line in the image to form a satisfying inverted "V." In the third image I have rotated the cricket to show that the photograph does not work so well when the insect is facing away from the oblique line (left).

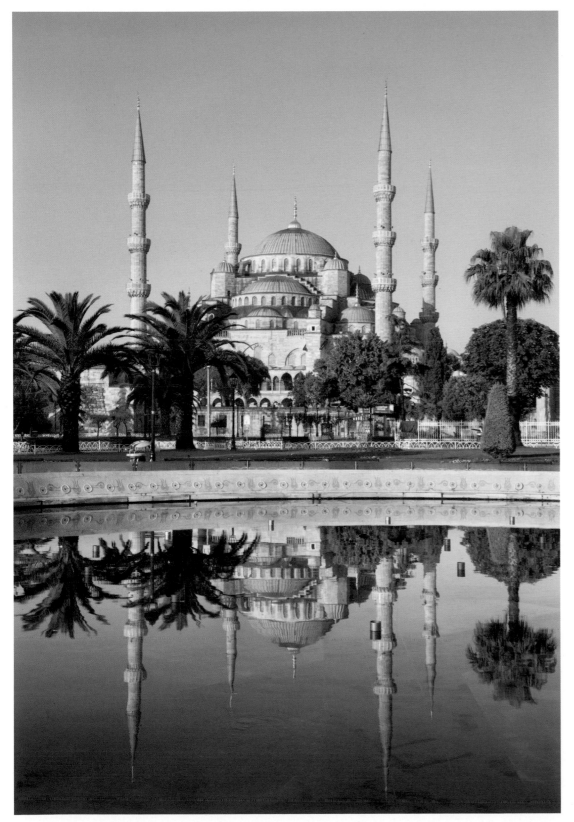

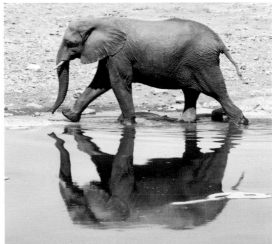

Left & Above: These are two cases where a choice is made to divide the picture space by a horizontal line—in both instances that between the water and land. This serves to emphasize the symmetry between the subject matter and its reflection.

Dividing Lines

When there is the option to include strong lines in a composition (whether they are straight or curved), remember the various connotations of lines running different courses and take time to consider how the orientation or inclination of the line(s) will best suit your intended message or the feeling that you wish to convey. Look at how changing your viewpoint can help the different lines in the scene to work together and support each other in this regard. Also think about how they balance each other in terms of their visual weight and how they will direct the viewer's eye to other elements in the scene. Take care not to allow the lines to divide the image field too effectively—splitting the image into two—unless this is your intention. Remember also that the viewer will be striving to create order and symmetry, so sloping horizons can detract from them seeing what you want them to see.

Emphasizing Shape

Shapes of all types surround us, so take time to look for them and examine them, and consider how you can reveal them to good effect in a photograph. Look also for shapes formed by the spaces between elements or by their shadows—these can be equally potent.

Shapes are, of course, a major part of visual imagery and carry their own connotations in terms of their associations and emotional impact. Reflect on this as you consider including any shapes present in the scene. Think about how the different shapes in the scene work together. Is there a narrative or message they support? Can lighting be used to create the required shapes or to alter, emphasize, or exaggerate existing ones? How else might shapes be emphasized for maximum effect if this is part of the message to be conveyed? Maybe a filter would help?

Above: The distorting effect of wide-angle lenses can be employed to emphasize shapes and influence the perception of their place in their surroundings. Photo by Mark Shuttleworth.

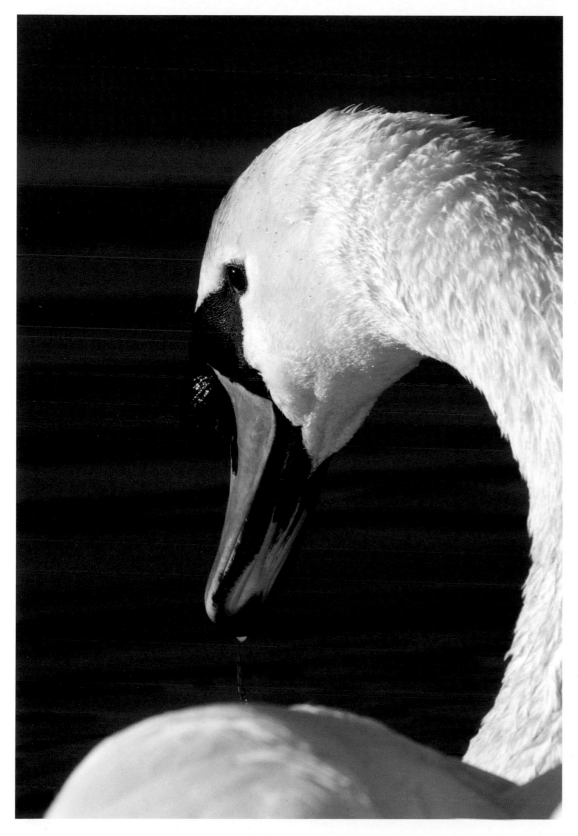

Left: This image relies on its strong shapes, lines, and colors. Ultimately, the point of interest is the eye of the swan, which provides a strong sense of relationship between the subject and the viewer. The sweeping curve of the neck and head supports a sense of what a swan often represents—grace and poise. There is a strong figure/ground distinction due to the light and dark tones of these areas, and the strong horizontal lines of the ripples in the background further emphasize the curve that breaks them. Finally, the strong orange and blue colors work well together, complementing each other.

TIP

MAJOR AND MINOR
The potency of certain images composed according to the "Major-minor Rule" depends on the oscillation of the viewer's eye between two elements. Here a distinct object or shape is repeated in the image, usually with one of them in the background, and often out of focus. It's as if the second shape echoes the first and the two balance each other with the eye tending to switch its focus from one to the other.

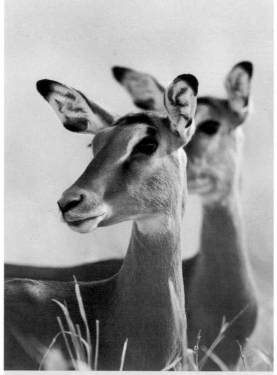

Above: A simple example of the Major-minor Rule involving two impala does in close proximity.

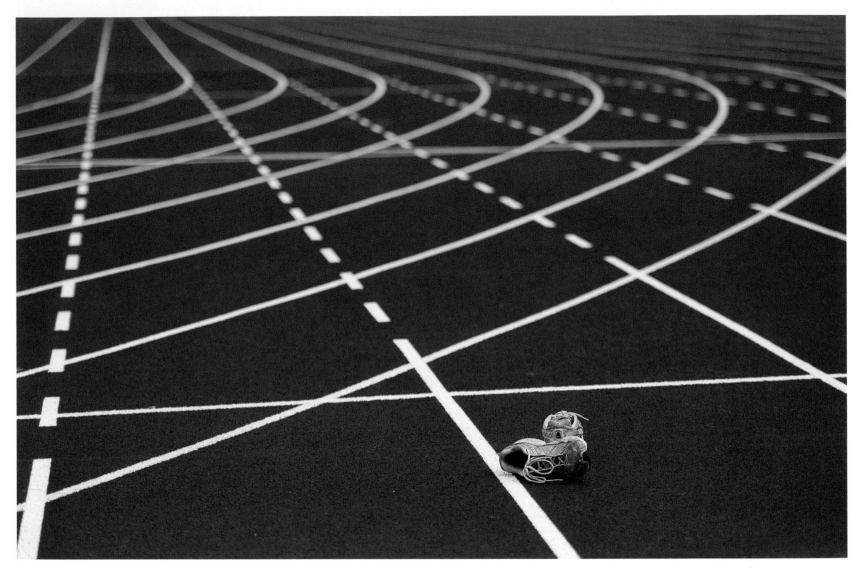

Defining Patterns

Regarding patterns, it's especially important that you're clear in your own mind what you want to say about the pattern. Continuing a pattern up to the edge of the frame will give the viewer the impression that it continues indefinitely beyond, while messages about the relationships between the objects that form the pattern may come from their degree of similarity and proximity, and their orientation and alignment. Examining a pattern can be a monotonous pursuit, so unless there's an interesting message associated, there is the risk of boring the viewer. To allay this risk it's often effective to break the pattern quite

starkly by including something of a different color or shape, but consider carefully where you position this important element: the center probably isn't going to work as the viewer's eye will go straight there, whereas you probably want them to see the pattern first, before they see it has been broken.

Above: The training shoes not only break the pattern here, but also pose some interesting questions. Photo by Mark Shuttleworth.

Right: The light on the wood of this old doorframe makes the frame an important feature in this snapshot of a dog.

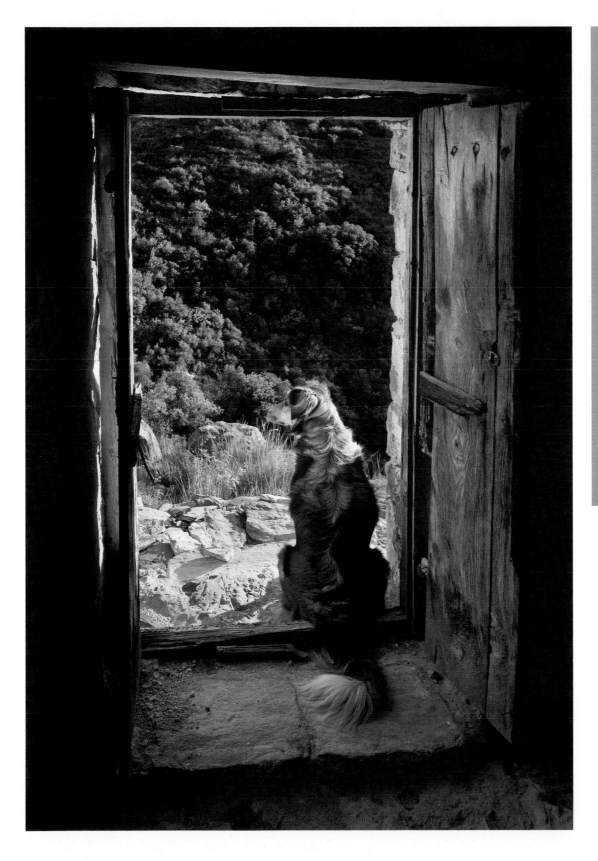

A FRAME WITHIN A FRAME

Can additional elements form a frame to help support your message or focus attention where it is required?

Think about the color, tone, and nature of the intended frame and how it complements the subject matter.

How obvious do you want the frame to be?

How much of the frame do you need to include? Will a partial frame suffice?

How much space do you want to allow around and beyond the frame?

How tightly do you want the subject matter to be framed? Do you want it to appear confined?

What viewpoint will provide the optimal juxtaposition of the frame and subject matter? Be precise.

What focal length do you need to help frame the subject appropriately and to reflect a sense of the distance between it and the frame?

What aperture will provide the required depth of field?

DISPLAYING IMAGES

Although it is perhaps beyond the remit of this book, it can be argued that everything that goes into displaying a photograph can be regarded as an extension of the compositional process. If we take this view, we could extend our consideration to encompass the type of paper it is printed on, the mount, the frame, the surrounding areas of the displayed image (including other images nearby), and the lighting it is viewed under.

The choice of paper you print your image onto can subtly influence the way it is perceived. Glossy papers, for example, can be good for images containing stark contrasts, high saturation, and strong shapes. This is because gloss paper generally offers the richest blacks and maximum tonal range. At the other extreme, matt papers may be appropriate for light (high-key) images and are often more flattering for portraits, for example.

When displaying our images, it is important to be aware that external elements can also act as distractions, leading lines, complementary colors, and so on, just as they do within the picture space itself. So, whether we are exhibiting our photographs in a gallery or simply showing them to friends in a photo book or album, it is worth considering their order, arrangement, and surroundings.

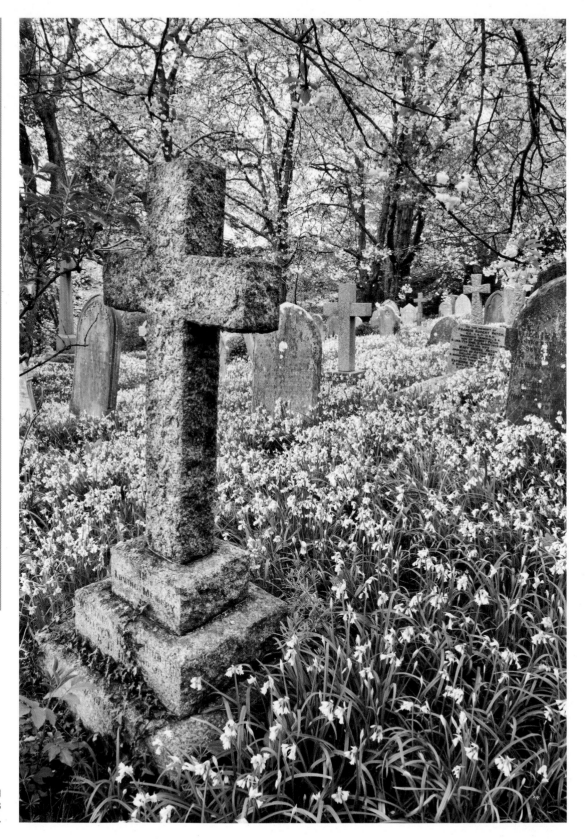

Right: The diminishing size of the crosses and spring flowers into the distance creates a sense of depth in this photograph of a cemetery.

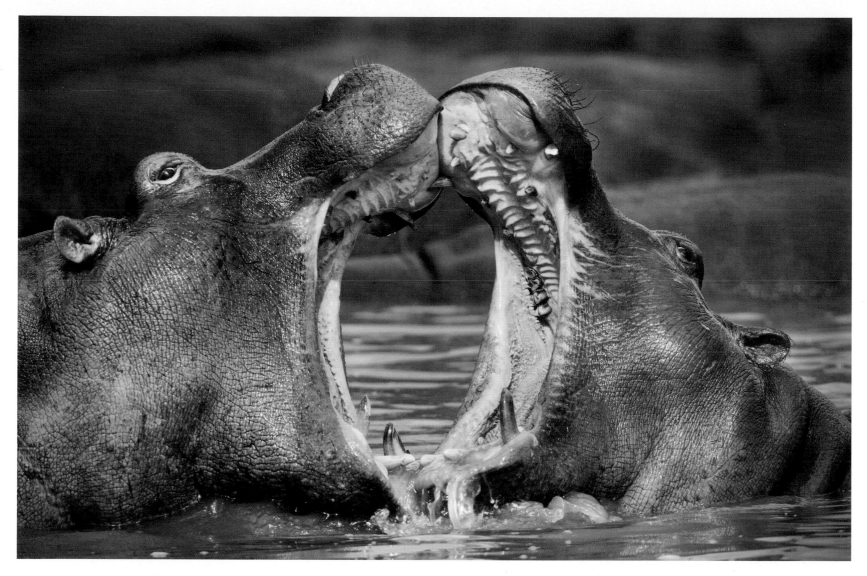

A Question of Depth

We often want to create a sense of depth in our pictures, particularly in landscape images. Many photographers rarely switch to portrait orientation, but this can be a simple and effective ploy here. Bear in mind how the relative scale of elements can be used to support the sense of distance in an image. "Scale constancy" tells us that a tiny car in an image is further away than a large car. Can the phenomena of aerial and linear perspective be used effectively?

Little or Large?

Even at the stage of planning, composing, and capturing our images it is worth bearing in mind the medium in which they are likely to be viewed. As we have seen, if they are likely to be viewed on the small screens of portable devices in tandem with many other images, they may benefit from being relatively simple and stark, and with a message that is quickly perceived. More complex compositions may warrant a larger display in a very different environment.

Above: This type of image would also work well on small screens—the subject matter fills much of the image and is clearly identifiable. The orb formed by the two mouths is centered, providing a simple shape to base the image on. The critical areas are relatively light in tone so the eye is drawn instantly to them. The key emotive element, the eye of the hippo on the left, is also, interestingly, precisely on one of the diagonals suggested by the Diagonal Method.

Further Tips & Tools

Above: A radically different viewpoint has been adopted here in this photo entitled "I don't like ketchup" by Mark Shuttleworth.

Before I offer a couple of simple checklists that might serve as reminders, there is one feature of your camera to check that will have relevance to your compositional decisions in general: does your camera capture exactly what you see through the viewfinder? The viewfinder doesn't always show exactly 100% of the image and you may need to take this into account, particularly with very precise compositions that include elements very close to the edge of the frame.

Even if your viewfinder has 100% coverage it is easy to miss potential problems that are close to the edge of the frame. It's very annoying when you bring up the image on the big screen only to see that a key person in the background has his or her head cut off! Take care at the time of capturing the image, and if you have time, scan the whole frame—including the edges—before releasing the shutter.

Exploring the Scene

Having embarked on your photo shoot, try to spend some time relating to the subject matter or environment to establish and clarify what it is you wish to convey. You can then start to experiment with different perspectives, radically altering the relative sizes and positions of the elements in the scene through a change of position or viewpoint. We all see the world at eye level, so by simply shooting from higher or lower we can create shots with an alternate perspective and new relationships between the pictorial elements. Small changes can make a big difference, but even experiment with the extremes. Pivoting LCD screens on the backs of many cameras mean you don't have to contort yourself to such a degree! Also look at what the environment has to offer to enable you to view your subject matter from different positions.

Above & Right: The roadside view (right) of this old stone tower-house in the southern Peloponnese of Greece suggests nothing very interesting graphically. However, a little exploration on foot and some clambering over rocks revealed a much more interesting perspective from the other side. The resulting image (above) says a lot more about the dramatic foundations of this unusual building. I returned on a less "contrasty" day with a more interesting sky as a backdrop to capture this.

Taking a Viewpoint

Remember that the photographer chooses the viewer's position by selecting the viewpoint and to some degree will influence their perceived relationship to the subject. For example, if we take an image of a small child from below their eye level (so we are looking up at them), this will give the viewer a sense that the child is a relatively dominant character. This is also why pictures looking down on small puppies are so popular: it makes them appear subordinate and vulnerable.

With experience, we undoubtedly get better at predicting what focal length and what positioning of the camera will create the required proportions and relationships of elements in the scene before us. However, much experimentation by exploring scenes whilst actually looking through the viewfinder precedes this. Fine adjustments made with our eyes glued to the viewfinder or studying the "live-view" image on the screen are also essential for the fine-tuning of our compositions. Zoom lenses enable us to readily change focal length as we vary our position to get the optimal composition for what we wish to convey.

Left: This picture was very much a "grab-shot" of this elderly lady on her way to the olive press with her day's pickings. I had to react quickly as she didn't want to hang around, so opted for a high viewpoint and relatively wide-angle to ensure that the subjects were not breaking the horizon with their faces coming up against the bright sky.

Above & Right: In this case my preferred viewpoint came down to what was important—the patch of wild flowers or their location on the edge of this dramatic gorge. The second (right) gives more emphasis to the latter and is, in my mind, the better shot.

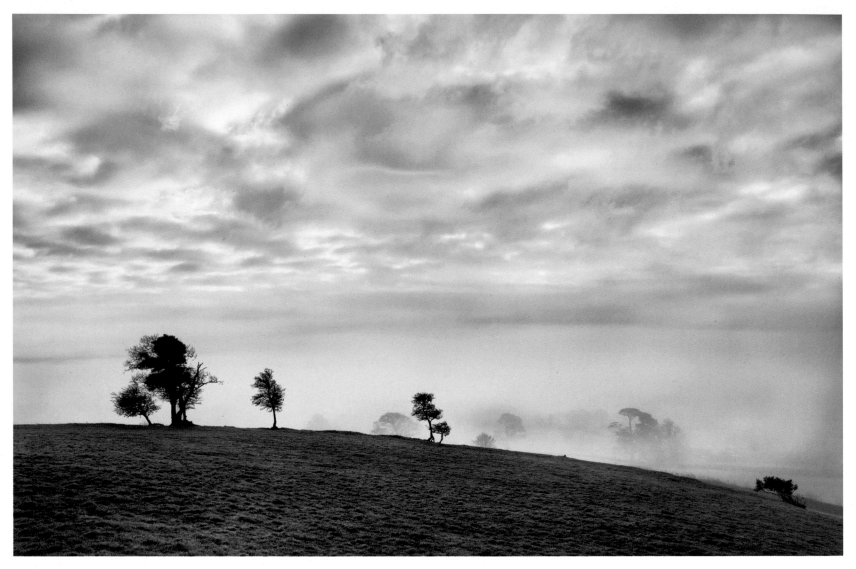

A Sketch Pad as Your Ally

Having explored the scene, you will hopefully have established in your mind's eye an approximation of the image you wish to make. Depending on the genre of photography that you are involved in you may then have the luxury of being able to precisely set this image up: studio and still-life work often gives you more control, whereas documentary, landscape, architectural, and nature photography often mean you are dealing with compromises.

Either way, a sketch pad—whether physical or in your mind's eye—is a very powerful tool at this stage in the process. Very simply, draw the elements and

lines as they are potentially about to appear in the viewfinder. Just a scribble that shows the outlines of the various objects, lines, and shapes will suffice. This will help you to simplify the scene and clarify the shapes of the objects and of the areas between them (the negative spaces). Then quickly consider how you could better balance these and note whether there are any undesired or superfluous elements that you could remove through your choice of focal length or by changing your position or waiting for elements to move a little.

Above & Top: The sketch doesn't have to be a work of art!

Left: Try positioning this duck somewhere suitable on the image.

Below: Hopefully you will have come up with something like this.

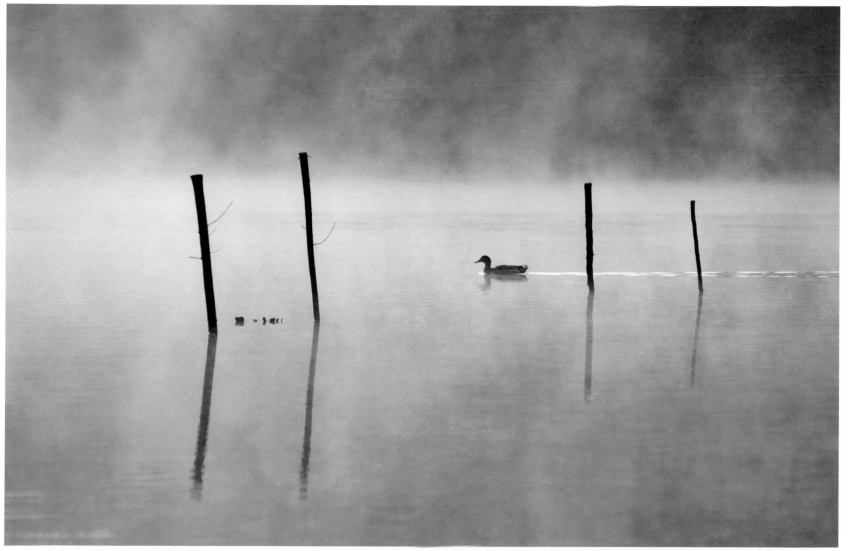

Above: A simple "tranquil" dusk image taken in Zanzibar.

Above left: Very simple, but it says quite a lot. Taking photographs isn't all hard work!

Simplify

Ask yourself if there is any way you can simplify things to clarify your message. The constituent elements of a scene are usually already there, as this is what has drawn you to it in the first place, so it is often a process of subtracting or removing the nonessential or distracting parts. In a good composition, one has the impression that nothing needs to be added and nothing needs to be removed from the picture—it is, in essence, "complete."

When we suggest simplicity in an image, the term needs some qualification. In absolute terms it reflects a quantitative value where a simple image would include fewer elements and fewer relationships as in the drawing of a young child. This does not necessarily make for a fine piece of art. By contrast, when we say that a work of art has "simplicity," it will generally mean that it conveys a wealth of meaning and observation in a very efficient and potent way. So, simplicity in this case is in the context of efficiency and effectiveness in conveying meaning.

Of course, in certain genres of photography you may have the luxury of being able to add elements that weren't initially present to further convey your intended message. Furthermore, this intended message may actually be one of complexity and messiness, in which case you would strive to augment this rather than to simplify it. These images too can take some careful composing to encourage the eye to examine and explore their contents, with their meaning gradually unfolding to the viewer.

SILHOUETTES

Silhouetting our subject matter simplifies an image by removing the detail from the shaded areas that face us. This focuses our attention on the shape and outlines of objects. When considering capturing a silhouette, ask yourself:

- Are the outlines interesting and do the elements form pleasing graphic shapes?
- Is the outline enough, or do you need to see other details to translate your message?
- How can you better clarify the outlines and contours? Do you need to change your viewpoint? For sunsets this often involves getting down lower to reveal the entire subject against the bright sky above the horizon.
- Are there any confusing overlaps that could be avoided by changing your position?

Left: The mist over this lake and the silhouetting of the subject matter obtained by shooting toward the sun both help simplify the image and draw attention to the profile of the heron.

Tips for Increasing Salience

To strongly convey our message we often need to isolate the subject matter and enhance its dominance. "Salience" is an element's level of impact. This can depend on its uniqueness, or it can also be achieved through exaggeration, depiction of scale, and enhanced clarity of contour or degree of contrast with its surroundings. One can go on to rank elements that will appear in an image according to their dominance in this regard, and this can be used constructively in your compositional considerations. For example, the dominant element could then be placed according to the Rule of Thirds, or could be positioned to form a triangle with the sub-dominant and other elements. Here are a few suggestions:

1 One way to focus attention on an isolated subject is to make the subject fill the frame: get closer or use a longer focal length. This is a simple strategy for ensuring that there is nothing else in the picture that could act as a distraction in any way. This portrait of my cat contains just what is necessary and nothing else.

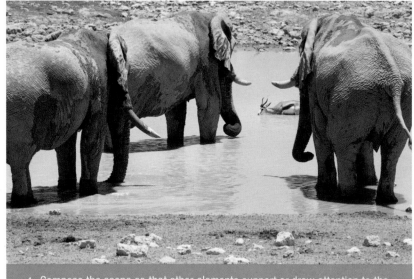

4 Compose the scene so that other elements support or draw attention to the main subject. Look for lines to use to lead you to the point of interest. Here the orientation and gaze of the elephants leads us to the main subject—the springbok cooling off in the water and apparently unconcerned about the elephants' proximity.

5 How might the lighting be modified to further emphasize the figure/ground distinction? Supplementary lighting, particularly spot-lighting, might be appropriate to help focus interest on a lighter subject—expose for the spot-lit area. These white Allium flowers against the dark background provide about as marked a figure/ground contrast as you can get.

2 Consider how you might better isolate the subject from its background by changing your position and angle. Also consider the foreground, particularly if you are shooting from low down. Look for potential distractions, especially lighter elements or strong colors that might draw attention away from the subject.

3 Consider using a wide aperture (smaller f-number) for a shallow depth of field that blurs the background effectively. Can the use of selective/differential focus help draw attention to the subject? Although tilt-and-shift lenses are normally used to enhance depth of field and avoid distortions in architectural shots, they can also be used to create a very narrow band of focus.

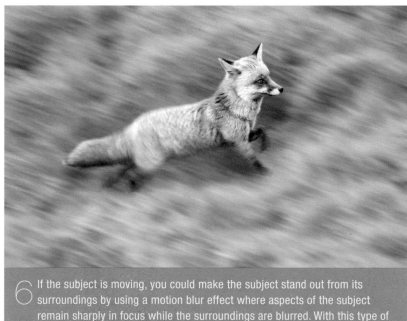

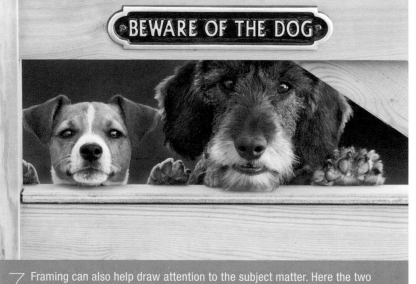

6 If the subject is moving, you could make the subject stand out from its surroundings by using a motion blur effect where aspects of the subject remain sharply in focus while the surroundings are blurred. With this type of "motion blur" shot, it is important to try to retain a degree of sharpness in important features of the subject as with this running fox.

7 Framing can also help draw attention to the subject matter. Here the two appealing subjects are tightly framed by the aperture in the gate. This ensures that no distracting content enters the picture. Importantly, the frame also provides context and completes the message, which is the humorous juxtaposition of these apparently harmless dogs with the sign.

Backgrounds

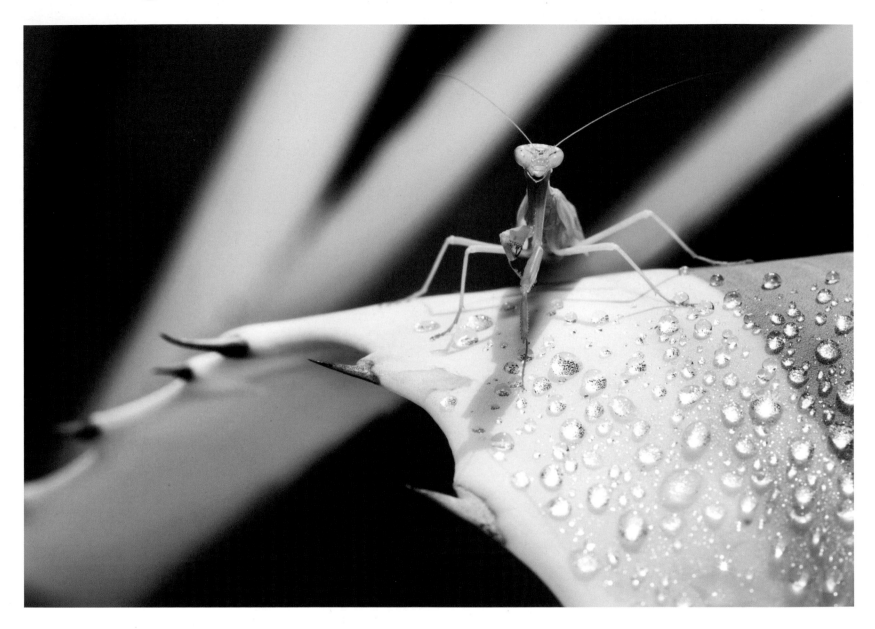

It is worth remembering that the background to a photograph is the stage for the main subject, and in this sense is as important as the subject itself. Even if the background has been blurred completely, so that elements within it are not readily identifiable, the colors and tones within it can still effectively contribute to the composition and hopefully augment the subject matter. Streaks and lines in the background could, for example, help lead the eye toward the intended point of focus.

So, bear in mind that backgrounds need not always be bland and featureless so as not to compete with our subject matter. They can more actively support our compositions. Indeed backgrounds often include ingredients that are an essential part of the story or message portrayed. They may even become the subject matter with nearer elements relegated to the supporting cast.

Left: In many situations a background with these types of strong, light lines would be detrimental, but in this case I feel that they actually enhance the composition. They support the subject matter, partly by framing the mantis, but also by continuing the strong diagonal line from bottom left to top right and by visually balancing the tones in the image.

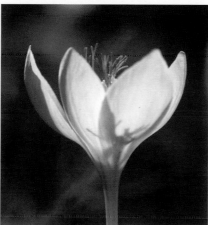

Above & Left: Its inclusion is debatable, but I think retaining the blurred crocus in the background improves this image. The background becomes a more active part of the image and you immediately get a sense of depth and know that it is not a studio shot.

Using Filters

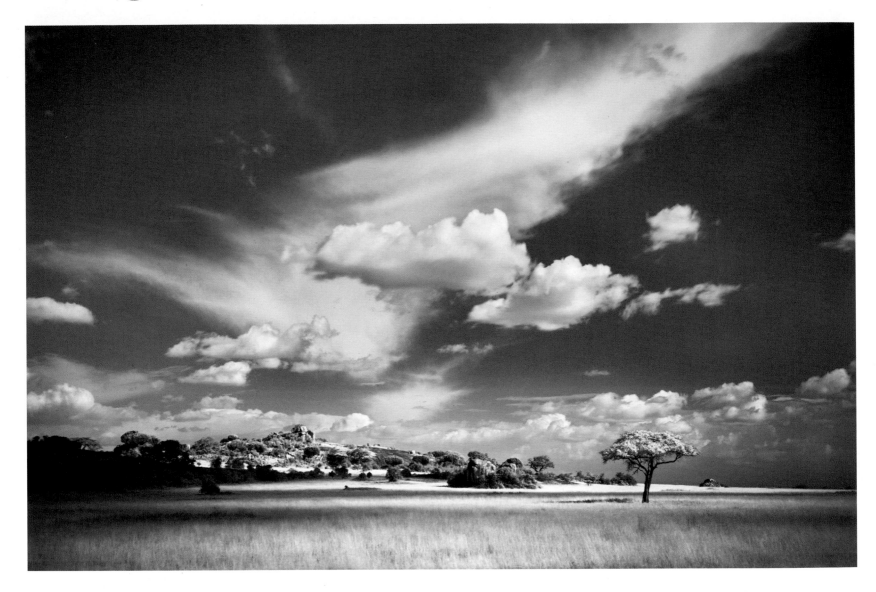

The use of various filters can profoundly affect your composition, so it is worth giving them due consideration at this stage. For example, colored filters in black-and-white photography can dramatically influence the figure/ground separation and make certain elements stand out from their surroundings. With digital photography these filters can be applied at the shooting stage using in-camera filter effects or on the computer

during post-processing. Doing it on the computer is a good way to learn how these filters affect the image, as you can undo and redo the effect.

Polarizing filters can also be used to exaggerate different colors (and consequently tones when the image is converted to black and white). A polarizer might be used to make the cloud formations a far more dominant component in the image, for

example, or it can help simplify a scene and clarify delineations between elements by cutting the glare from reflective surfaces, such as water.

Neutral density filters might also be useful, especially in relation to their capacity to blur clouds or water. This can markedly simplify the ground in a composition, drawing attention to the relationship between figure/subject elements.

We have seen how colors affect the mood of an

Left: For this image I used an infrared filter. It has helped the clouds stand out from the blue sky, making them a more active part in the composition. The typical "whitening" effect of this filter on the foliage of the lone tree on the right has also helped to give it more dominance in this Serengeti landscape.

Right: Two versions of the same shot to compare—the first (top) without and the second (bottom) with a polarizing filter, which effectively cuts through the glare on the surface of the water and leaves, and saturates the greens slightly.

image, so you may also consider filters that alter the color balance to affect the overall feeling of your photo. With digital photography these sorts of adjustments can be applied readily in a subtle and even selective way to your images. You could also consider various special-effect filters to support your composition. A soft-focus filter, for example, may help the salience of your subject matter and create the dreamy mood that you desire.

A Final Checklist

It is difficult to condense everything that we have covered in this book into a succinct checklist that could be used in the field. However, here is a starting point—a rather lengthy list of questions you could ask yourself each time your finger reaches for the shutter-release button. I have broken it into four sections to reflect the potential stages in the process. It can, of course, be edited according to your needs.

1 Vision

- What are your passions? Are you photographing something that interests you? If so, your enthusiasm will also give you the energy to work hard to compose the image!
- Have you done your research regarding timing, locations, and so on? For outdoor photography consulting weather forecasts, tide tables, or apps such as The Photographer's Ephemeris (TPE) for sun and moon positions can save you a lot of wasted energy.
- What do you find interesting about the scene or subject? What are you drawn to?
- What are you trying to say with this photo?
- Is the subject trying to say something to you?
- Have you taken time to form a "relationship" with the subject matter?

2 Exploration of the scene

- What do you want to be dominant and how can you make it so?
- What do you want to be in the frame and what shouldn't be there? Can you do some careful "gardening" to tidy up the image, removing or concealing any unwanted/confusing elements?

- Are there any strong shapes or lines that you can constructively incorporate into your composition? Don't just include them for the sake of it.
- Where do you need to be to achieve this? Can you improve the composition by changing your position or angle of view?

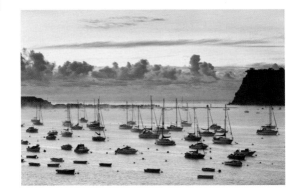

Above: For this early morning image of boats on the Teign estuary in England I chose a vantage point that was high enough to create separation between the boats. If I had been lower down, there would have been too much overlap between the neighboring boats.

- Would a different focal length help? Focal length very much influences the geometry of the image. Longer lenses with their narrower field of view can often be employed to simplify compositions. They also tend to create a very different perspective, making objects that are actually a long way apart appear to be much closer together. This can be used to support a sense of juxtaposition between objects.
 By contrast, wide-angle lenses might help you convey a better sense of depth and, of course, create a very different relationship between the elements in the scene. They tend to draw the viewer into the scene as the foreground is obviously very close.
 Extremes such as fisheye lenses give a "special effect" in themselves and if used in a considered

way they can help with your composition in certain circumstances. However, there is a risk of the effect becoming rather boring if it is employed repeatedly. When using them, remember that all lines are reproduced as straight lines as long as they pass through the central point of the photo. Otherwise they are rendered as curves, which are more pronounced the closer they are to the edges. This ability to transform straight lines into curves can be used to good advantage—to "embrace" or "encompass" other elements, for example. The "circle" they tend to generate can also make the viewer feel that they are also "embraced" within the scene. As with most of the more radical tools at our disposal, you generally want the effect to look almost as if it could be a natural part of the scene before you. You don't want your image to be too obviously a product of a distorting lens.

- Does the "portrait" or "landscape" orientation best suit your needs?
- Is there anything you can employ to create a sense of depth?
- Is there a particular journey you'd like the eye to take through the scene? If so, is there anything that can be done to aid this?
- Does the image balance in terms of visual weight? It is particularly important here to consider the balance around the vertical axis—do the left and right halves of the image balance? Imagine the image being suspended by a centrally positioned hook—will the weight in the image tend to pull it down more on one side than the other?
- Consider the relationship of the elements within the image. Is there a story to be told? Is there a concept or message to be conveyed? How might rearranging the elements help?

Above: This picture, entitled "The Tooth Fairy," depends on the viewer seeing three things immediately—the coin, the missing tooth, and the glee on the young girl's face—and quickly putting these together to work out what has happened. Placing the coin bottom left ensures it is seen early, while keeping it reasonably close to her mouth ensures that a connection is established. The oblique angle gives the picture extra dynamism. Photo by Mark Shuttleworth.

3 Technical considerations

- How much depth of field do you need to help clarify the subject matter or to better convey your message?
- What shutter speed do you want for the effect you have in mind?
- What is the appropriate exposure, bearing in mind these considerations? Would a graduated neutral density filter help to even it out across the scene?
- Would a tripod help?
- Is there a place for flash or other supplementary lighting?

- Is there a creative technique that would better express your vision? Blur, motion blur, convergence blur (by altering the focal length during the exposure), selective focus, long exposure?
- Might a filter help? A polarizer to cut out reflected glare or enhance colors? A neutral density filter to enable a long exposure? Or even a filter to add lens flare or soft focus?
- Before releasing the shutter, scan the entire composition through the viewfinder. Check that the scene is level (unless you intend otherwise) and make sure you have not cut off any parts of important elements. Also check for any distractions and look for "mergers"—when two separate elements overlap causing some degree of confusion regarding their relationship. Check the horizon—it's usually not ideal if it cuts through a person's head.

4 Variations and timing

- Do you need to wait for one element to move into position?
- If some of the elements are on the move, is it worth taking a sequence of images to improve your chances of having them in the desired place?
- Should you come back on a different day or in a different season? Snow and fog work as great simplifiers, hiding "the mess" and often reducing the number of colors and gray tones. You may be able to enhance the fog effect by using a longer focal length as there will then be a greater amount of fog between you and the subject. Such meteorological conditions can be powerful compositional aids.
- Is it worth waiting for the light quality to change? Might a different quality or direction of light influence the impact of the composition? We have seen, for example, how direct and diffuse light have very different results in rendering texture and form, and how direction of lighting also has a great impact on our perception of these qualities. The "contre jour" approach—taking pictures against the light—can be very useful for simplifying a scene and drawing attention to outlines and shapes. In the extreme this will produce silhouettes, but in lesser degrees you

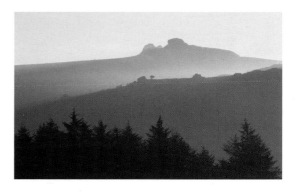

Above: Anyone who knows Dartmoor in the South West of England will instantly recognize the profile of this rocky outcrop as that of Haytor. The direction of lighting has effectively reduced the tones in the image to four distinct bands, helping draw attention to the profiles.

can also make use of the reduced number of gray tones that this approach offers. Backlighting also creates long, heavy shadows that can be powerful agents in your compositions.

- What is your market? Here you might consider taking variations of the same shot to suit a magazine cover or double page spread, for example. Vertical/portrait shots may better suit a cover image, and you may do well to allow some extra space around for text. Remember that any text added will become an additional element in the composition and there may be a need for enhancing its clarity by considering its figure/ground differentiation. It will also need to be balanced with other elements, so if there is a chance that you will use the image for greetings cards, magazines, or advertising, for example, it may be worth thinking about this at the time of shooting.
- Under very low light conditions the scene may be too dark to enable precise composition through the viewfinder. Fortunately now there is usually the option to view the image as seen by the camera on its LCD screen. In very low light you may still be able to use this to compose on screen if you set the maximum ISO possible. The camera will apply gamma gain, revealing a brightened version of the scene before you on the screen. Once composed, reduce the ISO setting to that required.

Image Processing

After capturing the image, the next part of the process is preparing the image for print or other form of display. One of the things I relish about digital photography is the scope we have in all stages of the image-making process. Rather than depending on laboratories processing our films and making our prints, we retain control over the process, conducting it in the comfort of our own homes.

Image-processing software provides us with a very powerful tool to enhance and adjust our compositions, although it is beyond the scope of this book to cover this in detail. However, as an example of the potential of these tools, we can consider how simple adjustments of levels and curves can influence figure/ground delineation, something that we now know to be so important in our compositions. Filters in mono-conversions are also particularly potent here.

We can also use "cloning" and "healing" tools to remove minor distractions, or increase the blur in backgrounds to further help draw attention to our subject matter. We can even go beyond this and radically change compositions by adding or removing objects, changing colors, or rotating and transforming portions of the image to profoundly alter the relationships of the component parts.

As well as correcting distortions, it's also possible to exaggerate them. Images can be stretched or compressed quite radically in various directions, or adjusted more subtly to adjust the rotation or proportions of the image without having to crop off important parts of the picture.

Of course to do these sorts of adjustments effectively and plausibly requires some mastery of these tools, and for most of us the challenge still remains getting it right in-camera.

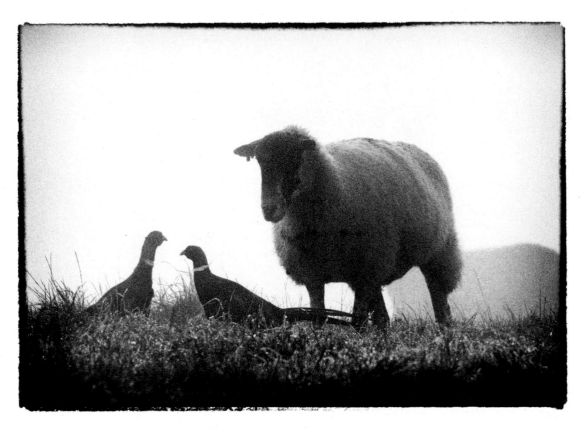

Above: Software can also mimic various film types. For example, the use of graphic films, such as orthochromatic ones, will often serve to simplify a composition as they give a very hard gradation and a reduced tonal range. Increasing the grain can also serve to simplify an image by reducing the clarity of precise textural details in the subject matter. Processing this rural scene in such a way has radically simplified the shot and altered its mood.

Above: An example of one of the options readily available to us in the digital era. The photograph above left has a depth of field rather less than I wanted, despite being taken with an aperture setting of f/18. The photograph above right is the product of "focus-stacking." Three images were taken with slightly different points of focus and then blended automatically. This extended the depth of field sufficiently to ensure that the front of the engine and the key figures on the platform were sharp.

Above & Right: The convergence of the minaret and embracing tree in the image above has been exaggerated by using Photoshop's Transform tool to drag the lower corners outward a little, as shown in the resulting image, right. This has also resulted in a better balance between the two elements and simplified the image by removing the superfluous part of the building from the bottom left.

Chapter 6
Photography as Art

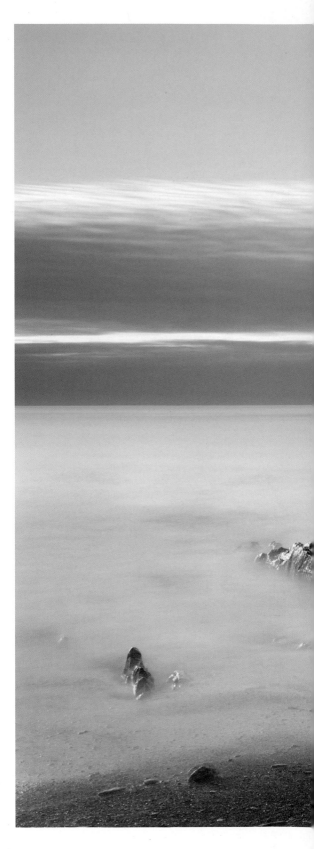

Throughout this book I have encouraged you to contemplate what you are trying to do through your photography. This may naturally lead you on to the question of photography's relationship to art. In particular, when can we call it art and when does it become "fine art photography?" I don't intend to answer these questions conclusively, but simply offer some of my thoughts. I believe that contemplating these issues can also help us put some perspective on what it is we are actually doing.

Right: A typical seascape image taken with a neutral density filter fitted to smooth out the moving water. The image immediately becomes much simpler when it is free from the distractions of the lines and curves of the waves and the variance of tones within the water.

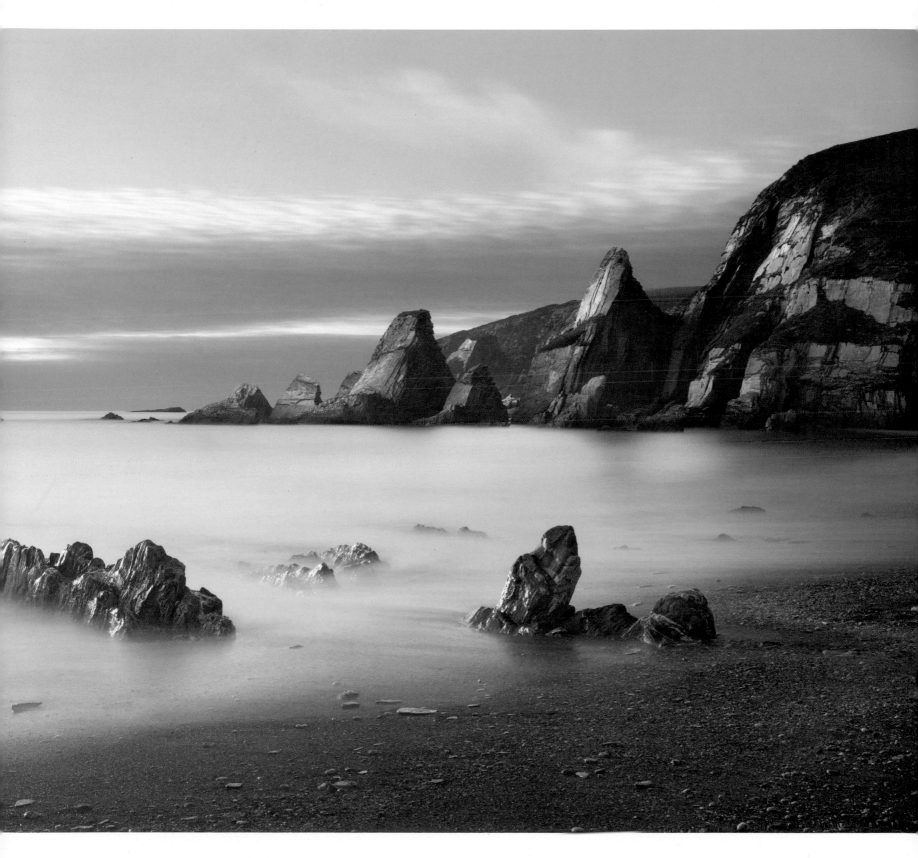

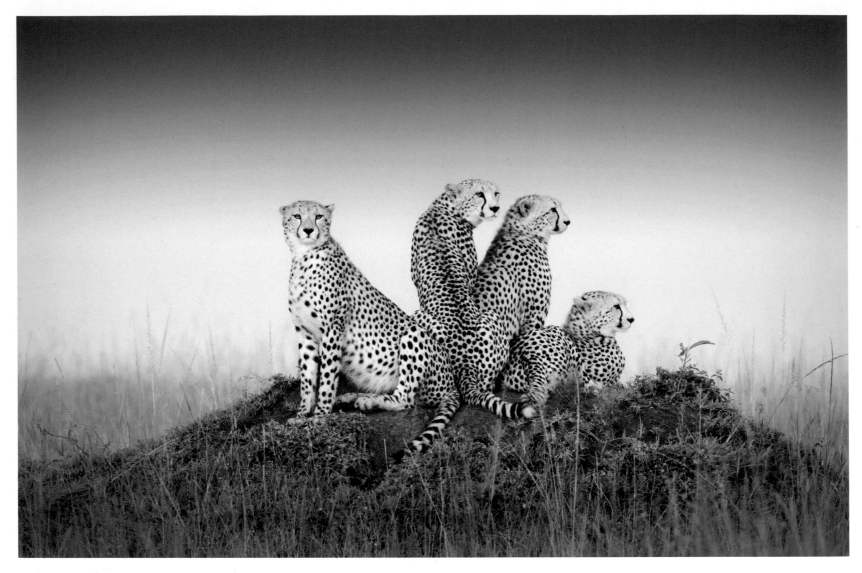

Collectively, dictionary definitions seem to suggest that an essential part of the production of a piece of art is the active, creative, and manipulative involvement of the artist: you can't have art without the artist. There is perhaps a subtle difference between art and design in this regard—art is whatever the artist says it is, with or without purpose or beauty, whereas design generally has an identifiable purpose.

So when do photographers become artists? In purely depictive photography, composing the image is a very rigid process and is concerned with showing the entire subject or a part of it with maximum clarity. The goal is accuracy of depiction; a faithful representation of reality. There is likely to be little active, creative, manipulative involvement from the photographer. So, perhaps here the photographer remains more of a technician than an artist.

Passive Onlooker

As already mentioned, there is no best or correct way to photograph any given subject. We have seen how our individual perceptions, conditioning, and "vision" will invariably result in our photos being unique expressions of ourselves. In some situations the subject matter can be allowed to be the dominant

Above: The impact of this photograph of a cheetah and her grown offspring depends largely on their array of postures being almost too perfect to be true. My viewpoint, selection of focal length, and quick reaction to a fleeting moment produced the foundation. The light was flat and the color version is surprisingly impotent, but fortunately I saw its potential as a black-and-white image. Subtle contrast and tonal adjustments add some mood and help give it a slightly surreal quality.

Above & Right: Perhaps many people would have walked around this lake without noticing the beautiful hues and patterns of these reflections on the water. It always surprises me that it sometimes takes an imaginative "photographer's eye" to show this sort of thing to people. In the same way, other people's photographs no doubt open my eyes to aspects of the world around us that I would have missed.

force and will dictate the photo more than the photographer. The photograph can be a celebration of the subject matter and the photographer can remain relatively passive and anonymous in the process. However, in trying to follow this approach we are still saying something about ourselves, even if it is simply that we wish to be passive and that our style is one of anonymity! Your vision in this case might involve the belief that the subject matter is more important than the photographer and this in itself will affect what and how you photograph.

So, clearly there is much scope for arguing that much of what we do as photographers is "art," particularly if there is a thinking, emotive being of some sort pressing the shutter-release button. Most of us are generally trying to enhance or modify what is actually in front of the lens in some way, however subtly, and through this, whether we claim an intention in terms of influencing the viewer or not, we are putting something of ourselves into the product. The simple choice of where we take our picture from has a profound impact on the composition of the picture and, as such, is a creative process.

As a result, it appears to me that whether someone's photography tends to be viewed as art or not will depend largely on how it is used and the intentions of the photographer. Making it art involves taking a degree of control over a part—or all—of the process of producing and displaying the picture, even if it is just deciding to set a different exposure to the camera's suggested reading. Hardware and software can't make the creative decisions for us.

Right: Silhouetting the Istanbul skyline by shooting toward the rising sun has simplified the scene, drawing attention to the contours of the dome and minarets of Hagia Sophia and the bold shape of the nearby streetlight. The placement of the sun behind a minaret gives it more "visual weight" helping to balance the otherwise dominant post at the left. A simple, graphic image taken for its aesthetic merit that might suit a "Fine Art" category.

Right: This image taken from the terrace of a house in Greece certainly conveys a sense of drama. The "revelatory" light bursting through the break in the clouds saves you from the otherwise oppressive darkness of the scene. In this case I put some degree of creative energy into the capture with decisions about what to include and the placement of the cloud forms and light patterns on the water. I also, of course, had some further input through the processing stages on the computer with a few simple measures to augment the contrast of the scene and some gentle dodging and burning.

Artistic Qualities

Despite all this, I think that most of us draw a line somewhere through all the work we have produced. On one side of it are the images we'd view as "art," or that we at least feel have an artistic quality. On the other side are the rest.

In one or two of the major international photography competitions, there is a category for Fine Art and it can be interesting to view the entries in this category and see if you can identify any differences between them and images entered in other categories, such as Landscape, Nature, and Still Life. I've certainly not been able to see any clear distinction, although the Fine Art category perhaps tends to include simpler imagery with an emphasis on strong shapes and patterns in the compositions. Many of the images, particularly those including people, also appear to be "staged," which suggests that the vision came first with the photographer going on to manifest it.

Aesthetic Merit

In my own work, this line is not fixed and undoubtedly changes over time with certain images flitting from one side to the other. I've heard it argued that photography is fine art when it is undertaken purely for its aesthetic merits. My criteria for defining whether one of my images could be regarded as "Fine Art" reflects this, in that it will depend largely on my intentions for its use. This no doubt also influences the creative energy that I put into the capture and processing of the image.

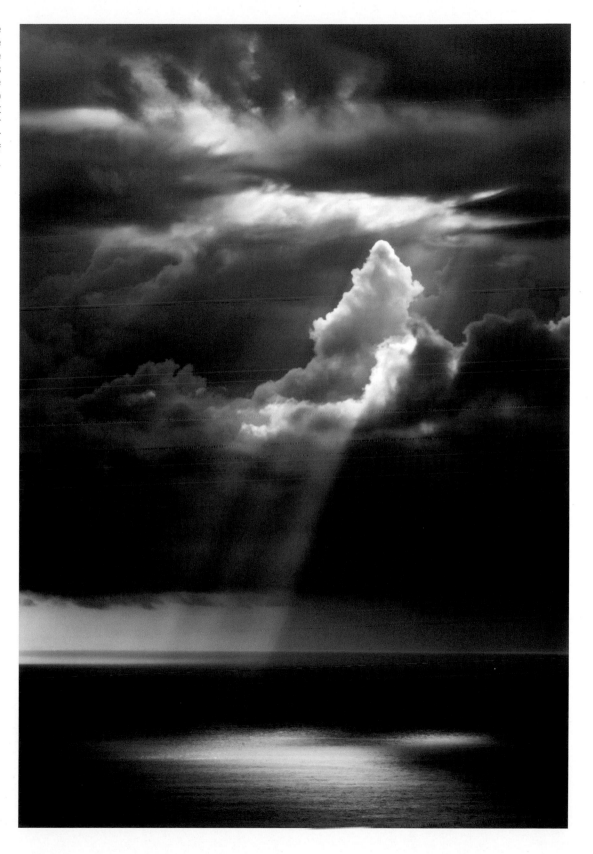

Neuron Activation

For example, if I expect the image to be framed and hung on a wall (whether in a private home or in an exhibition), that probably makes me more conscious of trying to express something and "move" the viewer. Often, for "artistic" images, the photograph's ability to evoke an emotional response is particularly important. These images are much more than simply depictive and need to do more than just show how clever you have been as a photographer. Of course, artistic images don't necessarily have to end up hanging on someone's wall, so these emotional responses don't necessarily have to be pleasurable.

A number of studies in relation to these considerations have been done on the perception of beauty and appreciation of art. Neuroaesthetics is the field that has emerged through combining neurological research with aesthetics. One proposal that has come from studies in this discipline is that pleasing sensations are derived from the repeated activation of certain neurons by that of primitive visual reflexes.

In an attempt to identify some of the criteria that determine whether we perceive something as beautiful, V.S. Ramachandran put forward a number

Above: These giraffes in the Mara Reserve of Kenya were nicely isolated on the horizon against a dramatic sky. Their slight separation and variation in size and posture add to the appeal.

of suggestions. Many of these we have stumbled on in our examination of the processes of visual perception, but the list acts as a good reminder and summary:

1. Peak Shift Principle: This is based on the observation that we sometimes respond more strongly to exaggerated versions of the stimuli. Utilizing this to capture the essence of something, an artist may amplify the differences of that object, exaggerating

what makes it unique, highlighting the essential features, and reducing redundant information.

2. Isolation: Isolating the desired visual form helps the above process whereby that aspect is amplified. To use this, an artist may exclude as many non-unique features as possible from the subject to avoid them detracting from its perception.

3. Grouping: It appears that the process of perceptual grouping that enables us to delineate a figure from the background may be enjoyable. A good example is the pleasure we derive from perceiving a dalmation in what initially appears to be random black marks on a sheet of white paper.

4. Contrast: Cells in our eyes and brain respond predominantly to step changes in luminance rather than homogeneous surface colors, so our perception is drawn to these areas. This may hold evolutionary significance since regions of contrast are generally information rich.

5. Perceptual Problem Solving: The discovery of an object after a struggle is more pleasing than seeing one that is obvious instantaneously.

6. The Generic Viewpoint: Our visual system prefers an "objective" vantage point; one that will give us more useful information about our surroundings. The visual system dislikes interpretations that rely on a unique vantage point. Rather it prefers to be given a good vantage point from which it can make its own mind up about the subject matter. For example, in a landscape image we may not like an object in the foreground that obscures an object in the background. However, in certain applications, defying this principle can also produce a pleasing effect so it can clearly be overridden by other factors.

7. Visual Metaphors: It is rewarding to grasp an analogy by highlighting crucial aspects that two objects share.

8. Symmetry: The aesthetic appeal of symmetry is easily understandable.

In this context it is interesting to ponder the effectiveness of abstract images as pieces of art. Again, a few dictionary definitions for the term "abstract."

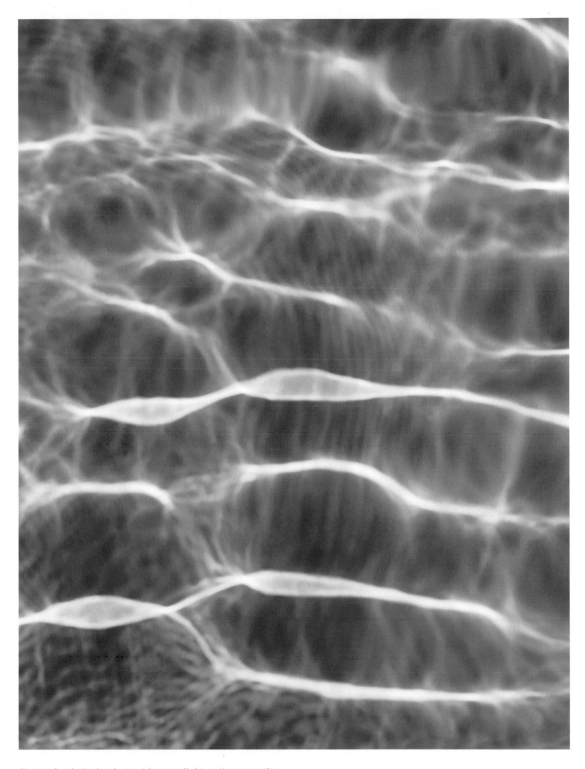

Above: A relatively abstract image: light patterns on the bottom of a swimming pool formed by disturbance in the water.

Above: Strong side-lighting emphasizes the contours and texture in this abstract shot of the surface of a rock. There is nothing to give you an indication of scale, however, so it could equally be of a mountain range taken from a plane window.

- Having no reference to material objects or specific examples; not concrete.
- Denoting art characterized by geometric, formalized, or otherwise nonrepresentational qualities.
- Without reference to specific circumstances or practical experience.

The term's use in art and photography tends to be a relative one. In the extreme it involves imagery that bears absolutely no likeness to anything in the real world; it is unidentifiable. In photography it is often a result of closing in on details in a scene that would perhaps not normally be clearly available for the naked eye to examine. Consequently, the viewer is left struggling to formulate a sense of depth and scale.

Abstract Attractions

The discipline of neuroaesthetics is starting to reveal some insights as to why we can still be attracted to abstract images, even though they seem to have no clear relationship to the world around us. For example, it appears that the amygdala, a part of the brain that detects threats in our peripheral vision (among other things), is stimulated by such images and generates certain feelings and emotions. Parts of the brain linked with meaning and interpretation are activated as well.

Also, as we have seen, we seem to take pleasure in the challenge of trying to work an image out and abstract images present us with a stiff challenge in this regard. Interestingly, it also appears that there is often more structure, order, pattern, and balance in many abstract images than the artist and viewer are consciously aware of. For example, fractal patterns (forms or shapes that are repeated in an image in such a way that if you zoom in you will find the same pattern on a smaller scale) are apparently often there to be perceived at some level of our awareness. These are widespread in the natural world, which perhaps explains the satisfaction they provide.

It is interesting to ponder such findings in relation to our notions of beauty. It is not entirely true to say that something is inherently beautiful because it is necessary for us to judge something first to give it this label. We probably often base this judgment on our recognition of, and identification with, the elegance that has gone into its composition. Much of this elegance corresponds with many of the mathematical sequences and derived ratios (such as the Golden Ratio) that we have discussed in this book.

Natural Sequences

It is interesting that these also seem to be widespread in the natural world. Growth occurs in biological organisms by cell division. One cell becomes two, the two become four, and so on. However, each cell of the same generation does not necessarily divide at the same time, so one cell becomes two, one of these then divides before the other, producing three. Then the other cell divides, producing five. Then 8, 13, and so on. This is the Fibonacci sequence that we met with early in this book.

If you count the number of leaves on branches of a plant, they typically follow a certain sequence and repeating patterns or fractals are commonly encountered. Nature has not used these patterns to please human beings, so why do we find such satisfaction in this aspect of design? The answer, perhaps, is that we are all formed by these same biological processes, so have this elegance in us too. So, maybe our appreciation and experience of beauty is related to our perceiving a resonation between a pattern that is outside us and a similar pattern within us? It seems that we are all born with this ability to respond to "beauty," and as photographers we are often trying to create it too.

One way or another, these types of findings and debate make us realize how much more there is to discover and understand in relation to what makes some photographs so effective. This type of research may eventually shed more light on this, but sometimes I wonder if it would be a shame if we got too obsessive about controlling our image-making. It's nice that there is still some mystery there and that we can often look at a photograph and conclude that it works, but we're not quite sure why!

Conclusion

So, what can we conclude about the role of composition in our image-making? Firstly, it is worth acknowledging that some aspects of our composition are performed unconsciously, but many are conscious creative decisions. Secondly, composition is not just about putting a few lines in an image and balancing the weight—you can have a carefully composed shot that tells us virtually nothing other than it is carefully composed. Composition on its own is generally not the purpose of our photographic endeavors. Rather it is a valuable tool to use if we intend to convey something to others, whether it's a story, message, insight, mood, or simply some detail of content.

We've seen that our eyes—whether we are photographer or viewer—do not work like cameras. They are linked to our brain and the signals that reach our consciousness are filtered by the processes of perception. To a limited degree this, along with other psychological processes linked to our perception of two-dimensional images, has been studied and we can use the principles that arise from these studies to help us realize our intentions. Whether we intend an image to be perceived easily, giving a sense of harmony and order, or whether we intend to upset the viewer by making things a little more challenging for them, these principles are still at our disposal.

Based to some degree on these principles of perception (but also on experience), various "rules" have been espoused. The rules are usually grounded in a desire for harmonious, organized, readily perceived, and pleasing images. If our intention is another, very different type of image and response then we may choose to break the rules, but even here a knowledge of the rules is beneficial, as it will help you to more consciously and creatively break them. The degree to which you break them can provide a whole spectrum of responses in the viewer. They give you, as a photographer, more control over the subtleties of how your images are perceived and received. We can also see why some would argue that, strictly speaking, "rules" do not exist in composition.

Sometimes, for an image to have impact, a certain frame of mind is needed on the part of the viewer, so how this type of image will be received is far from predictable. These are often images that don't rely so much on the configuration of their elements and perhaps, therefore, are not so open to interpretation according to the principles that have been discussed in this book. Or maybe they are, but we have not yet found the more subtle factors and clarified the explanations that would help us understand the responses they engender.

In closing, I'd like to stress that the best tools at our disposal for mastering composition are not bought from camera stores—they are within us. To better express something about our subject matter and ourselves in our photographs, we should take steps to engage more in the process. Before we start we need to take time to establish a relationship with our subject matter; to engage our hearts and emotions. Secondly, we need to engage our imaginations; to let them run wild to form our vision for an image.

Then, perhaps, we bring our cameras and our eyes into the process. That is to say, having formulated a vision we now use our eyes objectively to see what is actually in the scene. Then, we try to engineer the scene, which may involve simply waiting for something to move, or adjusting our camera, lens, or shooting position, so that the scene best reflects our vision. We do this largely by bringing our bodies into play; using our legs to explore the scene and the options different viewpoints offer.

It's amazing how often you see photographers standing behind tripods with the tripod legs at full extension simply so that they can stand comfortably, without stooping. Tripod legs are adjustable, and so are ours! We may need to lie down and, heaven-forbid, get a little dirty or wet! When you see a serious, passionate photographer at work, and they're truly "in the zone," you'll see that they are lost in their creative experience—they won't be aware that they've just knelt in a mud patch. Throughout the process our minds are also at work—as we have seen, the arrangement of elements in our compositions is a considered process.

I would like to thank you for joining me on this exploration of a fascinating topic. I hope you will now go on to look at your own photographs—and those of other photographers—with a critical eye and a greater understanding of why some shots work and others don't.

Above: Raising the contrast has helped simplify this image of giraffes in Kenya so that we can focus on the graphic shapes of these wonderful creatures and the acacia tree alongside.

Glossary

Anomaly When an object or element is emphasized due to its dissimilarity to others surrounding it.

Aspect Ratio A numerical way of describing the shape of the frame by stating the horizontal and vertical measurements together as a ratio.

Burning This term originates as a description of a darkroom process whereby a portion of the photographic paper is exposed to light from the enlarger for longer, resulting in a darkening of that part of the image. The term is still used when digital images are similarly manipulated to darken specified parts of the image. *See also Dodging.*

Closure In the context of visual perception, this term describes our tendency to provide imaginary "missing" details to complete a potential pattern or shape that is not otherwise completely defined.

Color Constancy This is the phenomenon of visual perception whereby we can identify two areas of slightly different color in an image (due to their differing degrees of illumination) as being the same material and thus actually the same color. This is based on similarities they have in other respects and our experience of the world around us.

Compositional Frame When objects or shapes within a scene act as a "frame within the frame" to encompass or partially surround other key elements within the scene.

Continuance A term used to describe our potential to perceive what are actually separate elements in an image as being the same element captured in or conveying a sequence.

Contrast This is a description of the extent to which adjacent areas of an image differ in brightness. It reflects the gradation between the highest and lowest luminance values.

Counter Form Imaginary shapes generated by our minds due to our tendency to strive for Closure (*which see*) or to continue existing lines, shapes, or contours.

Cropping To select and isolate a part of an image with the aim of improving composition or fitting an image to the available space.

Depth In terms of visual imagery, this is a description of the sense of a recession of elements within the image into the distance. It is thus an impression of a third dimension that is actually lacking in the two-dimensional image.

Depth of Field The distance extending in front of and beyond the point of focus that is also perceived as being acceptably sharp. If an object is placed within this zone it will appear to be in focus.

Divine Proportion—*see Golden Mean.*

Dodging The opposite of Burning (*which see*). Here a portion of the image is lightened. Software now enables us to selectively apply this to certain tones too.

Dynamic Section A rectangular picture plane is divided by two lines, one running diagonally corner-to-corner and the other running from one of the other corners to meet the first line at a 90-degree angle. The lines and intersection point are supposedly good places to position elements.

Dynamic Tension This term describes the sense of unease, imbalance, and movement that we can gain from an image where elements are placed in an imbalanced or unconventional way.

Element In the context of this book, this term is used to encompass the various distinct entities that might be identifiable in the scene before us or within a photograph. These act as the component parts of our compositions. Distinct objects, areas of different or contrasting tone or color, lines, shapes, patterns, and even relatively empty or "inactive" spaces can thus be considered as elements.

Emergence This is the process whereby we suddenly perceive and recognize a complex form in an image.

Equivocation When a picture can be seen in two or more ways due to its perceptual ambiguity.

Fibonacci Sequence or Ratio Leonardo Fibonacci proposed that there was a ratio often seen in nature that is pleasing to the eye—that ratio is 1:1.618. He also associated this with a mathematical sequence given his name. In this sequence, each subsequent number is the sum of the previous two.

Figure This term is often used in this book in the context of its meaning as defined in the Figure/Ground principle of the Gestalt Theory. Figure is the element or elements that we perceive as being subject matter within the image at any one time. Ground is the rest of the image. One can become the other as our focus of attention shifts and our interpretation of the image changes.

Form The perception we gain of the three-dimensionality of an object in a photograph due to the change in tones across it related to the light direction and the shadows cast.

Format In the context of picture format this is a term for the proportion of the horizontal-to-vertical dimensions of the image (*see also Aspect Ratio*).

Gestalt Theory A theory defined by psychologists early in the 20th century in their attempts to understand and define the principles underlying our "visual intelligence" and perceptive processes. It looks at how we acquire and maintain stable perceptions that provide us with some useful meaning out of the complex and potentially chaotic world around us.

Golden Mean A proportion or "golden" ratio. If used to divide planes and pictorial elements are placed along the resulting lines or points, the compositions are supposedly more aesthetically pleasing. The ratio is derived by dividing a line of length c into two parts, a and b, whereby the ratio of a:b is the same as the ratio of b:c.

Golden Ratio—see *Golden Mean*.

Golden Section—see *Golden Mean*.

Golden Spiral A logarithmic spiral whose growth factor is related to the Golden Ratio. Elements can be aligned along such a spiral with apparently pleasing results.

Ground— *see Figure*.

Hourglass Effect When, due to our tendency to retain a sense of three-dimensionality in a two-dimensional image, we get a perception of two cones converging to a point of interest where they meet. Our attention is strongly drawn to and focused on this point.

Hue The attribute of color that enables it to be classified as red, green, blue, yellow, or purple. This is related to its spectral position.

Invariance A principle of visual perception whereby geometrical objects are recognized and identified regardless of their scale, rotation, translation, certain deformations, different lighting, and so on.

Law of Prägnanz As one of the fundamental principles of the Gestalt Theory, this law states that our psychological processes attempt to make order, harmony, symmetry, simplicity, and structure out of seemingly disconnected bits of information.

Lead Room—see *Rule of Space*.

Leading Space—see *Rule of Space*.

Multistability A description of our tendency to switch back and forth between two possible perceptions within an image when there is ambiguity between them.

Negative Space An area of image that is empty or not containing subject matter and "inactive." It is often used as a relative term—a space containing little compared to the "positive space" containing the subject matter and elements key to the composition of the image.

Nose Room—see *Rule of Space*.

Optical Lines These assumed or implied lines are ones that our eyes tend to follow, such as the direction of gaze of a person in the picture.

Panoramic Format This is when the Format (which *see*) of a picture is particularly elongated, typically exceeding an aspect ratio (*see Aspect Ratio*) of 2:1.

Perspective The art of suggesting three dimensions on a two-dimensional surface by accurately recreating the spatial relationships that objects receding into the distance in a scene actually present to the eye.

Phi—see *Golden Mean*.

Point Used to describe an element in a composition, this term identifies a shape that is small, simple, and concentrated in form that attracts the eye with great force.

Positive space—see *Negative Space*.

Rabatment The imaginary line created if you divide a rectangular picture to form a square with sides equal in length to the shorter side of the rectangle.

Reification The constructive and generative tendency of our perceptual processes, whereby we perceive shapes and objects that are not there.

Rule of Space A subject in a photograph should have space to move into in the direction in which they are facing or moving.

Salience This is a pictorial element's level of impact and thus degree of dominance in the image.

Saturation In relation to color this is a description of its purity and thus to some degree its intensity, though this also depends on its luminosity or brightness.

Scale Constancy A phenomenon of visual perception whereby we identify two separate elements of differing sizes in the image (due to their differing distances from us) as being the same type of object and actually the same size. It is based on similarities they have in other respects and our experience of the world around us.

Tone A description of the lightness or darkness of a part of an image that enables it to be distinguished from other parts that have a different tone. In the context of color it describes the shade of that color, which is the quality of that color that varies according to the amount of white or black mixed with it.

Triptych A display composed of three separate images or panels that are brought together in this way.

Vectors Imaginary lines generated by our minds to continue existing ones or to connect otherwise isolated lines or elements.

Visual Attention The process whereby something catches our eye in the real world or in an image.

Visual Weight A term used to describe the tendency an element in a picture has to draw the viewer's attention. It can also be used to describe the impression of actual weight that a pictorial element has.

Useful Web Sites

For more information visit the author's web site:
www.richardgarveywilliams.com
or contact him by email at:
richard@richardgarveywilliams.com

Equipment
www.dpreview.com Resource for photographic equipment: buying guide and reviews.

www.dxomark.com DxOMark is the trusted industry standard for camera and lens independent image quality measurements and ratings. The site is a resource for sensor and lens reviews and comparisons.

www.digital-photography.org Digital camera and lens reviews.

www.calumetphoto.com For photographic equipment in general.

www.calumetphoto.co.uk (UK).

www.warehouseexpress.com For photographic equipment in general (UK).

www.mifsuds.com For photographic equipment in general including secondhand (UK).

www.formatt-hitech.com Hitech filters.

www.cokin.co.uk Cokin filters.

www.leefilters.com Lee filters.

www.hoyafilter.com Hoya filters.

www.wildlifewatchingsupplies.co.uk Various accessories useful to outdoor photographers (UK).

www.whitewall.com Photo lab: mounting, framing, and printing.

www.dscolourlabs.co.uk Photo lab: printing and associated products (UK).

www.teamworkphoto.com Various accessories (UK).

www.blurb.com or **www.blurb.co.uk** Create your own photographic books and albums.

www.colorvision.com Datacolor display calibration and printer profiling software and devices.

Software
www.breezesys.com or **www.breezesys.co.uk** Browser for viewing and manipulating images.

www.adobe.com Photoshop Creative Cloud, Lightroom, and Elements image-browsing and processing software.

www.niksoftware.com Powerful image-processing software.

www.onOnesoftware.com Various software packages for image manipulation and resizing.

www.photoephemeris.com The Photographer's Ephemeris is a software app that enables you to see how the light will fall on the land, be it day or night, for almost anywhere on earth.

Associations
www.naturephotographers.net The web site of the Nature Photographers Network™, an international cooperative network of amateur and professional photographers dedicated to the art and technique of nature, wildlife, and landscape photography.

www.worldphotographyforum.com Forum community for photographers.

www.1x.com/photos Forum with catalog and sales opportunities.

www.fineartamerica.com or **www.fineartengland.com** Sell your images as prints and cards online.

www.the-aop.org Association of Photographers (UK)—a membership organization of professional photographers, assistants, students, agents, affiliated university and college courses, and affiliated companies.

www.fiap.net The International Federation of Photographic Art is a federation whose members are national photographic federations. It acts as a worldwide international body devoted to promoting and encouraging photographic art in all its aspects.

www.thepagb.org.uk The Photographic Alliance of Great Britain is a member of the FIAP and is the organization that coordinates specific activities for photographic clubs in the UK.

www.capacanada.ca The Canadian Association for Photographic Art is also a member of the FIAP.

www.rps.org The Royal Photographic Society is an association in the UK promoting the art and science of photography.

www.talkphotography.co.uk Forums for members.
www.photographycorner.com Resources and forums for members.

Index

AMMONITE
PRESS

To place an order, or request a catalog, contact:

Ammonite Press

AE Publications Ltd, 166 High Street, Lewes, East Sussex, BN7 1XU, United Kingdom

Tel: +44 (0)1273 488006

www.ammonitepress.com